W9-AZO-474

A Gallery
of
American Samplers

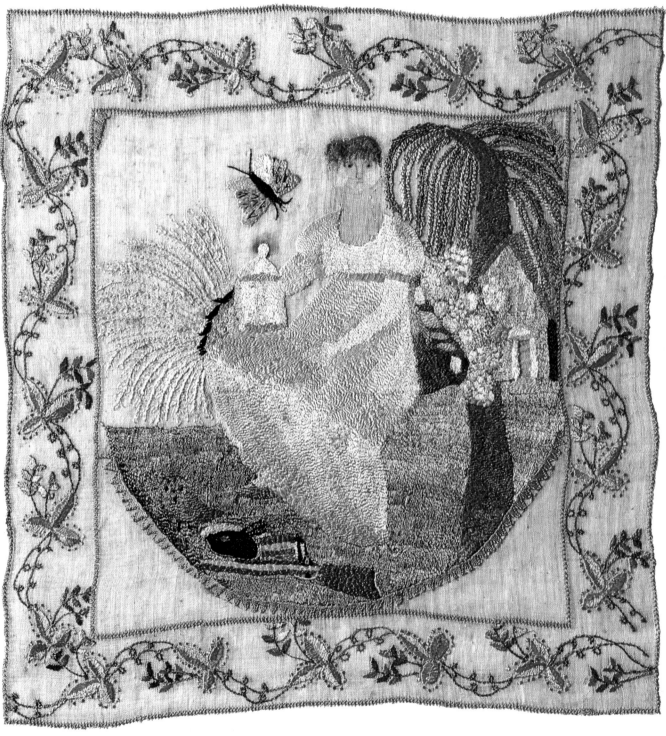

A Gallery of American Samplers

The Theodore H. Kapnek Collection

Glee F. Krueger

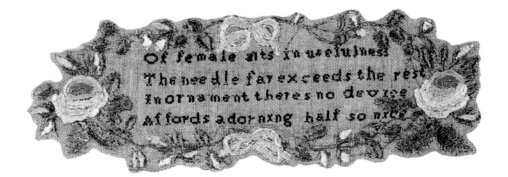

Of female arts in usefulness
The needle far exceeds the rest
In ornament there's no device
Affords adorning half so nice

E. P. DUTTON
in association with the
MUSEUM OF AMERICAN FOLK ART
New York

Acknowledgment

Lack of space makes it impossible for me to acknowledge individually the many persons and institutions that have so graciously shared their knowledge and resources during the preparation of this book and the accompanying exhibition at the Museum of American Folk Art, New York. Nevertheless, I want each and all to know how very grateful I am for their kind help.

Frontispiece, page 2: Detail from sampler made by Barbara A. Baner, Harrisburg, Pennsylvania, 1812. See figure 64, page 48, for the complete sampler.

Page 3: Detail from sampler made by Mary Ann Morton, Portland, Maine, 1820. See figure 81, page 58, for the complete sampler.

Page 5: Detail from sampler made by Elizabeth J. Demeritt, Rochester (New Hampshire or Massachusetts), 1st quarter of 19th century. See figure 65, page 49, for the complete sampler.

First published, 1978, in the United States by E. P. Dutton, New York. / All rights reserved under International and Pan-American Copyright Conventions. / No part of this book may be reproduced or transmitted in any form or by any means, electronic or mechanical, including photocopy, recording, or any storage and retrieval system now known or to be invented, without permission in writing from the publishers, except by a reviewer who wishes to quote brief passages in connection with a review written for inclusion in a magazine, newspaper, or broadcast. / Published simultaneously in Canada by Clarke, Irwin & Company Limited, Toronto and Vancouver. / Printed and bound by Dai Nippon Printing Co., Ltd., Tokyo, Japan. Library of Congress Catalog Card Number: 78-59876. / ISBN 0-525-47515-X (DP); ISBN 0-525-11130-1 (Cloth). *First Edition.*

Contents

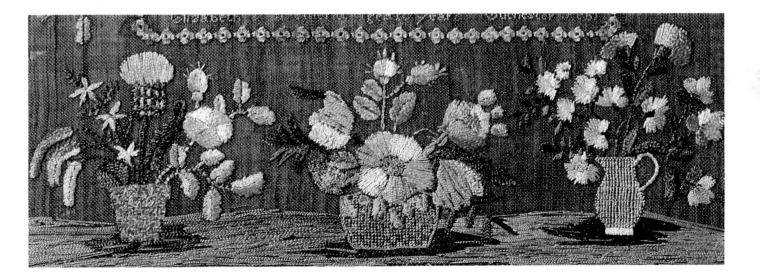

Foreword

"Why samplers?" is a question that I am continually asked by people who have either seen my collection or know of my interest. Some twenty-five years ago I started a collection of miniature furniture (cabinetmakers' samples) of the eighteenth century, both American and English. As I browsed through antiques shops and attended antiques shows, I was always fascinated by and admired the samplers that hung in profusion on the walls.

About twelve years ago I started the collection with my first purchase of three English samplers, and from there on I was hooked. It was about eight years ago that I decided to dispose of my English samplers and to concentrate on collecting American pieces. As with almost any branch of collecting it has been both fun and educational.

When young collectors have asked my advice on what to collect, my answer has always been samplers, for I believe they are still underpriced and their importance is generally underestimated. The collecting of samplers, compared with other fields of collecting, gives you the pleasant advantage of generally knowing where a piece was made, when it was made, and by whom, because samplers are very often signed and dated. If the name of a school or town is included in the needlework, it makes the job of genealogical research much easier, for in most cases this information helps in tracing, through historical societies and family records, the history of the child who made the sampler.

Samplers demonstrate the great importance of a young girl's learning the basics of needlework as a preparation for her duties as an adult. First, the youngster had to learn a variety of stitches that would prove useful in both practical and ornamental work, and in addition the sampler often shows that the needleworker had also learned her ABCs and a simple religious or moralistic verse. A common example of the latter is the following: "By this work you can plainly see/the care my parents took of me." Another delightful verse, which is reproduced on the title page of this book, sings praises to the needle:

> Of female arts in usefulness
> The needle far exceeds the rest
> In ornament there's no device
> Affords adorning half so nice.

It is interesting that in the twelve years since I started my collection, the many samplers that formerly hung in antiques shops and at shows have almost disappeared. This is due not only to the tremendous revival of interest in needlework of all types in the past few years, but also to the number of collectors, museums, and historical societies that are endeavoring to expand their holdings in this field.

In putting together my collection I have been fortunate in having the counsel and encouragement of Glee Krueger, the author of this book. I value her friendship and her knowledge. Doris Ashley of the Philadelphia Museum of Art deserves my gratitude for her help in the restoration and preservation of the pieces. Both ladies have added much to the pleasure I have received from my collecting American samplers.

THEODORE H. KAPNEK

Introduction

Definition of a Sampler

The sampler was originally a cloth used to practice stitches and stitch combinations. It was also a means of learning to execute embroidery patterns and designs. Initially unframed, and of relatively narrow width, it could be rolled and stored much as an Oriental scroll, and then consulted at whim whenever the embroideress chose to use it as a convenient reference source. The sampler preceded the introduction of needlework pattern books that became available to a select few in the sixteenth century. Basel, Cologne, Nürenburg, Zwickau, Venice, and Paris were among the Continental cities that produced these pattern books in the sixteenth and seventeenth centuries. Johannes Schonsperger (1523–1524), Peter Quentel (1527), Giovanni Antonio Tagliente (1530), Giovanni Andrea Vavassore (1530), Giovanni Ostau (1561), Vecellio (1592), Richard Shorleyker (1624), Johann Sibmacher (1597), and Rosina Helena Fürst (1666) were some of the early publishers and designers of pattern books.[1] These books were not directed to the male professionals, but to the feminine audience, as when Vecellio dedicated his book to "noble and skilled ladies." [2]

English designers followed the lead of the Continental publishers with numerous translations and writings of their own. John Wolfe and William Barley in England published earlier material from France and Venice. Under the title *New and Singular Patternes and workes of Linnen* Wolfe produced in 1591 a translation of the earlier publication in Paris by Jean Le Clerc of Frederic de Vinciolo's book, *Les Singuliers et Nouveaux Pourtraits pour touttes sortes d'ouvrages de Lingerie*.[3] London's James Boler produced twelve editions of *The Needle's Excellency* between 1634 and 1640. These patterns were those of Johann Sibmacher. In *Samplers* Donald King discusses and illustrates a number of the English samplers that incorporate these early patterns. Those include the geometric designs of cutwork, a hound chasing a rabbit, a parrot-and-spray motif, and a swan and lady and gentleman.[4] Some of these themes were to be replayed in various ways on American samplers. In one example by Jane Shearer (fig. 53) the design is derived from the 1666 patterns of Rosina Helena Fürst (fig. 10).

When the sampler emerged in America, it continued to provide sources for both owner identification and/or ornamentation. These needs were met by the variety of letter styles, numerals, and occasional small, individual design motifs incorporated in the samplers. Any of these, or a combination, could be applied to innumerable sheets, towels, pillowcases, quilts, blankets, coverlets, and even the occasional crewel-embroidered bed furnishings that an affluent family might possess. Full names or initials and dates and even towns are to be found on surviving pieces. In costume, the marking techniques can be seen on petticoats, nightgowns, and even corsets. Many accessories such as work-pockets and worked pocketbooks, in either wool or silk, were carefully marked. The daintiest silk or muslin reticules, dresser scarves, or handkerchiefs would be so identified.

An example of such marking is in the large, imposing portrait of Rachel Ann Maria Overbagh Ostander and

1. Westtown School, Westtown, Chester County, Pennsylvania. The old building from the girls' grounds, showing pupils and staff in the 1860s. Courtesy Westtown School, Westtown, Pennsylvania.

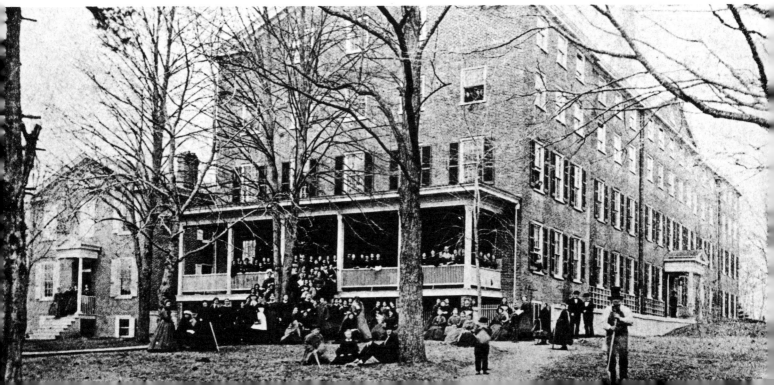

her son Titus by the American folk artist Ammi Phillips. This distinctive Green County, New York, painting of about 1838 shows Mrs. Ostander in a fashionable leg-of-elephant-sleeved dress of dark hue. Silhouetted against this dark expanse is a crisp white handkerchief clearly cross-stitched with red initials, "R A M O." [5]

In spite of such marking, articles became separated from their owners. *The New-Hampshire Gazette* of January 17, 1809, records such a loss:

> TAKEN from a Sleigh belonging to the Livery Stable, last Saturday evening, a white lace work bag, lined partly with pink, containing a linen cambric pocket handkerchief marked Eliza Hall; a red morocco purse with nine dollars, and a ticket in the Dixville Road Lottery, No. 10437; a red morocco purse with nine dollars, and a scissors with a silver sheath, initials E.H.; a silver knife and fork, with pearl handles; a gold tooth pick with silver case; a silver pencil case; —whoever will return it or give information of the same to ELIJAH HALL, in Daniel Street, or at this office, shall be handsomely rewarded.

Although the sampler served for many generations as a reference for marking techniques, the definition and purpose of the sampler did not remain constant. Whereas in 1530 John Palsgrave's dictionary compilation of *Lesclarcissement de la Langue Francoyse* stated that a sampler was "an example for a woman to work by," [6] by the end of the eighteenth century Dr. Samuel Johnson defined it as "a pattern of work; a piece worked by young girls for improvement." [7]

In our first American dictionary of 1806 Noah Webster of Hartford repeated Johnson's view emphasizing the youthful educational value of a sampler and stated it to be "a piece of girl's needlework, a pattern." [8] Philadelphia's John Walker also defined it as "a piece worked by young girls, any pattern of work" [9] in his dictionary of 1822, and reiterated this in 1836 with "a pattern of work, a piece of work by young girls for improvement." [10]

Although our first sixteenth-century definition by Palsgrave indicated adults were those working the early samplers, it is fascinating to see in London's Victoria and Albert Museum several seventeenth-century English embroidery pieces by Martha Edlin. These include a technically sophisticated polychrome-silk embroidered sampler of 1668 made by Martha at the age of eight, a second one with horizontal bands of cutwork finished in 1669, a stumpwork casket dated 1671, and finally, a beadwork one of 1673.[11] This collection of truly exquisite pieces by a very young girl makes one realize how early ornamental needlework was a required part of the education of privileged young women.

In America in the seventeenth century many of the stitch and design techniques used abroad are repeated with almost no change. In the eighteenth century these designs and stitches take on a particular American flavor, for they possess a more naturalistic and looser, unrestrained character. The American pieces are often more individualized in conception and often more flamboyant in appearance than those of other countries. Workmanship varies in quality: some is superb, but much lacks the discipline and polish of the English or Continental examples.

American Needlework Schools and Teachers

ENGLISH INFLUENCE

The many American-made samplers seen today in museums, historical societies, private collections, and in the homes of the maker's proud descendants are legacies of the rich needlework heritage of Western society. Especially dominant was the English influence on American needlework during the formative years of this nation.

This influence on needlework was sustained by the many teachers that came to American private schools from England. Numerous Englishwomen described their needlework skills, good breeding, genteel manners, and moral precepts through advertisements in American newspapers.

The New-York Mercury of May 20, 1765, carried a typical advertisement by Mary Bosworth:

> Mary Bosworth, Lately from London, takes this method to inform the public, that she has opened a school in Cortlandt street, near Mr. John Lary's; wherein she teaches young masters and misses to read and learn them all sorts of verse; she likewise learns young ladies plain work, samplairs, Dresden flowering on cat gut, shading with silk or worsted, on Cambrick, lawn or Holland; she draws all sorts of lace in the genteelest manner. Those gentlemen and ladies that will be pleased to favour her with care of their children, may be assured that she will make them her chief study to deserved their approbation.[12]

A similar advertisement appeared in *The Salem [Massachusetts] Impartial Register* of Thursday, October 15, 1801:

> *Female Academy.*
> MRS. BROWN, not long since from London, acquaints the Ladies of SALEM, and the public in general, that she will educate Young Ladies in the following works—Sampler Work, working of Muslin in its various branches, Tambour, Embroidery, Print Work, Filligree, the elegant accomplishments of Drawing Landscapes and Flowers, and of Painting on Satin and Paper.—In the afternoon, the Young Ladies, who choose, will be taught Reading, Writing, Arithmetic, English Grammar, Composition, Geography, and the use of Globes, if Globes can be obtained. The terms of Education will be 5 dolls. per quarter. Strict regard will be had to the morals, manners and fitting of the Misses. Such as come out of the country will be taken to board 2½ dollars per week, Board and Education, Mrs. Brown will commence teaching on Monday next, Sept. 21st, in the House opposite to Mr. William Gray's new house, Essex-Street.
> N.B. Making of Flowers, and Stamping of Linen, will be taught separately at 4 dollars each, on Wednesday and Saturday afternoons. Twenty five scholars only will be taken this season.
> Salem, Sept. 17, 1801

Between 1700 and 1770 the population of the American Colonies more than tripled in size, from 629,000 to 2,148,000. By the mid-eighteenth century this growth was concentrated in five major seaports: Charleston, Philadelphia, New York, Boston, and Newport. This urban growth was sufficiently rapid and large enough to encourage and support a cultured society [13] that demanded artistic refinements, leisure pursuits, and pastimes commensurate with their newly acquired wealth. Within this framework attention was paid to a genteel education for young ladies. The cornerstone of this pleasing though somewhat superficial teaching was the creation of ornamental needlework, and the foundation of this was the mastery of the basic sewing skills by means of the sampler. So this one teaching device became a focal point for much of what a young woman would achieve with the needle through the rest of her life.

TYPES OF SCHOOLS OFFERING NEEDLEWORK

In America during the eighteenth and early nineteenth centuries, there existed a variety of schools that taught needlework. Although advertisements whetted the appetite of pupil and parents with lengthy descriptions of ornamentals, many schools offered a simple choice of "plain Needle Work" [14] or "Plain Sewing, Marking, Muslin Work." [15] These basic skills could have been introduced at home by a mother or grandmother, or frequently in the dame school.

The last was a small community school that in a sense was the equivalent of our nursery schools and kindergartens. Baby tending was the object. Its educational goals were modest, for arithmetic, reading, knitting, sewing, and sampler making were essentially its products. These schools were casual in arrangement. Sometimes they met in a public building, a room of a large home rented by the dame, or in her own home. The teacher was often a spinster or a widow. Many a nineteenth-century memoir recalls with a trace of nostalgia the experiences in the dame-school environment, despite the fact that many also vividly remember the chastising they received from a ruler, a thimble, or a switch. Some pupils were literally tied to the dame's apron strings. Such was the example of four-year-old Jonathan Tucker, whose father, Captain Andrew Tucker, kept the receipts for schooling his children at Mistress Mary Eden's school in Salem. A mature Jonathan provided the following information when he presented his school receipts to the Essex Institute in Salem:

Capt. ANDREW TUCKER to MARY EDEN Dtr to Schooling Andrew from february 2-1803 to april 16—2½ months to 3/ pr month	0: 7:6
to Schooling John from february 7-1803 to august 7—6 months 3/ pr month	0:18:0
to Schooling Jonathan from february 14-1803 to august 20—6 months 3/ pr month	0:18:0
to Schooling Martha from april 11-1803 to august 30—3 months 3/ pr month	0: 9:0
	2:12:6

received pay
Mary Eden.

The House where the venerable Madam Eden assisted by her daughter Miss Polly, kept school is No. 136 Boston Street, and is the most ancient-looking house in Salem. I believe that it has not been changed or received any repairs, exterior or interior, since the date of the above bill. She taught the boys to sew and knit, to keep them quiet and orderly. Her severe mode of punishment was to pin the delinquent to her apron. [16]

Salem, June 1865—Jonathan Tucker,—one of her pupils was then four years old.

This need to maintain a quiet, orderly classroom may explain the survival of the occasional boy's sampler, whether made in Sweden, Canada, America, England, or elsewhere. Both a boy's efforts and the small, simple example produced by Harriot Sacket at Sheffield, Massachusetts (fig. 35), would probably be examples of the dame-school type of sampler or a first attempt at home. The majority of the examples in the Kapnek Collection are, however, much more sophisticated.

Besides the dame school, another type of school gave instruction only in needlework, without the usual reading, writing, and arithmetic. The teachers in such schools often had other careers, and their teaching was secondary or part time, as it was obviously done to augment a meager income. In Boston, *The Massachusetts Gazette and Weekly News-Letter* of April 28, 1774, carried the following advertisement:

To the LADIES,
M. Asby Millener, from London,
in Quaker-Lane, BOSTON;

Intends on the first Monday of May next to open a SCHOOL for the Instruction of young Ladies, the Art of Millenary, and all other kinds of Needle Work in the most compleat Manner.

All kinds of Millenery made up on the shortest Notice & in the newest Fashion. Blond, Brussels, and all other Kinds of Laces, washed and mended in the compleatest Manner, by their humble Servant.

MARY ASBY.

Although Mary Asby offered her services as a milliner in 1773, it wasn't until the following year that she considered teaching as a part of her repertoire. [17]

Nearby in Salem, Massachusetts, in 1798, Mrs. Solomon, an actress, advertised that she would teach "the art of Tambour Work, from 2 to 5 o'clock every afternoon." [18] Notices of her performances in various local theatrical roles had appeared repeatedly in *The Salem Gazette* as far back as August 1, 1792, six years before mentioning a single word about needlework instruction.

In Norfolk, Virginia, a mother and daughter combined the skills of medicine, seamstress work, and teaching to serve their clientele and to ensure themselves an adequate living.

Norfolk, Dec. 10, 1773

MRS. HUGHES MIDWIFE (late from the West Indies, where she had practiced for a Number of

Years, with Great Success) begs Leave to inform the Ladies of this Place that she had rented a House in Church Street, adjoining the Church Wall, where she will be ready to receive the Commandments of those who may please to employ her.—She likewise cures Ringworms, Scald Heads, Sore Eyes, the Piles, Worms, in Children, and several other disorders, No Cure, no pay. And she makes Ladies Sacks and Gowns, Brunswick Dresses, Cloaks, Cardinals, Bonnets, Calashes, &c, &c. in the best Manner and newest fashion.

N.B. Mrs. HUGHES Daughter proposes teaching young Ladies TAMBOUR WORK, and will board young Ladies from the Country, who incline, to become her Scholars, at a Reasonable Rate.—Gentleman's Tambour jackets and Sword knots, and Ladies who want their Gowns sprigged either in Silver or Gold, may have them done by applying to her, with thanks for their Custom.[19]

Although Mrs. Hughes in her advertisement claimed that she and her daughter were lately from the West Indies, she had, in truth, come directly from Newport, Rhode Island, where she had placed three advertisements for these same skills.[20] Apparently unable to establish themselves in Newport, they moved south to try again.

The "select" school—boarding and day school, seminary or academy—produced most of the advanced sampler work illustrated in this book and the accompanying exhibition. These schools existed all over the eastern seaboard, and inland, the most prominent cities, of course, being the locus of the largest numbers of schools from the first quarter of the eighteenth century on. Many advertisements can be found in the early newspapers of Charleston, Annapolis, Baltimore, Philadelphia, New York, New Haven, Boston, Salem, Newport, and Portsmouth. Boston probably had the earliest-known needlework schools, for the notices of Mistress Mary Turfrey are recorded in the Boston newspapers as early as 1706. However, it is only in the diary of William Bentley that we learn of the crewel-embroidered apron made by Philip English's youngest daughter, Susannah, at this school, for Mrs. Turfrey did not include needlework information in her advertisements in *The Boston News-Letters* of September 2–9, 16–23, 30–October 7, 1706. We know little of this teacher except that she was the wife of Captain George Turfrey, commander of Fort Mary, and lived near the corner of Newbury (now Washington) and Essex streets.[21]

The existence of a very small number of American seventeenth-century samplers, early letters of families, diary references, and scattered town educational information assures us that there were a number of teachers in this early period before 1700, but no specific teacher can be attached to a particular piece of work.

The names of the schools, whether seminary, academy or boarding and day school, varied even in the advertisements that the teachers placed in the newspapers. Mary (or Polly) Balch of Providence, Rhode Island, referred to her school both as a "Boarding and Day School" and the "George-Street Academy."[22] But letters to her pupils might be addressed more casually. James Howard,

a young Connecticut man at Yale, wrote to his sister in the summer of 1805, "Miss Lucy Howard/ At the boarding house of Miss Balch/ Providence/ Rhode Island." [23]

City directories with their school titles and "teacheress" or "preceptress" designations were of necessity very brief and the usual newspaper advertisements often equally generalized; so the reader fails to learn what really was taught by teacher or school: whether or not, for instance, samplers were generally classified as part of "marking." Because many advertisements failed to distinguish them at all, it would seem that the sampler was simply included under the class of "plain" or "plain sewing," whereas the more elaborate and elegant accomplishments (such as needlework pictures) fell into the category of the "ornamental."

While eastern and southern schools were flourishing, there appeared in Harrisburg, Pennsylvania, a series of advertisements in the summer of 1799 for a school specifying a fuller range of needlework:

MRS. BELL

HAVING discontinued her School for Young Ladies for the month of August, gives notice to all who may be disposed to commit their Children to her care, that she intends to commence it again on the first of September next.—Her terms are as follows: For plain tuition, (viz.) Reading, Writing, Arithmetic, and Plain Needle Work, (in which are included Samples and Gobeline Work). Twenty Five Shillings per quarter. Tambouring, Embroidery, and Drawing, for Day Scholars, Four Dollars per Quarter: and for those who board with her, who may learn all the above branches, Thirty-Five Pounds per Annum.[24] (fig. 11)

Literally hundreds of preceptresses such as Miss Balch and Mrs. Bell taught during a period of two hundred years, yet it is the period from 1785 to 1830, however, that contains the majority of these schools. Within this same period two important religious groups, the Moravians and the Quakers, gave their special flavor and progressive character to the teaching of their young women pupils. Indeed, their excellent educational system was to mold several generations.

The former, the Church of the United Brethren, called Moravians, established a boarding school at Germantown on May 4, 1742. It was founded by the Countess Benigna, daughter of Nicholas Lewis, Count of Zinzendorf, with the aid of two women and three men. Benigna's father was revered for having received a group of Moravian exiles on his estate at Berthelsdorf in Upper Lusatia in 1722. These were followers of the martyr John Huss, and a small group of them emigrated with him to Pennsylvania in 1741.

The school established itself in Ashmead House in Germantown with twenty-five pupils. From there it moved to Bethlehem, then on to Nazareth, and returned once more to Bethlehem on January 5, 1749. Here the educational system of the Moravians grew, matured, and eventually extended far beyond the confines of the church.

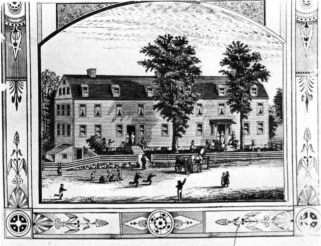

NINE PARTNERS BOARDING SCHOOL. (From a Sketch by Alex. H. Coffin, 1820.)

2. Engraving of the Nine Partners' Boarding School, Dutchess County, New York. The engraving is based on a sketch of 1820 by Alex H. Coffin, a pupil. Courtesy Haviland Records Room, New York Monthly Meeting, New York.

Although the school was originally intended only for girls of the Moravian faith, it was opened in 1785 to include other denominations and became known as the Moravian Female Seminary.[25]

From the school records and from remaining needlework we know that a wealth of plain spinning, weaving, sewing, chenille, and later crepe and ribbon work, and silk embroidery was worked by girls generally eight to twelve years of age. The word *tambour* is also mentioned with great frequency. Knitting and sampler making were recorded at examination time in the school journal of April 9, 1791:

> In the morning we were making preparations for the love-feast. In the afternoon, at two o'clock, we assembled in the hall to conclude our examination by a love-feast, during which were shown to the company specimens of our writing, drawing, painting, embroidery, and tambour, and of the younger misses' knitting and samplers.[26]

One of the most significant aspects of the church and its teaching is the total impact of the Moravian Seminary on the world at large. It is especially interesting to note that more than 5,500 young ladies were educated at Bethlehem between 1786 and 1870.[27] The school began to attract pupils from Europe and the Caribbean Islands thanks in part to kindly Brother Hübener's administration:

> Seventy pupils entered the Seminary during his administration. Of these, the cities of New York and Baltimore contributed the majority. Seven of the then thirteen States of the Union had youthful representatives in the school at Bethlehem, viz: New York, Maryland, Pennsylvania, New Jersey, Rhode Island, Connecticut and South Carolina. Their acquaintances with the Bretheren's missionaries among the slaves induced the wealthy planters of the West Indies Islands to send their daughters from home to be educated in Moravian seminaries; and during Brother Hübeners term of inspection several young ladies were received into the school from the three is-

3. Excerpt of a letter from Benjamin Tallmadge to the Hon. John R. Cushman of Troy, New York, relating expenses of the Sarah Pierce School, March 30, 1823. Courtesy Litchfield Historical Society, Connecticut.

lands St. Jan, St. Croix, and St. Thomas. The first of these was Peggy Vriehuis, of St. Jan, who came in July, 1787.[28]

Both Bethlehem and Lititz (also in Pennsylvania) were known for their schools, each providing an education for the girls identical to that of the boys, but still stressing the need for comprehensive needlework skills for each young miss entering.

In addition to the influence on teaching made by the Moravian seminaries, the Quakers also gave a positive, progressive note to their education of young women. Examples of this Quaker method are those from the Westtown School, at Westtown, Chester County, Pennsylvania, and a piece from the boarding school at Nine Partners', Dutchess County, New York.

In the particular case of Westtown, much of the curriculum, the goals, and the moral attitudes stressed were based on the preliminary efforts made so successfully in the London Yearly Meeting. The result was the establishment of a national boarding school at Ackworth in 1779. The type of education sought may be seen in the records of the *London Yearly Meeting Epistle* of 1712 quoted by Watson W. Dewees in *A Brief History of Westtown Boarding School*:

> Should any one query what kind of an education early Friends desired for their children, abundant material for an answer could be found in the recorded minutes of that period. While they, in common with all other classes, were satisfied with a course of study very much shorter than that now considered essential, it cannot be denied that the prevailing standard was a liberal one. When we view the subject in connection with the state of schools among other classes, their plan of education seems surprisingly broad and practical. An emphatically religious education was desired—an education, which, while it made the mind the receptacle of such human wisdom as would conduce to the greatest usefulness upon earth, encouraged that obedience to the manifestations of Divine Grace which would restrain and bring under right control the natural

11

propensities of the child. That which puffeth up was to find no place, while that which teaches the accountability that must attach to all human action, and the due subordination of all desires and feelings to the one great end of man's existence on earth, was to be the corner-stone of the system. The spirit which animated many, is shown in the advice to parents to "be good examples in all things, as become men and women professing godliness, that good footsteps may be left by us to future generations, which may be helpful to the preservation of those who succeed us in the right way of the Lord." [29]

Bearing these moral precepts in mind, the dedicated women of the Westtown Committee of the Philadelphia Yearly Meeting of the Society of Friends tended to the practical and made consistent efforts to simulate Ackworth when they opened their school on May 6, 1799. To make the new school function smoothly, the following rules were devised:

> That spelling, reading, writing, arithmetic, and book-keeping, shall be taught in the different schools, and such other useful branches of learning as the circumstances of the pupils may require, and the state of the Institution shall permit.
>
> That the board and lodging of the children shall be plain and frugal, without distinction, except in cases of sickness.
>
> That boys and girls be accommodated in separate apartments under care of separate tutors.
>
> That no tutors, assistant, or domestics, be retained in the institution, whose deportment is not sober and exemplary.
>
> That no children shall be taken in under the age of eight years, or entered for less than one year.
>
> That if children are sent with clothing not sufficiently plain as to color, or which shall require washing, it shall be returned; but if the make only be exceptionable, it shall be altered and the expense charged. [30]

Sewing was the only subject offered that really differentiated the curriculum of the girls from that of the boys. Two weeks out of six were spent in the sewing school, and the girls would attend reading and writing classes also. Plain sewing was the first hurdle for the young student. Next came darning, which was taught in part by means of a required darning sampler. This cloth usually contained six units of pattern darning with a central square that simulated knitting by means of chain stitches or a combination of chain and back stitches. It had to be done to perfection. With this task completed, the student could then tackle the embroidering of spectacles cases, silk globes representing the earth, and samplers containing bordering alphabets and moral sentiments often expressed in verse. Some of the more proficient girls could go on to create views of the school in stitchery to be framed and exhibited. However, the more elaborate types of needlework were frowned on and, in general, discouraged by the Committee. [31]

Helen Hole, in *Westtown Through the Years, 1799–1942*, states that the earliest dated sampler worked by a Westtown student in the school's possession is that of Hannah Price, made in the ninth month, thirteenth day, 1800. She also states that the oldest marked darning sampler is that of Mary Evans with the date of 1802. [32]

A series of women teachers directed the sewing room activities—from Elizabeth Bellerby in 1799 [33] to Rebecca Conard in 1843. [34] At the latter date the school decided to abolish the sewing room as no longer being pertinent, [35] thus ending a forty-four-year period of sampler making. At this time the classics were added. Today Westtown is one of the few schools founded in the eighteenth century that is still in operation. A trip to Chester County to see Westtown will acquaint one firsthand with one of the most fascinating schools in America (figs. 1, 41, 61, 68).

Another Quaker school is represented in the Kapnek Collection—the Nine Partners' Boarding School in Dutchess County, near Poughkeepsie, New York (December 20, 1796–1857). The school started with a student body of seventy boys and thirty girls, who ages ranged from seven to fourteen. A print based on the sketch of young Alex H. Coffin depicts the school and its students while he was a pupil there (fig. 2). Rebecca Field's sampler (fig. 44) is an example of one of the styles of sampler making taught here.

A pair of New York City schools contribute to our understanding of the many different types teaching needlework to young girls. Instead of being solely religious in its affiliation, or private boarding and day schools for children of the distinguished or affluent, these schools served the needy and the black.

In the late eighteenth century the New York Manumission Society was formed, and under its auspices the first New York African Free-School was begun shortly after in 1787. The purposes of the society were threefold: to prevent slavery, to stop kidnapping within New York of those who were already free, and to educate the children of these blacks. [36] Charles C. Andrews, a former teacher of the young boys, wrote a history of the African Free-School and noted that among the sewing preceptresses after 1791 both Miss Lucy Turpen and Miss Mary Lincrum had been pupils of the Female Association School. [37]

A report of promotions at examination time in the African Free-School listed 404 enrolled in the Sewing School. They were taught by Eliza J. Cox in School No. 1 from May 1823 to April 20, 1824. [38] A list of the work done in the sewing department during that year gives specific knowledge of the types of sewing and embroidery young girls were expected to master.

> Shirts made, 93; pillow cases, 61; sheets 7; cravats, 49; towels, 23; hdkfs. 15; risbands and collars, 25 pair; dresses for scholars, 13; fine samplers, 9; bench covers, 1 pair; pocket books 2.
>
> Knitting done.
>
> 27 pair children's socks, 26 pair suspenders, 7 pair stockings, 6 pin cushions.
>
> Present state of the Sewing School.
>
> Number of girls belonging to this department, 154, of which number there are, acquainted with

making of garments and marking, 56; capable of knitting stockings, socks, suspenders, &c. 42. The remainder are progressing in the lower branches.[39]

In 1802 a school was established by an Association of Ladies, members of the Society of Friends, who were organized for charitable purposes.[40] The Female Association, as it was called, used the Lancastrian plan or monitorial systems of instruction in the classroom, and the work here served as the model for what was taught the young misses in the African Free-Schools. The Association incorporated March 26, 1813, to be eligible for the benefits of the common school fund. The Free School Society granted use of apartments for a school for girls in Free School No. 1 in Tryon Row.[41] On February 18, 1812, Mary I. Morgan became the teacher of twenty pupils at School No. 2 in Henry Street.[42] A third school for girls was opened January 1, 1815. During its initial three-month existence, 271 pieces of needlework were finished by the girls. The inventory lists the following:

> 18 shirts, 11 shifts, 21 sheets, 16 samplers, 23 cravats, 4 night-caps, 4 thread cases, 2 pair stockings, 47 diaper towels, 15 pocket kerchiefs, 8 pillow-cases, 7 table-cloths, 33 coarse towels, 9 check aprons, 25 infant shirts, 2 pair neck-gussets, 5 muslin aprons, 5 pair wristbands, 4 muslin borders, 3 window-curtains, 1 pair muslin sleeves, 2 calico ruffles, 6 housecloths. The following quarter presented an equally flattering report of the industry of the pupils. Susan Morgan, teacher [43]

The Association Schools continued growing in number and importance until they finally closed the rooms they had occupied in 1845 in School No. 5. All these early programs became absorbed into the general system of the New York Public School Society.[44] A small but exquisite reminder of its history is the sampler worked by Martha Dunlavey in 1820 at the Female Association School No. 2 (fig. 77).

TEACHERS OF NEEDLEWORK

Maiden ladies, young and old, were an indispensable part of the teaching of needlework in private schools. The "spinster" had often barely completed her own schooling. Many of these young women would serve an apprenticeship with another more experienced woman preceptress and then after several terms would leave to form small schools of their own in an adjoining town or far away.

If they married, the school would have to close unless a relative or an assistant could replace them. Sometimes a teacher or preceptress from a different state would be encouraged to begin in, perhaps, Philadelphia or New Jersey, having established themselves first in New York. Many an advertisement alludes to this moving about from place to place.

Professional embroiderers, such as Bernard Andrews of New York and Boston, pursued needlework careers but augmented them by teaching. Andrews's New York advertisement illustrates the extent of his skills:

4. Needlework pattern inscribed and dated, "Susanha . Heebneren 1828," Montgomery County, Pennsylvania. Ink and watercolor on paper, with stags facing each other, hearts, tulips, geometric motifs, double-headed eagle, and three border designs, 8″ h. x 12″ w. Schwenkfelder Library and Museum, Pennsburg, Pennsylvania.

> Bernard Andrews, Embroiderer, in Broad-Street at Michael Houseworth's, nearly opposite his Excellency General Gage's; Makes and mends all Sorts of Embroidery Work, in Gold, Silver, and Silk, for Ladies and Gentlemen, in the newest and neatest Fashion; likewise Pulpit Cloaths and Tossels. He likewise buys, cleans, and mends, old Gold and Silver Lace. Said Andrews Makes and sells all kinds of Paper Work in the neatest Manner, as Hat, Patch, and Bonnet Boxes, at the most reasonable Rates.
> If any Ladies should have an inclination to learn Embroidery, or any of the above-mentioned Work, he will attend them either at his Lodgings or at their own Houses, as it shall best suit.[45]

Two years later, Bernard Andrews offered these services at his lodgings at Mrs. Geyer's, the Flower-Maker in Pleasant Street, Boston.[46]

DURATION OF THE SCHOOLS

Most of the schools had a limited life-span. Many were terminated within a term or two, generally within three years. Some, however, under the direction of a church or community association had considerable longevity. Thus the Quakers and the Moravians had many fine schools that served multiple generations of young students. Individuals such as Sarah Pierce, Ruth Patten, Susanna Rowson, Susanna Babbidge, Catherine Fiske, Sarah Osborn, Polly Balch, Mrs. Saunders, and Miss Beach set records for longevity.

Whether brief or lengthy in existence, most schools exhibited great mobility. Thus countless addresses are listed in city directories or newspaper advertisements. Mobility was generally a sign of a successful enterprise, and the moves indicated the need to house increased numbers of students in larger, more healthful and gracious quarters. Many a school would start as an individual enterprise with six or fewer pupils and then increase rapidly enough to require larger rented quarters. In some cases the purchase of a house for the

INSTRUCTIONS FOR MARKING ON LINEN.

As many things have been spoken of for the information of the younger sort of the male kind, so it may not be amiss to say some small matter in relation to the instruction and benefit of the female kind.

Marking is indispensibly necessary and useful for the training up of the younger sort of the female kind to the needle, it being introductory to all the various and sundry sorts of needle-work pertaining to that sex: Therefore I have set down the alphabet in capitals, or great letters and small, likewise the figures, that girls or young women, by frequent practice, may soon attain to perfection in marking on linen. The marking copies are as follows :—

B b 2

5. "Instructions for marking on linen," from George Fisher, *The Instructor, or American Young Man's Best Companion, Improved;* printed by John Bioren, Philadelphia, 1812, page 293. Courtesy Litchfield Historical Society, Connecticut.

growing student body was proof of the success of the school.

Increased numbers of pupils necessitated more teachers. Often a dancing master, music instructor, or perhaps a French teacher was hired if the preceptress herself were not capable of teaching all these accomplishments as well as administering the entire school. Sometimes a dancing master or music teacher was available one day or one afternoon a week and was shared by more than one boarding school in town. For this reason Mr. Shaw provided music at Miss Balch's school in Providence on Wednesday and Saturday afternoons and at other hours for Mrs. Remington's school. Mr. Guignon (or Guigon) was the dancing master for the pupils of Miss Balch (fig. 12).[47]

In this fashion, or in variations on this theme, many a simple day school became a boarding-and-day school, courting pupils from greater distances. The Litchfield [Connecticut] Female Academy conducted by Miss Sarah Pierce advertised in the *Albany* [New York] *Argus*, May 19, 1827. The English and French Seminary of Mrs. Francis and Miss Caines of Middletown, Connecticut, placed column-long advertisements in the *Providence* [Rhode Island] *Patriot and Columbian Phenix* in the issues of April 12 and 19, 1826. Boston's *Columbian Centinel* carried advertisements of seminaries and academies throughout Massachusetts and many other states.[48]

Letters from parents exchanged information about the curriculum and the costs of schooling for their daughters. An excerpt from the letter (fig. 3) of March 30, 1823, from Benjamin Tallmadge of Litchfield to John R. Cushman of Troy, New York, relays this information:

> . . . Miss Pierce has $5 the Quarter for her instruction, including, Geography, Grammar, ancient & modern history, Composition, Philosophy, Chemistry, Logic, reading, writing, spelling, and needlework— If music Lessons are taken, that will be $12 per quarter, and if lessons per week— painting will be $3 the quarter. So much on the subject of schooling.[49]

Physical Characteristics of Samplers

A sampler is composed of various elements: the background fabric, the types of embroidery threads used, the dyes or color of background and embroidery, and the design of the whole piece.

The background fabric is usually referred to as a ground. Linen was the primary fabric used in America from the seventeenth century to well into the nineteenth, and it was frequently imported from Russia, Holland, Scotland, Austria, Silesia, Poland, Bohemia, among other countries.

Most of the linen used, however, would be of home manufacture, for the early Colonists, such as the residents of Connecticut and Massachusetts in the 1640s, were required to raise flax or hemp. Many records of weaving and spinning can be found in early Colonial records. Some examples of these efforts were noted in the Boston and Newport newspapers where spinning schools received early encouragement. *The Newport Mercury* of May 9–16 and 16–23, 1768, records such a school:

> A Spinning School
>
> WILL be opened immediately, by Sarah Geers at Mr. John Fryer's House on the Point, between the Alms-House and Liberty-Mast; Any persons who will be pleased to favour her with the Instruction of their Daughters, may depend upon having them taught in the best Manner.

Still another school for spinners produced a more extensive notice in *The Newport Mercury* of April 18–25, 1768:

> A Spinning-School,
>
> Will be opened on Monday next, at Mary Wing's at the upper End of the Point, where young Misses may be taught to spin, in the best Manner, either Flax, Wool, or Cotton, by a Person thoroughly acquainted with the Business; the Price for each Spinner will be nine Shillings Lawful Money a Quarter: the Spinners finding themselves Flax, &c.— It is hoped this School will meet with suitable Encouragement, as such a one seems to be much wanted: All persons inclining to promote the same, may be further informed at said Mary Wing's by the Person proposing to keep the School, who will be much obliged to those who may please to favour her with the Instruction of their Daughters.
>
> Newport, April 18, 1768

Not only did two Newport schools give notice of spinning instruction, but they also provided specific instructions to the readers to help prepare the linen they raised for spinning.

> To make Flax as soft as SILK.
>
> Take what quantity of flax you please, but let it be of the best and cleanest prepared ready for spinning, then take fresh calf's dung, as much as will enclose the quantity of flax you need to soften, let it be thus covered, for five or six hours, to be soaked, then wash it clean, and it will be as soft as silk and be fit to be spun to the finest thread.[50]

In the very same issue of *The Newport Mercury*

(January 18–25, 1768) an article describes the home manufacture of a single family:

> . . . Dr. Moses Bloomfield, of Woodbridge in New Jersey, has within the year past manufactured in his own family, 580 yards of linen and woollen cloth, and every yard at an average worth 4s. a yard. The whole of the wool and flax of his own raising. Several others in the neighborhood are imitating the example; and this plainly shews what we in these colonies could do, would generally in earnest set about it.

Although the linen noted above may have been of a fine and close weave, much that was used in samplers was open and coarse in nature. Much unbleached linen was used and has become even darker with exposure to a wooden frame backing, acidic matt board, or brown paper. Some samplers were worked on fine bleached-linen grounds.

The linen was also occasionally colored dark teal blue, yellow, gray, or black. An example of the last color is found in a sampler by Narcissa Lyman of York, Maine, made in 1827 (Old Gaol Museum, York, Maine).

Some sampler grounds were made of fine wool. These were probably imported fabrics purchased in the larger cities or brought home from a trip abroad. The wool called "tammy" or tannery cloth was in use in the eighteenth and nineteenth centuries in the British Isles. It came into use in the 1720s in England, but a Welsh example is recorded in 1709.[51] In the Kapnek Collection samplers with wool grounds are those made by Maria Bolen, a Philadelphia child, who used this ground in her sampler of 1816 (fig. 70), and the 1796 sampler of Elizabeth Whitman (fig. 39).

Tiffany, "a light-weight, sheer muslin: a kind of gauze,"[52] is one of the names for a fabric favored by some of the young embroiderers in American schools in the early nineteenth century, and possibly before. The sampler of Catherine Shindle (fig. 48) made in Mary Walker's School, Lancaster, Pennsylvania, 1803, employed this ground.

The 1812 Philadelphia edition of George Fisher's *The Instructor, or American Young Man's Best Companion, Improved* (page 293) explains a method that used tiffany for Drawing from Nature:

> A Method of Drawing after Nature by means of a Transparent Plane.
>
> Frame a piece of tiffany or fine lawn of the size you intend your picture: fix it so that the whole object may be seen through it. A sight-board, that is a flat piece of wood with a hole in it must be placed parallel to the tiffany or lawn. The outlines of the object, as they appear through the hole, must be traced on the tiffany by a crayon of white or red chalk, charcoal or any other proper substance. To take these outlines off on paper or vellum, lay the tiffany in an horizontal position on the paper or vellum, so as to touch in every part.
>
> When well fixed, it must be struck with some flat substance in every part. The figure by this means will be transferred, and where imperfect may be

6. Upper-case alphabet for marking on linen, from George Fisher, *The Instructor, or American Young Man's Best Companion, Improved;* printed by John Bioren, Philadelphia, 1812, page 294. (The personal copy of Lambert Hitchcock.) Courtesy Litchfield Historical Society, Connecticut.

corrected by a black lead pencil from the natural view through the sight board. Paper may be used for the same purpose as the tiffany, being made transparent by the oil of turpentine or glass, by drawing the outlines with a black colour, mixed with a drying oil. Then lay the paper gently without rubbing on the glass; moisten the paper a little with water before you lay it on.

Linsey-woolsey is a ground sometimes used in samplers made here between 1798 and 1832. In examples that have been examined the linsey-woolsey combines a vertical blue-green linen (warp) with a yellow-green horizontal wool filler (weft). A number of such linsey-woolsey grounds were microanalyzed by Malcolm Delacorte, Conservator of Textiles, Department of Anthropology, at The American Museum of Natural History, New York. The linsey-woolsey grounds have been found in samplers from Washington, D.C.; Marblehead, Boston, Taunton, Charlestown,[53] Franklin, Danvers, and Salem, Massachusetts; from Portsmouth and Dover, New Hampshire; from Clinton, Wallingford, Wethersfield, and the New Haven area of Connecticut; and the Kittery–

7. Lower-case alphabet, numerals, and crown for marking, from George Fisher's *The Instructor, or American Young Man's Best Companion, Improved;* printed by John Bioren, Philadelphia, 1812, page 295. (The personal copy of Lambert Hitchcock.) Courtesy Litchfield Historical Society, Connecticut.

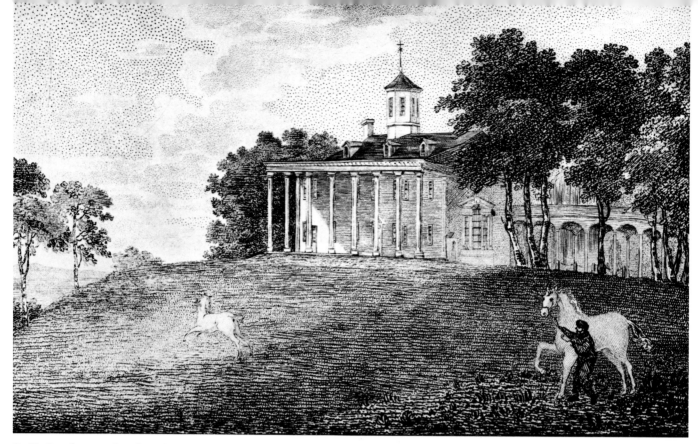

8. Undated original etching by William Russell Birch (1755–1834) of Mount Vernon, inscribed, "Mount Vernon, Virginia, the Seat of the late Gen.¹ G. Washington / Drawn, Engraved & Published by W. Birch Springland near Bristol, Pennsylvᵃ" from the series "County Seats of the United States" of 1808. 3¹⁵⁄₁₆″ h. x 5½″ w. Courtesy Prints Division, The New York Public Library, Astor, Lenox and Tilden Foundations, New York.

South Berwick area of Maine. In Pennsylvania the Westtown School and P. H. Maundell's Seminary in Philadelphia made use of this ground.[54] Six examples from the Kapnek Collection dating from 1800 to 1822 show how linsey-woolsey was used in various schools and locations (figs. 42, 43, 59, 62, 68, 84).

Linsey-woolsey is a ground also seen in some Canadian samplers from St. John's, New Brunswick, Niagara-on-the-Lake, and Ontario.[55] No examples have been noted in existing collections in England, although the fabric had prior use there.[56]

TYPES OF EMBROIDERY THREAD USED

Another important element of the American sampler is the kind of embroidery thread used. It was embroidered in either floss or twist, and both types of thread could be used either simultaneously or singly on an individual piece. The thread was often used unraveled, which gave a special sheen to the embroidery as the ripples of silk caught the light, giving an added elegance to the needlework. The Sarah Stivour School of Salem, Massachusetts, is noteworthy for producing examples with long satin stitches applied diagonally across the linen surface, thus creating a strong, distinctive quality in the work of this New England school.

The Connecticut Historical Society in Hartford has a collection of richly colored silks that young Jerusha Pitkin used at school in Boston in the mid-eighteenth century while working on an unfinished coat of arms. Some of the silks are still in the original twisted skeins, while others have been color separated and attached to sewn sheets of plain paper or small folders of manuscript or printed pages.[57] Such silks are the same type that were also used on many early samplers.

Linen thread predominates in the white-work samplers of the seventeenth century. The threads were used to create geometric surface patterns, the smooth satin stitches, and in the lace areas the handsome reticella designs. Linen is seen with some frequency in the next centuries, but the use of silk predominates in sampler work.

Wool appears occasionally in eighteenth- and early nineteenth-century work. In the Valentine Museum of Richmond, Virginia, are two examples by local children who used wool embroidery in the border of each sampler: Mildred Malone of Richmond, whose sampler is dated September 8, A.D. 1817, and another piece worked by Flora Virginia Holmes.[58] The similarity of these pieces may indicate that the same teacher or school is the design source. An undated sampler by Mary H. Allison of Henderson, Kentucky, born December 9, 1826, used wool for the entire embroidery on linen. Wool embroidery became prevalent in the 1830s and thereafter when Berlin work began its great popularity.

Other materials were sometimes added to the embroidery on American samplers. Engravings, cut out as if for use in découpage, watercolors on silk and paper, human hair, silver or gold thread, mica, pricked paper, brass strips, padding of silk appliquéd faces and of the

embroidery itself, beads, both metallic and colored, purl, etc.—all these enhanced the surface of many a sampler, particularly from the mid-eighteenth century through the first quarter of the nineteenth.

Sometimes, particularly in the samplers from Pennsylvania, beautiful silk-ribbon borders were added. These were handled in a variety of ways. Many of them were sewn flat on the ground, with mitering of the four corners. Many were flat borders with corner rosettes. Still others were quilled or gathered into a serpentine line that was in turn attached to a flat ribbon below of contrasting hue (figs. 29, 64, 78, 99, 104, 121).

DYES USED ON THE EMBROIDERY THREADS

Most very early American samplers have a rather limited range of natural colors. These, if once deep and rich, have softened and mellowed with age. Some, if the sampler were stored away and never exposed to the ravages of sun and household abuse, retain a freshness and vigor that belie their years. These early samplers used dyes from natural sources. The transition in the nineteenth century to synthetic dyes was spearheaded by the accidental discovery by William Henry Perkin of a lavender dye produced artificially from a coal-tar derivative.[59]

Before this discovery the woman at home or the professional dyer had to rely solely on imported dyestuffs and such local sources as plant leaves, roots, bark, and berries to give the lovely colors we see produced by hand dyeing, or when we see old embroideries.

Advertisements in American newspapers of imported dyestuffs show how dependent the dyer was on madder and cochineal as sources of reds, logwood for black, indigo for blue, and fustic and quercitron for yellows.[60] Cochineal and indigo were the most costly of these dyes as seen in a comparative cost listing for each in a dye manual of 1831.[61]

Madder, with its principle, carminic acid, gave wonderful pinks, crimson, and scarlet on wool and silk when properly mordanted with alum or tin.[62] Cochineal was a dyestuff that required 70,000 dried female insects to yield a pound, just one of the many factors adding to its cost.[63]

Indigo was chiefly imported from India, France, and the East and West Indies, although there were early attempts to raise it in South Carolina, Georgia, and Louisiana. These efforts stopped when cotton replaced indigo as a more profitable commodity.[64]

Fustic was imported from Cuba, Tampico, and Jamaica, as well as from Brazil. It was known as "dyer's mulberry,"[65] as its source was a tree of the mulberry family.

The home dyer had to be resourceful with the plant materials at hand. Martha Genung Stearns in her article "Family Dyeing in Colonial New England" quoted an elderly lady's remarks about the sources she chose:

> Butternut bark made a beautiful brown; a certain moss made a tan brown. Alder bark made a seal brown. Birch bark a gun metal gray. Yellow-root, barberry bark and sassafras made yellow. It always took two things to make green; indigo and golden rod colored green, also laurel leaves and hickory bark. Black was one of the hardest colors to set; mercury or poison ivy made a pretty good black. Purple flag and elder berries gave lavender, but a fast lavender and purple was hard to get. To set the color in cloth, copperas, alum, salt and

9. Line engraving by Samuel Seymour (1796–1823), inscribed, "Mount Vernon, The Seat of the Late Gen.¹ G. Washington, Drawn by W. Birch, Engraved by S. Seymour, Philadelphia, Published March 15, 1812." 11⁷⁄₁₆″ h. x 16¹⁄₁₆″ w. Courtesy Prints Department, The New-York Historical Society, New York.

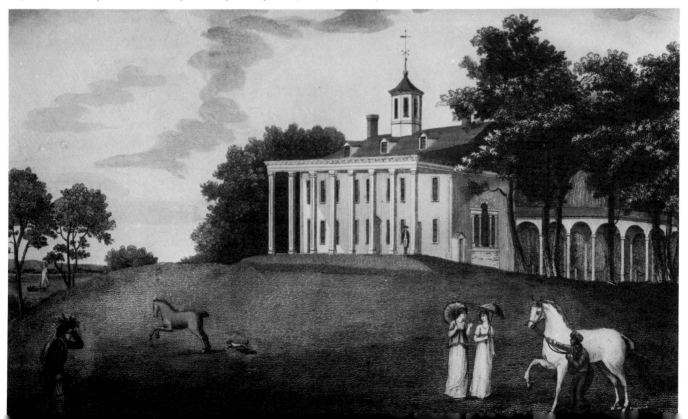

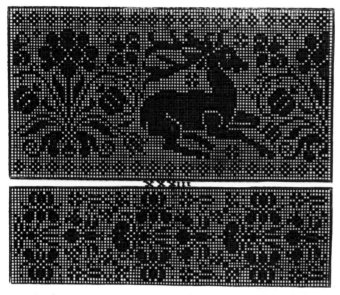

10. Reclining stag, an engraving from *Das Neüe Modelbuch, von Schönen Nädereÿen Ladengewürck, und Paterleinsarbeit,* by Rosina Helena Fürst, Nürnberg, 1666. Beinecke Rare Book and Manuscript Library, Yale University, New Haven, Connecticut; Gift of Susan Dwight Bliss.

sometimes rusty nails were used. Every family had a dye-pot, most commonly used for indigo. After the spinning of the yarn or thread was finished, the housewife was busy getting the dye prepared. All the family knew that chamber-lye should be saved for this. The indigo and yarn were put into the earthen pot full of chamber-lye and allowed to stand for a long time, after which it did not need to be set. The odor was very offensive, and sometimes sweet-fern, flagroot or hardwood ashes were used to offset the odor.[66]

Experiments with the dyeing of wool yarns have been carried on at Harlow Old Fort House, Plymouth, Massachusetts, and are recorded by Rose T. Briggs, and a list of twenty dye sources are given as representatives of the dye plants used by the early Colonists. The list included beach plum, black oak, black walnut, bracken, goldenrod, hemlock, onion, red maple, sumac, willow, bayberry, Saint-John's-wort, and apple.[67]

The first two American editions of George Fisher's *The American Instructor or, Young Man's Best Companion,* printed in 1748 and 1753 by Benjamin Franklin and David Hall, chose to delete certain material from the English version. However, the segment entitled "of colours, and Dying" was retained and gave instructions to the dyer on pages 251 to 253 for working with woad, madder, logwood, powder of Brazil, vermilion, and gambogia.[68] His instructions in this book appear to be among the earliest on dyeing printed in America.

P. G. Comstock, editor of *The Silk Culturist* and secretary of the Hartford, Connecticut, County Silk Society, published in 1839 *A Practical Treatise on the Culture of Silk, Adapted to the Soil and Climate of the United States.* It informed the reader about dyeing silk thread Black, "Best Blue," and "Dark Blue," but referred his audience to a manual prepared by Congress for full instructions on making "fancy colors."[69]

STITCHES

A great variety of stitches are employed on early samplers. Before 1700 and shortly after, cross, satin, eyelet, long-armed cross, back, outline, Montenegrin, arrowhead, running, double running, and detached buttonhole stitches were used. Reticella lace techniques and drawnwork with areas of needle weaving and spider stitch may be seen on some early American work.

During the eighteenth century and into the nineteenth, cross, herringbone, satin, surface satin, chain, Oriental, French knot, bullion, stem, rococo (queen), Florentine (Irish), buttonhole, inverted buttonhole, split, back, flat, slanting and upright Gobelin, seed, long and short, running, punch work, and straight stitches were used with frequency. Tent, couching, feather, and fly were also used. In Connecticut examples of the 1830s from the Bantam, New Haven, and Guilford areas, the lettering and design often employed the ray stitch. The alphabets have a wispy, feathery appearance created by the use of this stitch.

Many American samplers employed cross-stitch with almost irritating frequency. In many a beginner's sampler this stitch is the only one used.

Pattern darning may also be seen on some of the samplers worked at the Westtown School in Chester County, Pennsylvania. Martha Woodnutt worked just such a piece (fig. 68). This is the technique also employed in multiple patterns on a number of American bed ruggs and some crewel embroidery.

Diagonal pattern darning is one of the methods used for covering the background surface of samplers from the Balch School in the period between 1785 and 1797, as seen on existing pieces. Certain areas of design used counted-thread techniques, such as the rococo (queen) stitch in border flowers, or rows of strawberries. The outermost border frequently was a rice stitch in a shade of green. Vases of flowers at the sides of the composition often used split stitches worked through a ground of coarse brown linen, a layer of rag newspaper, and a third, bottom layer of finely woven linen.[70]

There are enough positively identified examples remaining from the various schools and teachers that a comparison between these and others gives an excellent means of further identification, and in many cases a teacher or school can be traced with some ease.

Designs and Their Sources

American samplers, judging by the few examples surviving from the seventeenth century, began by adhering quite closely to English and Continental forerunners. Although also of a vertical format, American samplers of this period, which varied in length from sixteen to twenty-nine inches, never quite reach the extremes in length of those done abroad.

The designs on these earliest samplers were worked from left to right in horizontal bands. They often included some of the same motifs used abroad: the Tudor rose, the acorn, the honeysuckle, the S form, carnation and strawberry, trefoil, and fleur-de-lis. The bands of

these motifs varied in height: some quite broad with the floral units enclosed in arcades, while most were narrow. The designs appear quite rigid and stiff.

In the eighteenth century this dependency on a band of set motifs began to disappear and a pictorial type of sampler began to emerge. Initially, the design grew from the base upward and was partially enclosed by three quite wide borders. These borders, once nonexistent, then narrow, finally assumed such importance visually that they threatened to swamp the central portion. The design organized itself about a verse, the child's inscription that usually cited her age and the date the sampler was completed, and one or more alphabets in upper- and lower-case block lettering or script. Some of the earliest samplers featured the use of satin, eyelet, and cross-stitch alphabets, and the letters themselves were quite angular. Early samplers used alternate colors for the letters, using one, two, or more letters of one hue, then changing to another hue and still another, then repeating the arrangement. Sometimes the letters were followed by numerals, often one through nine followed by a zero. Occasionally, the numbers went very high, as in the work of Elizabeth Hext of Charleston, South Carolina, who counted up to 52, but this feat of a nine-year-old is a rarity in American sampler making (fig. 16).

The motifs in the borders might be carnations, tulips, grapes, honeysuckle, Tudor rose, or the popular strawberry, or a combination of two or more elements. These flowering vine borders gradually became softer in appearance: the flowers began to bend, droop, open, or close in a naturalistic way. The bowknot was a popular device in both centuries, stitched often in blue silks with pansies, roses, carnations, lilies, tulips, poppies, pineapples, and strawberries combined in opulent silken bouquets, winding and twisting throughout the borders. These graceful, serpentine vines framed townscapes, rural scenes, or the ever-popular basket or urn of flowers. Sometimes the basket of flowers would be placed in the middle of a landscape of capering animals and birds. Scale was unimportant to most of the embroiderers, and both scale and perspective remained unmastered so that many a house, animal, or human figure took on a quality of whimsy from the unexpected change of scale. The sampler makers were also absorbed by the rendering of architectural details, and their naïve way of creating shutters, cupolas, rooftops, pergolas, fences, fan-lights, and bell towers never ceases to amaze and charm. Seated figures, furniture, flying birds, feeding rabbits, galloping horses, cats walking fence railings, etc.—all are disposed in a noteworthy way, if the embroideress fancied the subject matter.

In the second half of the eighteenth century samplers and other forms of needlework began to feature public buildings. A canvas embroidery might combine Harvard Hall and Stoughton College,[71] while a sampler would show the First Baptist Church, or the Congregational Church, the University Hall, and Providence Court House, as is seen in the work of Polly Balch's pupils in

11. Advertisement of Mrs. Bell for her school, Harrisburg, Pennsylvania, in *The Oracle of Dauphin and Harrisburgh Advertiser*, August 7, 14, 21, 28, 1799. Courtesy The New-York Historical Society, New York.

12. Advertisement of Miss Mary (Polly) Balch for her school, Providence, Rhode Island, from *The Providence Gazette and Country Journal*, January 2, 1813. Courtesy Rhode Island Historical Society, Providence.

Providence, Rhode Island.[72] Saint Paul's Chapel, William and Mary College, the Yale buildings, or Mount Vernon were some of the nineteenth-century themes used.[73] Often the building became so important that there was no surrounding design.

SOURCES OF SAMPLER DESIGNS

Many sources were relied upon for the basic designs. Teachers, students, framers, engravings, reissues of old pattern books, books with engravings, and tradesmen's manuals were likely sources. Professional painters and embroiderers also imported patterns that could be purchased by the students. Some stores even rented patterns. George Dame established a Young Ladies' Academy in Portsmouth, New Hampshire, and the *New-Hampshire Gazette* of March 29, 1808, contained this advertisement:

DRAWING & PAINTING

furnish a pleasing ornament, and are necessary accomplishments for young ladies, not only in the display of taste and genius, on paper, silks, &c. &c. but in drawing and designating patterns for the use of the needle.

For sampler making and other more advanced work the teacher often provided the patterns. Often she would state that she could supply the latest in English designs or could provide her own originals much cheaper.

Such was the claim of Boston's Mrs. Condy in 1738 and in subsequent advertisements. Even after her death her daughter Elizabeth Russel was disposing of her mother's patterns and notified the public of their availability in the *Boston Gazette*, December 15, 1747.

In 1723 Mrs. Rodes had arrived in Philadelphia and noted in her advertisement in *The American Weekly Mercury:*

. . . She likewise draws all Manner of Patterns for Flourishing on Muslin and those in Fashion of Lace, . . . She likewise draws Patterns for Embroidering of Petticoats, &c.[74]

Mrs. Mary Mansfield, a teacher in New Haven, Connecticut, listed her designing prowess in the *Connecticut Journal* of April 18, 1793:

She teaches . . . plain sewing, knitting, embroidery, lace making, drawing, &c. And if any Ladies should think it too much trouble to draw their own patterns, if they will take the trouble to call on her, she will endeavour to suit them. She draws patterns of any kind, either for muslin, upon sattin, screens, pocket books, spreads, &c.

In addition to the patterns that were imported or made by teachers, young girls also made their own. The Schwenkfelder Library and Museum at Pennsburg, Pennsylvania, is fortunate to have such a draft from Montgomery County, Pennsylvania. It is drawn in ink, colored, and inscribed, "SUSANHA HEEBNEREN" (fig. 4). It is 8 inches by 12 inches and is rendered in shades of brown ink and watercolor on paper, the colors being bright blue, black, pink, orange-red, and green. The colors of the letters in the pattern alternate just as they did in seventeenth- and early eighteenth-century stitchery. Pairs of stags confronting each other, hearts, tulips, paired birds, crowns, and flowers in jardinières are sprinkled throughout. Three segments of arcaded border patterns line the top.

It is uncertain which of the numerous Susanna Heebners of Montgomery County produced this pattern. It is possibly the work of Susanna Heebner, the daughter of Abraham and Christina (Wagner) Heebner. She was born January 5, 1797, and died prior to 1879. She was the granddaughter of Hans Christopher Heebner, a famous transcriber and compiler of hymns and other compositions.[75]

Patterns for needlework were often derived from various books. An English book by George Fisher entitled *The Instructor: or Young Man's Best Companion* was in its fifth edition when advertised in the *London Evening Post*, February 19–21, 1740. To the body of the text was added, "The Family's Best Companion; with Instructions for marking on Linnen." Subsequent printings followed in England and Scotland, which also included this material in table form.[76]

In Philadelphia, Benjamin Franklin and David Hall published the first American edition of the Fisher book in 1748 with the title *The American Instructor: or, Young Man's Best Companion*. On the title pages of both the 1748 and 1753 editions were noted "With Instructions for Marking on Linnen." [77] Although the title page in each edition asserted these instructions were included, the printers actually removed the marking instructions as not being suitable for the American audience. They neglected, however, to remove the pertinent information from the title pages. Numerous American editions followed, and in 1785 Isaiah Thomas printed the thirtieth edition, which included the paragraph containing instructions for marking, and on pages 374 and 375 appeared the two upper- and lower-case marking alphabets. The latter alphabet included with numerals one to ten and zero a small crown and an ampersand.[78] The use of the small crown in all copies seen in this country may be one of the reasons that the crown is visible on many American samplers.

John Bioren, a Philadelphia printer, included these tables and instructions in his edition of 1812 (see figs. 5, 6, 7).

Engravings also proved an excellent source for samplers as well as the more advanced forms of needlework. In 1815 Catharine Schrack of Philadelphia worked a large pictorial sampler with the design of Mount Vernon. The original source for this was the undated etching made by William Russell Birch, who emigrated from England to the Philadelphia area with his son Thomas in 1794. The etching, from the series, "Country Seats of the United States" of 1808, was titled: "Mount Vernon, Virginia, the Seat of the Late Gen^l G. Washington/ Drawn Engraved and Published by W. Birch Springland near Bristol Pennsylv^a" (fig. 8). In this version a

white groom holds the reins of a horse in the lower right side of the etching and a galloping horse looks toward the Potomac at the left.[79]

The actual design that Catharine Schrack used for her needlework design was a later version of this etching, a line engraving by Samuel Seymour that had been first published on March 15, 1804. An impression was later issued without the original imprint line and was inscribed, "Mount Vernon, the Seat of the Late Gen¹ G. Washington Drawn by W. Birch, Engraved by S. Seymour, Philadelphia Published March 15, 1812." It is this 1812 impression of the Seymour engraving that included not only the two fashionably dressed ladies standing with parasols, but also a black groom, and at left a field hand with his cut grain in one upraised hand and a sickle in the other. Another horse is seen running with a dog behind him nipping at his heels (fig. 9). All these elements are included in Catharine's embroidery, although she chose to omit George Washington standing on the porch and to add a sun smiling in the blue sky (fig. 69).

Early needlework pattern books have proved a durable source of design since their beginnings in the 1500s. Rosina Helena Fürst of Nürnburg, an embroideress and copper engraver, was probably the first woman to publish such a pattern book in 1666, the year that her father, art dealer Paul Fürst, died. Her book, *Das Neüe Modelbuch von Schönen Nädereijen Ladengewürck und Paterleinsarbeit,* was a design source for the reclining stag in the 1806 sampler of Jane Shearer (fig. 53).[80] Plate LIX, in her book, of the reclining stag (fig. 10) is almost a mirror image of the one used in the American sampler. The later version, however, omits or lacks the prongs on the lower of the two antlers and the chest line. Although the stag is a frequently used motif in American samplers, Jane Shearer's version is the one that most closely copies the Fürst pattern.

It only remains for me to express my deep pleasure in being associated with Ted Kapnek in this book and the accompanying exhibition of his samplers at the Museum of American Folk Art in New York. Not only does Ted have a collector's discerning eye, but also the most delightfully infectious enthusiasm for his subject. All who have had the privilege of seeing the collection in Ted's home immediately find themselves sharing this enthusiasm wholeheartedly, and as a result obtaining knowledge in a field that could well be entirely new to them. That, naturally, is a goal of any great collection such as this one, and Ted Kapnek and I hope that this knowledge and appreciation will be experienced by all who read this book and view the exhibition.

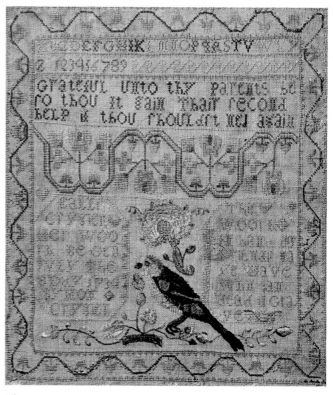

14

14. Ealli Crygier, New York, 1734. *Inscription:* "Ealli / Crygier / Her Woo / rk Begen / IVLY The / 8 day 1734 / SYMON / CrYgier." *Stitches:* cross, straight, satin, stem, outline, Oriental. Silk on linen, 13⅜″ h. x 11½″ w.

15

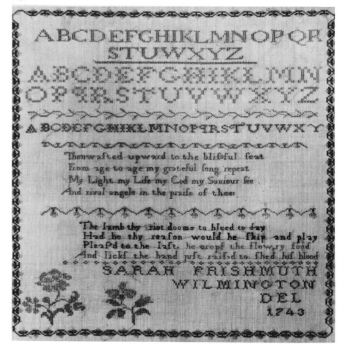

13

*13. Sarah Stone, Salem, Massachusetts, 1678. *Inscription:* "Sarah Stone 1678." *Stitches:* satin, cross, double running, eyelet, detached buttonhole, back, long-armed cross, Montenegrin. Silk on linen, 16¾″ h. x 7⅞″ w.

* Additional information is provded in Appendix 1 for all sampler captions preceded by an asterisk (*).

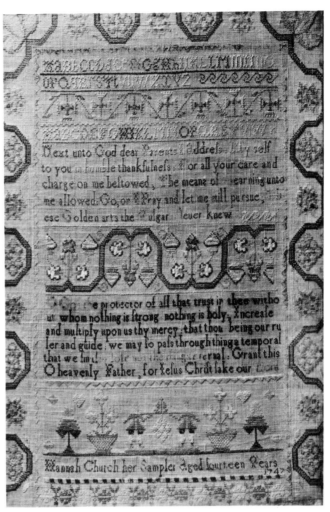

16

17

°17. Hannah Church, Little Compton, Rhode Island, 1747. *Inscription:* "Hannah Church her Sampler aged fourteen Years/ 1747." *Stitches:* cross, satin. *Colors:* white, tan, magenta, bluish green, yellow-green, two shades each of brown, blue, and yellow. Silk on linen, 16½″ h. x 11″ w.

°16. Elizabeth Hext, Charleston, South Carolina, 1743. *Inscription:* "David Hext Ann Hext/Elizabeth Hext Is My Name Carolina Is My Nation/Charles Town Is My Dwelling Place And Christ Is My/Salvation This Sampler Was Ended In/The Ninth Year of Her Age 1743." *Stitches:* cross, eyelet, satin. *Colors:* lavender, red, viridian, indigo, blue-green, medium blue, yellow, cream, two shades of green. Silk on linen, 17″ h. x 8⅜″ w.

°15. Sarah Frishmuth, Wilmington, Delaware, 1743. *Inscription:* "SARAH FRISHMUTH/ WILMINGTON/ DEL/ 1743." *Stitches:* cross, eyelet. *Colors:* salmon, pale pink, two shades each of brown and blue-green, golden ochre, cerulean blue, brick red. Silk on linen, 16⁵⁄₁₆″ h. x 16⅛″ w.

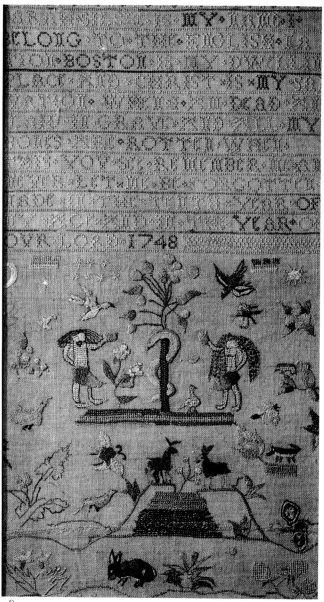

18

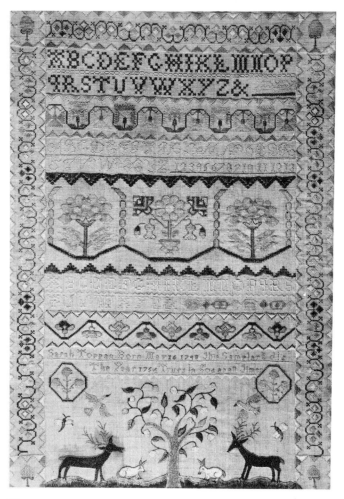

19

*19. Sarah Toppan, Newbury, Massachusetts, 1756. *Inscription:* "Sarah Toppan Born May 16 1748 This Samplar I did/The Year 1756 Trust in God at all Times." *Stitches:* satin, cross, Oriental, outline, stem, eyelet, rococo (queen), rice. *Colors:* rose, lavender, two shades of green, pink, dark blue-gray, ochre, white, pale blue, beige, yellow, yellow-green, light and dark brown, cream. Silk on linen, 19¼″ h. x 13⅜″ w.

*18 and 18a. Sarah Silsbe(e), Boston, Massachusetts, 1748. *Inscription:* "SARAH.SILSBe.IS.MY.NAMe.I/.BeLONG.TO. THe.ENGLISH.NA/TION. BOSTON.IS.MY.DWeLLIN/ PLACe. AND.CHRIST/.MY.SAL/VATION.WHeN.I.Am. DeAD.AND/ LAID.IN.GRAVe.AND.ALL. MY. BOneS. ARe.ROTTeN.WHeN/ THIS.YOU. See. ReMeMBeR. Me. AND/NeVeR.LeT.Me.Be.FORGOTTen/MADe.IN.THe. TeNTH.YeAR.OF.OUR.LORD. 1748." Stitches: cross, straight, satin, long-armed cross, outline, darning. Silk on linen, 22″ h. x 12″ w. *Note:* Brown ink-drawn sketch lines are visible.

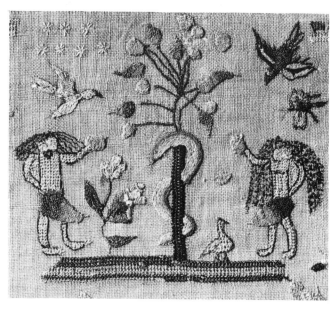

18a

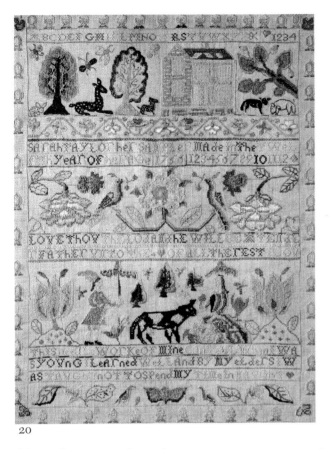

20

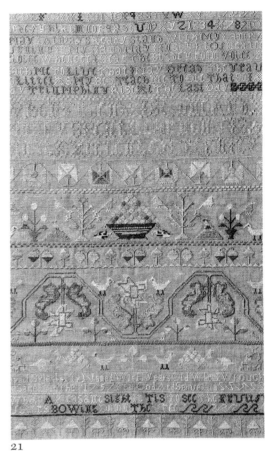

21

°20 and 20a. Sarah Taylor, Hampton, New Hampshire, 1756. *Inscription:* "SArAh TAYLOr SAMPLer MAde In The TWEL/FTH YeAr OF her AGe 1756." *Stitches:* cross, satin, outline, stem, tent, eyelet, back, rice, seed, split, long-armed cross. Silk on linen, 16½″ h. x 12¾″ w.

21. Abigail Byles, Boston, Massachusetts, 1757. *Inscription:* "Abigail Byles Is My Name I Was 11 Years Old When I Wrought / The Same Iune The 1757." *Stitches:* cross, satin, eyelet, rococo (queen). Silk on linen, 17¼″ h. x 11″ w.

20a

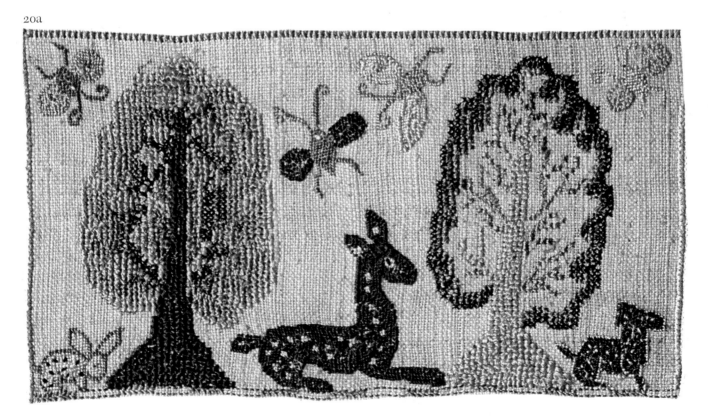

25

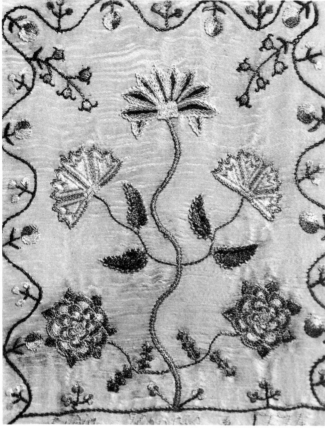

22

22. Lydia Hoopes, possibly Chester County, Pennsylvania, 1774. *Inscription:* "Lydia Hoopes 1774." *Stitches:* satin, outline, Oriental, straight, bullion, chain. *Colors:* tan, rose, russet, cream, medium green, three shades of blue. Silk embroidery on silk, 7⅜″ h. x 6″ w.

23

°23. Lucy Low, Philadelphia, Pennsylvania, 1776. *Inscription:* "Lucy Low Her Sampler Aged 12 1776." *Stitches:* cross, stem, eyelet, satin, chain, split, bullion, Oriental. Silk on linen, 14½″ h. x 11⅜″ w.

°25. Mary Hafline, probably Pennsylvania, 178(?). *Inscription:* "MARY . HAFLINE WORKETH . THIS . IN . THE ./ ELEVENTH YEAR.OF HER ACH.JACOB./ COMETH.TO. THE . WELL AND . METETH . WITH . RACHEL . 178" *Stitches:* cross, chain, satin, rococo (queen), daisy. *Colors:* lavender, viridian, white, two shades of pink and blue, yellow, cream, dark brown, black. Silk on linen, 12½″ h. x 12½″ w.

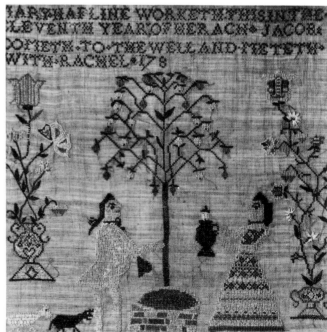

25

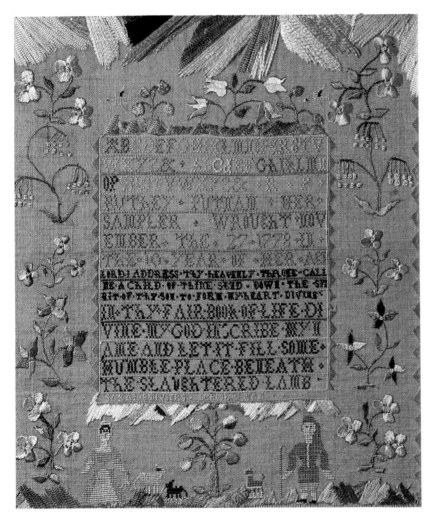

24

*24. Ruthey Putnam, Salem, Massachusetts, 1778. *Inscription:* "RUThEY. PUTNAM.HER./ SAMPLER.WROUghT. NOVEMBER.The.27 1778. IN/ ThE.10.YEAR.OF.HER. AgE/ SARAH STIVOURS.SCHOOL. MAM." *Stitches:* hem, cross, buttonhole, satin, French knot, outline, bullion. Silk on linen, 17¼" h. x 14¾" w. *Note:* Original ink sketch lines are visible below silks.

26

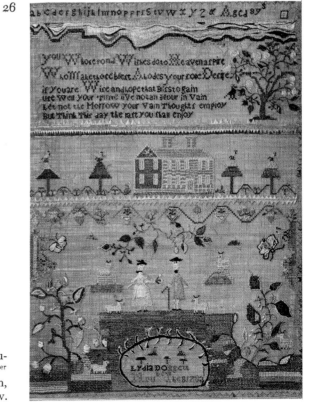

*26. Lydia Doggett, Newburyport, or Attleboro, Massachusetts, 1783. *Inscription:* "Aged 8 yˢ/ Lydia Doggett/ Novᵇᵉʳ The 8 1783." *Stitches:* eyelet, cross, satin, outline, stem, straight, chain, French knot. Silk on linen, 21⅜" h. x 15⅝" w.

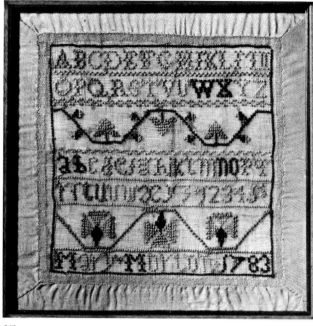

27

27. Mary Morton, probably Pennsylvania, 1783. *Inscription:* "Mary Morton 1783." *Stitches:* cross, hems overcast or whipped. Silk on linen(?), bound with pale blue silk ribbon, mitered at corners; 4¾″ square without ribbon, 5¾″ including ribbon.

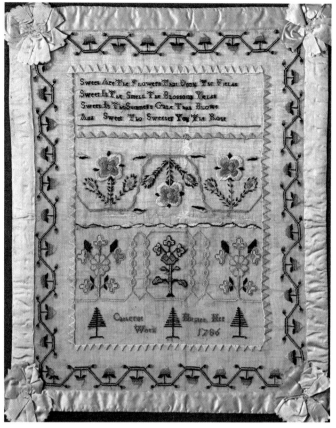

29

29. Catherine Hiester Berks County (probably Reading), Pennsylvania, 1786. *Inscription:* "Catherine Hiester Her/ Work 1786." *Stitches:* cross, satin, outline, stem, daisy. Silk on linen, 19⅜″ h. x 15⅜″ w. Border is bound on four sides with pale blue silk ribbon with corner rosettes.

28

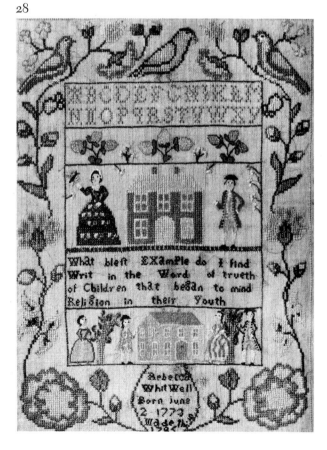

°28. Rebecca Whitwell, School of Newport, Rhode Island, 1785. *Inscription:* "Rebecca/ Whitwell/Born june/ 2 1773/ Made thi/ˢ/ 1785." *Stitches:* cross, hem, tent, Oriental, straight, daisy, seed. *Colors:* russet, cream, two shades of green gray, two shades of blue and khaki, black, brown, lavender, light tan. Silk on linen, 16¾″ h. x 12½″ w.

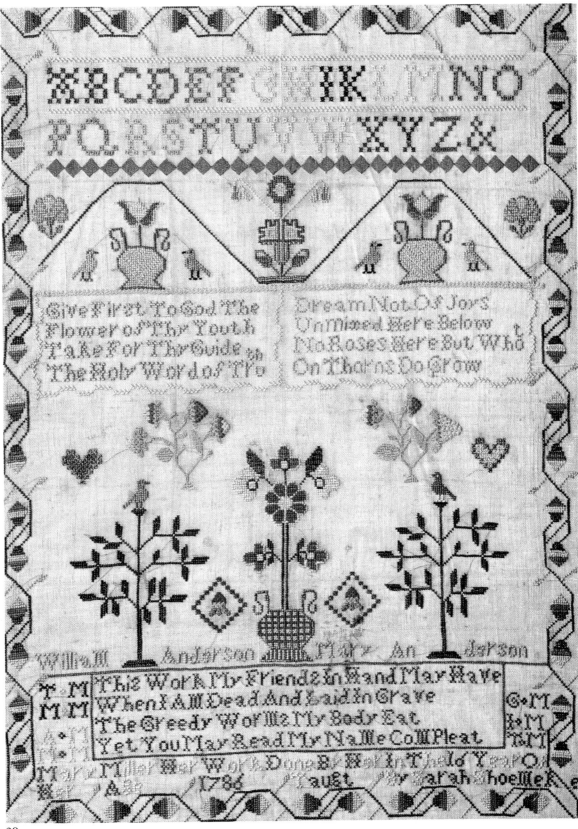

30

°30. Mary Miller, near Pemberton, New Jersey, 1786. *Inscription:* "Mary Miller Her Work Done By Her In The 16 Year Of/ Her Age 1786 Taugt By Sarah Shoemeker," and: "William Anderson Mary Anderson/T.M/M.M/ A.M/ M.M/ G.M/ M.M/T.M/. *Stitches:* cross, eyelet, satin, herringbone, rice, rococo (queen). Silk on linen, 18″ h. x 13½″ w.

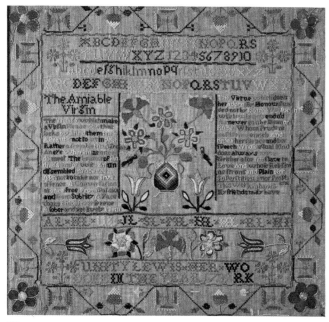

31

*31. Unity Lewis, Philadelphia, Pennsylvania, 1789. *Inscription:* "UNITY LEWIS.HER WO/RK DONE IN THE YEAR 1789," and: "AL.HL.UL.JL.SL.ML.NL.HL.RL.HI." *Stitches:* rococo (queen), outline, French knot, cross, tent, split, satin, eyelet. Silk on linen, 16½" h. x 17⅜" w.

33

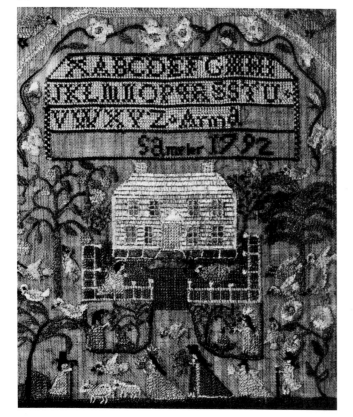

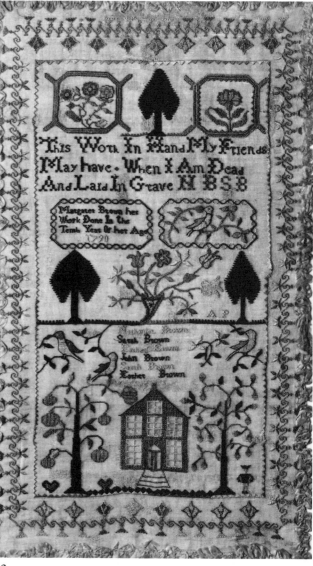

32

32. Margaret Brown, possibly Chester County, Pennsylvania, 1790. *Inscription* (in octagonal cartouche): "Margaret Brown her/ Work Done In the/ Tenth Year Of her Age/ 1790"; (below): "Nathaniel Brown/Sarah Brown/Esther Brown/John Brown/Sarah Brown/Esther Brown." "AP" may be the preceptress. *Stitches:* cross, satin, rice, French knot, eyelet. *Colors:* russet, cream, indigo, teal blue, gray-blue, light yellow-green, deep pink, viridian, dark olive green. Silk on gauze, bordered with quilled pale blue silk ribbon, 22¾" h. x 13⅛" w.

33. Anonymous, New England (Massachusetts ?), 1792. *Inscription:* "Annª/ SAmpler 1792." *Stitches:* cross, satin, tent, chain, upright and slanting Gobelin, outline over satin. *Colors:* black, garnet, pink, tan, terra-cotta, light brown, blue-green, two shades of yellow-green. Silk on linen, 13" h. x 11" w.

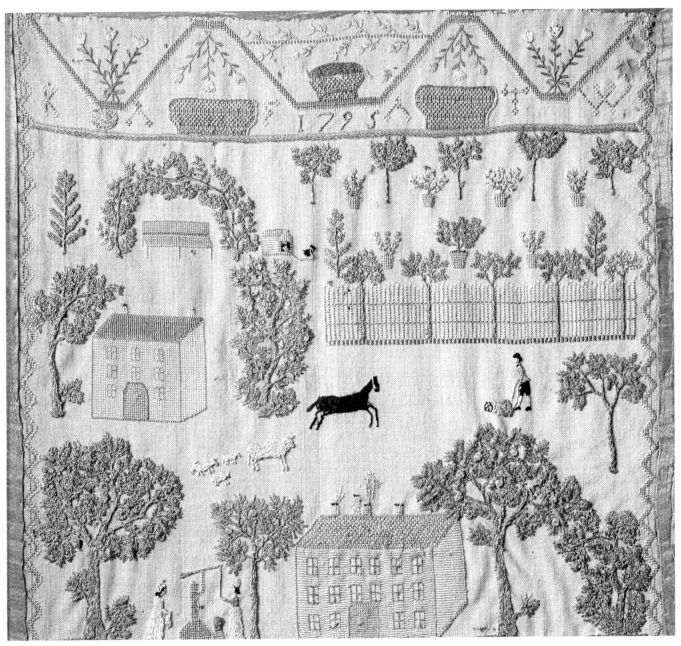

34

°34. Anonymous, probably Chester County, Pennsylvania, 1795. *Inscription:* "KA FA TW/ 1795." *Stitches:* cross, chain, French knot, daisy, back, straight. Silk on wool, with green, silk-ribbon border, 11¼″ h. x 12¼″ w.

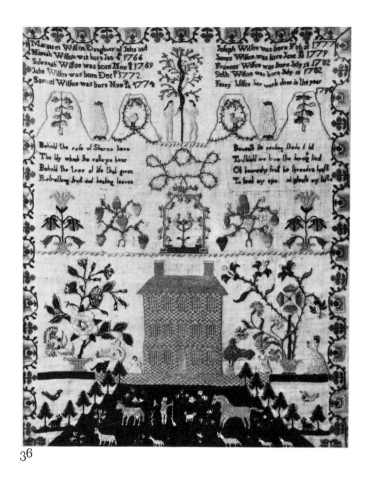

35

35. Harriot Sacket, Sheffield, Massachusetts, 1795. *Inscription:* "HARRIOT / SACKETS / PREASANT / TO. POLLY / BRASS of / SHEFFIEL/D AUGUST. 15 1795." *Stitches:* cross with overcast or whipped hem. *Colors:* cream, yellow, dark green, two shades of brown. Silk on linen, 3⅜″ h. x 2¾″ w.

36

36 and 36a. Fanny Wilson, Family Register, Pennsylvania (?), 1795. *Inscription:* "Fanny Wilson her work done in the year/ 1795." *Stitches:* cross, satin, rococo (queen), tent, split, straight, Oriental, seed, outline. *Colors:* russet, olive green, yellow, viridian, tan, rust, brick red, pale green, pink, white. Silk on muslin, 19½″ h. x 15½″ w.

38. Rebecca Kil'eran, Boston, Massachusetts, 1796. *Inscription:* "Rebecca Killeran.Boston.August.19.1796." *Stitches:* cross, eyelet, chain, outline, seeding, couching, straight, French knot. *Colors:* crimson, red-violet, cream, tan, brown, blue-green, dark blue, dark olive green, rose, medium chrome green. Silk on linen, 20¼″ h. x 16½″ w.

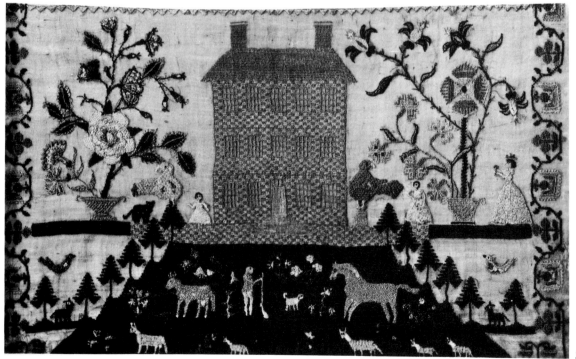

36a

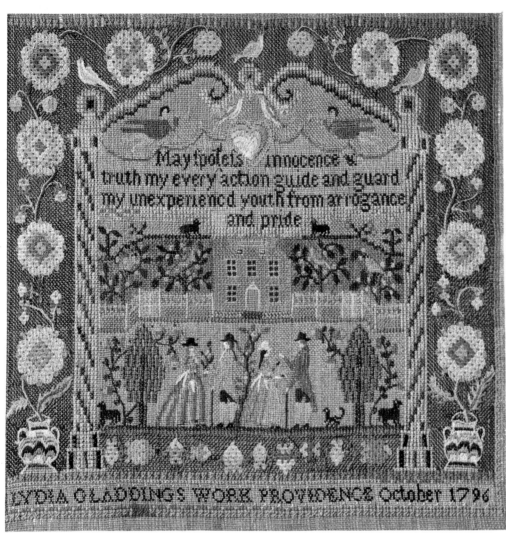

37

°37 and 37a. Lydia Gladding, Providence, Rhode Island, 1796. *Inscription:* "LYDIA GLADDINGS WORK PROVIDENCE October 1796." *Stitches:* cross, diagonal pattern darning, rococo (queen), rice, tent, Oriental, outline, satin, stem, chain. Silk on coarse linen canvas, 12″ h. x 12¼″ w. Attributed to the school of Miss Mary Balch, Providence, Rhode Island.

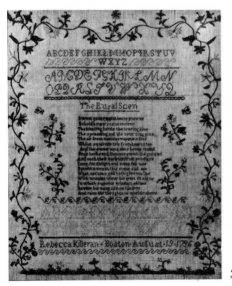

38

37a

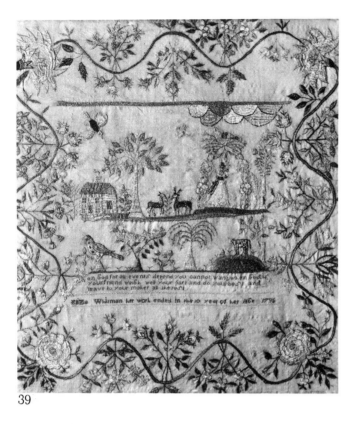

39

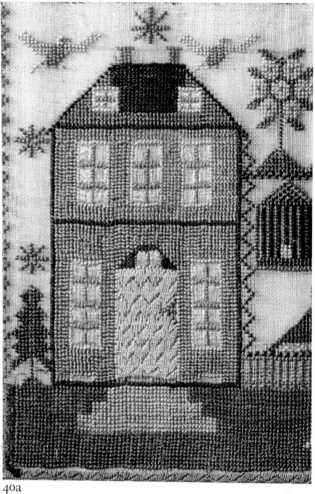

40a

°39. Eliza Whitman, Massachusetts, 1796. *Inscription:* "Eliza Whitman her work ended in the 10 year of her Age 1796." *Stitches:* cross, outline, chain, Oriental, French knot. *Colors:* black, shades of brown, cream, white, pink, shades of blue, green, yellow. Silk on wool, 21½" h. x 19" w.

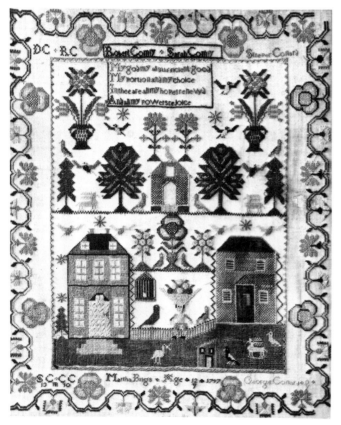

40

40 and 40a. Martha Briggs, Halifax, Massachusetts, 1797. *Inscription:* "Martha Brigs [sic]. Age . 12 . 1797." *Stitches:* cross, satin, tent. *Colors:* mauve, russet, viridian, indigo, cream, olive, pale green, two shades each of terre verte, blue; deep salmon pink, blackish brown. Silk on gauze, 17¾" h. x 14⅜" w.

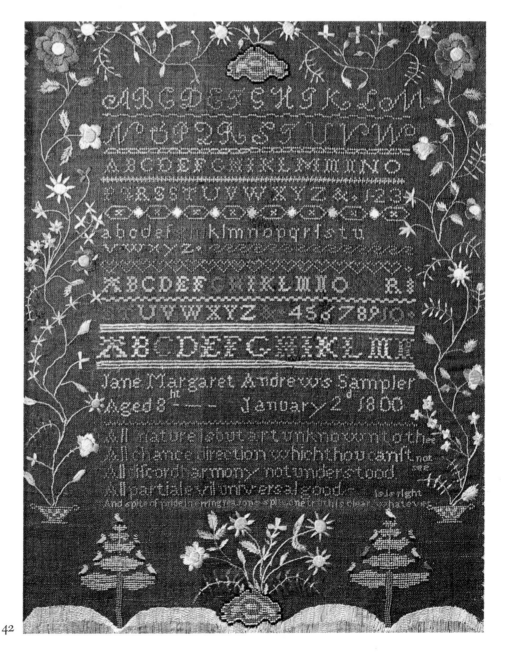

41

41. Ruth James, Westtown School, Westtown, Chester County, Pennsylvania, 1800. *Inscription:* "WESTTOWN SCHOOL/ Ruth James.1800." *Stitches:* cross, outline. *Color:* puce. Silk on linen, 11⅞" h. x 13⅝" w. *Note:* Ruth James of Philadelphia entered school in the fifth month of 1799 and again in the fifth month of 1806.

°42. Jane Margaret Andrews, area of Kittery–South Berwick, Maine, 1800. *Inscription:* "Jane Margaret Andrews Sampler/ Aged 8ht — / January 2d 1800." *Stitches:* cross, satin, tent, outline, slanting Gobelin, stem, eyelet, straight, encroaching satin. Silk on linsey-woolsey, 22" h. x 17¼" w. *Note:* Heavy paper is used as a filler under the satin-stitched flower centers.

42

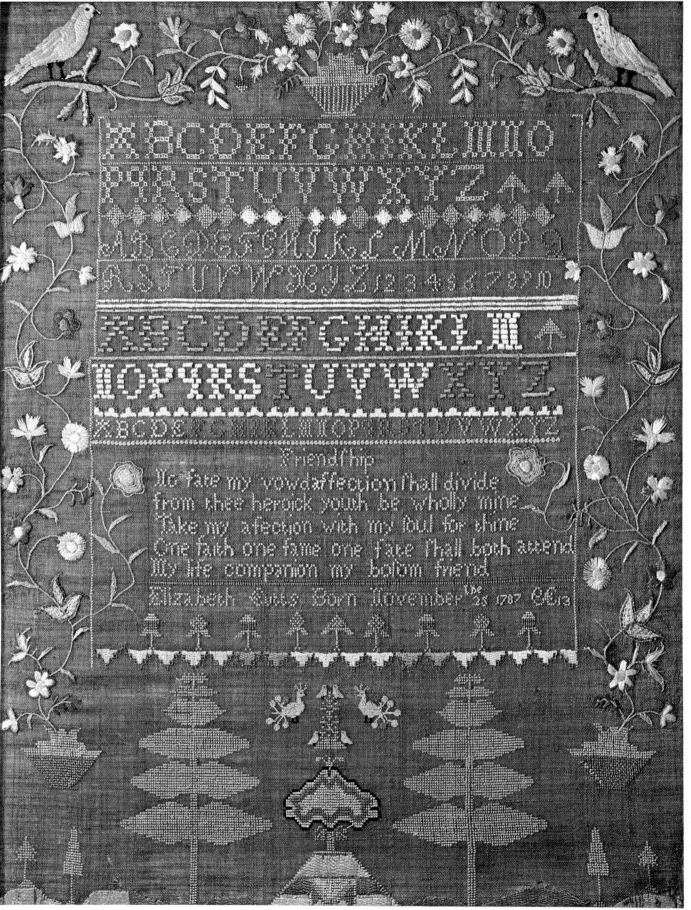

43

44

44. Rebecca Field, Nine Partners' Boarding School, Dutchess County, New York, 1801. *Inscription:* "Rebecca Field Boarding School/Ninepartners 1801." *Stitches:* cross, eyelet, outline. *Colors:* tan, brownish black. Silk on linen, 12⅛″ h. x 12⅛″ w.

43. Elizabeth Cutts, Berwick, Maine, 1800. *Inscription:* "Elizabeth Cutts Born November the 25 1787 AE 13." *Stitches:* cross, satin, chain, rococo (queen), eyelet, cross-stitch over satin. Silk on linsey-woolsey, 26¼″ h. x 18½″ w.

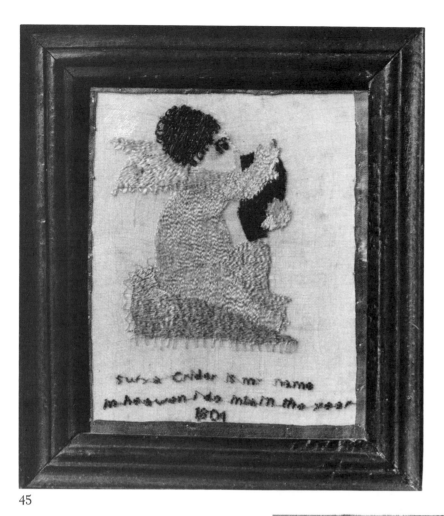

45

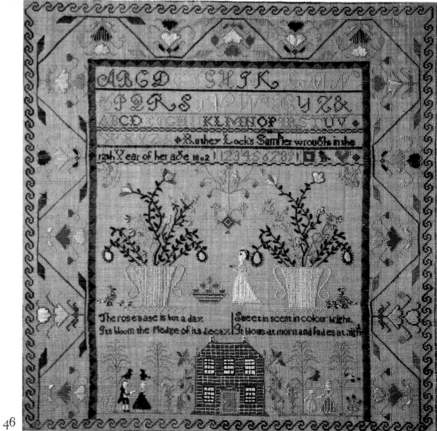

46

38

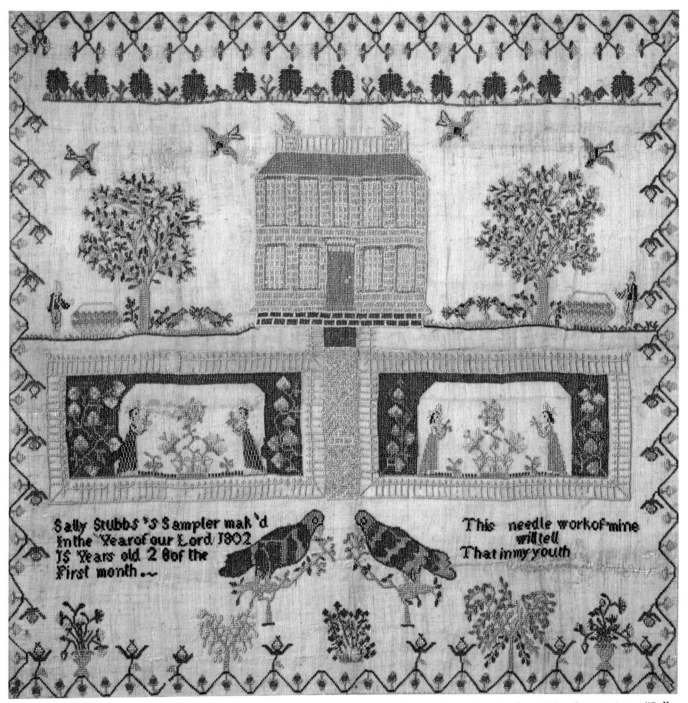

47

45. Susy A. Crider, probably Lancaster County, Pennsylvania, 1801. *Inscription:* "Susy a Crider is my name/ in heaven i do intain the year/ 1801." *Stitches:* tent, straight, outline, stem, buttonhole, flat, split. *Colors:* cream, pale rose, viridian green. Silk on gauze, with brown hair, border bound with flat, green silk ribbon, 4⅝" h. x 3¾" w. *Note:* Touches or red sketch lines visible on gauze. Original frame.

°46. Ruth Locke, Lexington, Massachusetts, 1802. *Inscription:* "Ruthey Lock's Sampler wrought in the/ 12th Year of her age 1802." *Stitches:* satin, cross, outline, upright Gobelin, twisted chain, back, straight, Oriental, eyelet. Silk on linen, 21½" h. x 21½" w.

°47. Sally Stubbs, Maryland, 1802. *Inscription:* "Sally Stubbs's Sampler mak'd In the Year of our Lord 1802/ 15 Years old 28 of the / First month." *Stitch:* cross. Silk on gauze, 17¾" h. x 18" w.

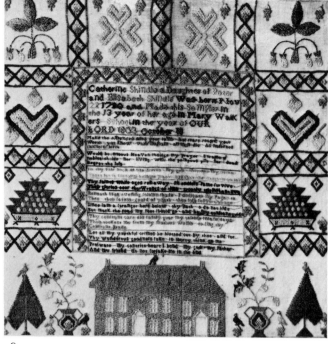

48

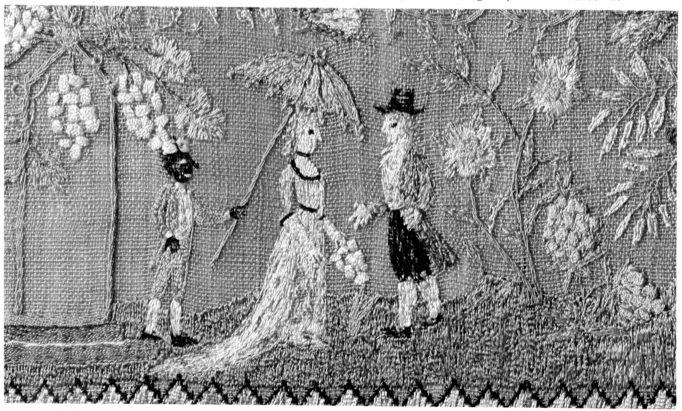

Southern Boarding School Delaware 1803

When all thy mercies, O my God,
My rising soul surveys,
Transported with the view, I'm lost
In wonder love, and praise.

O how shall words, with equal warmth,
The gratitude declare,
That glows within my ravish'd heart,
But thou canst read it there.

Unnumber'd comforts to my soul
Thy tender care bestow'd,
Before my infant heart conceiv'd
From whom those comforts flow'd
When Nature fails, and day and night
Divide thy works no more,
My ever grateful heart, O Lord,
Thy mercy shall adore.

Mary Kennedy Daughter of David & Margaret
Kennedy was born on the 26 of the 11th m 1789

Mary Kennedys Work 1803

49

48. Catherine Shindle, Lancaster, Pennsylvania, 1803. *Inscription:* "Catherine Shindle a Daughter of Peter/and Elisabeth Shindle Was born Nov/22 1790 and Made this Sampler in/the 13 year of her age in Mary Walk/ers School in the year of OUR LORD 1803 October 18." *Stitches:* cross, rococo (queen), chain, stem, outline, buttonhole, tent. *Colors:* light green, gray, pale pink, ochre, two shades of blue and brown. Silk on tiffany, 16½″ h. x 16½″ w.

49. Mary Kennedy, Wilmington, Delaware, 1803. *Inscription:* "Southern Boarding School Delaware 1803/ Mary Kennedy Daughter of David and Margaret Kennedy was born on the 26 of the 11th m 1789/Mary Kennedys Work 1803." *Stitches:* cross, eyelet. *Colors:* cream, rose, peach, brown, viridian green. Silk on gauze, 16¾″ h. x 13⅜″ w.

50a

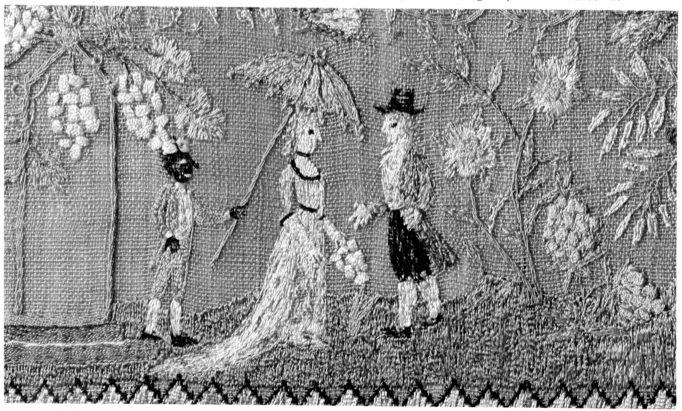

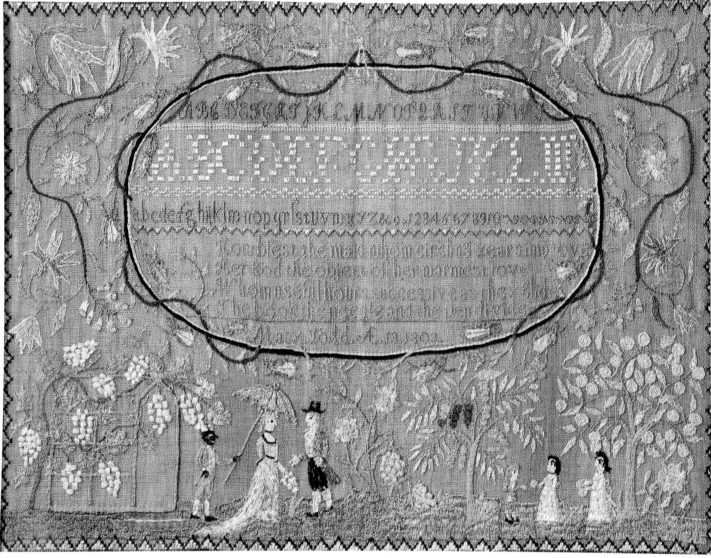

50

°50 and 50a. Mary Todd, Westfield, Massachusetts, 1803.
Inscription: "Mary.Todd.ÆE.13.1803." *Stitches:* cross, satin,
outline, chain, French knot, couching, Oriental, herringbone.
Silk on linen, 16½" h. x 21⅞" w.

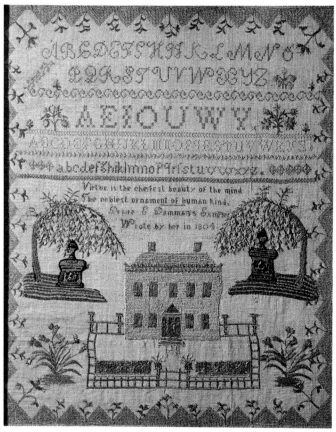

51

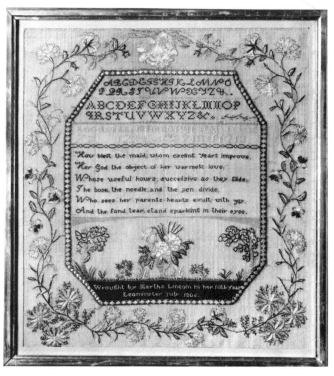

52

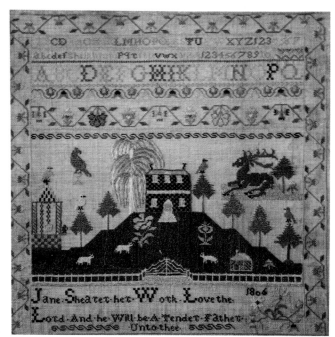

53

°51. Desire Ells Daman, Scituate, Massachusetts, 1804. *Inscription:* "Desire E Damman's Sampler/ Wrote by her in 1804." *Stitches:* cross, hem, Oriental, straight, outline, daisy, eyelet, chain, slanting Gobelin. Silk on linen, 19¼" h. x 15½" w. See Ruth T. Daman's sampler (fig. 54).

52. Martha Lincoln, Leominster, Massachusetts, 1806. *Inscription:* "Wrought by Martha Lincoln in her 10th year/ Leominster july 1806." *Stitches:* cross, satin, stem, Oriental, split, tent. *Colors:* salmon, white, cream, tan, yellow, green, black, violet, yellow-green, blue-green, two shades of blue. Silk on linen, 17¹¹⁄₁₆" h. x 15⅜" w.

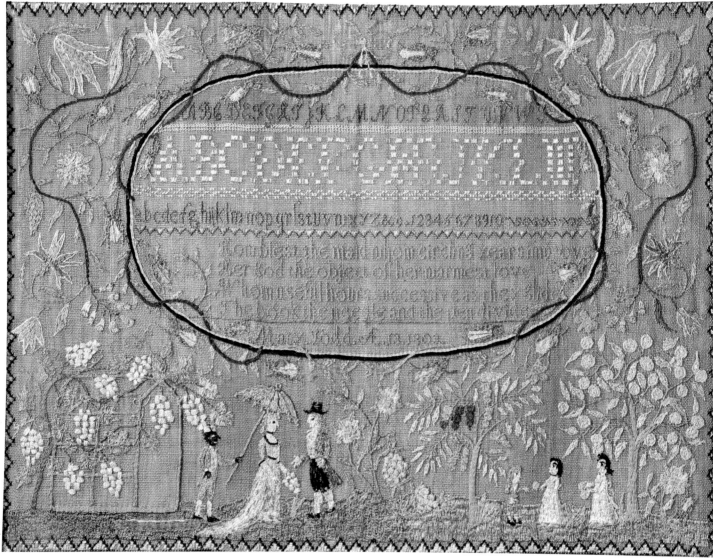

50

°50 and 50a. Mary Todd, Westfield, Massachusetts, 1803.
Inscription: "Mary.Todd.AE.13.1803." *Stitches:* cross, satin,
outline, chain, French knot, couching, Oriental, herringbone.
Silk on linen, 16½" h. x 21⅞" w.

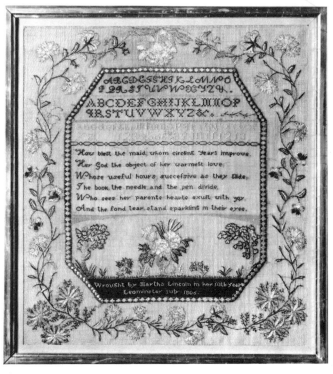

51

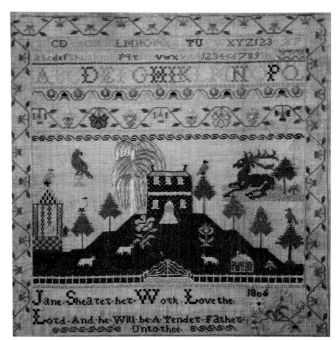

52

°51. Desire Ells Daman, Scituate, Massachusetts, 1804. *Inscription:* "Desire E Damman's Sampler/ Wrote by her in 1804." *Stitches:* cross, hem, Oriental, straight, outline, daisy, eyelet, chain, slanting Gobelin. Silk on linen, 19¼″ h. x 15½″ w. See Ruth T. Daman's sampler (fig. 54).

52. Martha Lincoln, Leominster, Massachusetts, 1806. *Inscription:* "Wrought by Martha Lincoln in her 10th year/ Leominster july 1806." *Stitches:* cross, satin, stem, Oriental, split, tent. *Colors:* salmon, white, cream, tan, yellow, green, black, violet, yellow-green, blue-green, two shades of blue. Silk on linen, 17¹⁄₁₆″ h. x 15⅜″ w.

53

"Beyer carefully depicted the methods of transporation in the area—carriages, trains, and their tunnels through the mountains, covered bridges, and canal boats."

lithographer. Lewis Miller, an itinerant folk artist, made numerous drawings throughout the state between 1846 and 1871. He too painted for his own pleasure. William Henry Bartlett drew about a half-dozen Virginia scenes from which steel engravings were made to illustrate *American Scenery* (1840). Henry Howe spent a period in Virginia in 1843 and sketched numerous landscapes which were used for wood engravings to illustrate his *Historical Collection of Virginia* (1845).

At the time Beyer was working in Virginia, three other landscape artists were active in the state. William Skinner Simpson and his son William Skinner, Jr., both of whom were talented amateur artists, earned their livings as insurance brokers, but executed many exceptionally fine watercolor views of central Virginia in the area of Petersburg. The third of these artists, David Hunter Strother, used the *nom de plume* Porte Crayon. From around 1853 to 1856 he drew numerous Virginia landscape and genre scenes to illustrate a series of

magazine articles on Southern life. These drawings were also used in his book *Virginia Illustrated* (1857). Of these artists only Bartlett, Howe, and Strother worked with a profit-making motive—they hoped their views would sell as illustrations for books and periodicals.

Like other Virginia landscape artists, Edward Beyer is scarcely known to most historians of American art, but he painted some of the finest landscapes of 19th-century America. One can but hope more works survive. ∎

Above: Beyer contrasts the linear regularity of the houses, streets, and railroad in the *U.S. Armory in Harpers Ferry* with the untamed, surrounding countryside, where the undulating hills are dominant. Lithograph from the *Album*, 11¾″ x 17¾″. Courtesy The Old Print Shop.

19th-Century Moravian Schoolgirl Art

BY KATHLEEN EAGEN JOHNSON

The Moravians, a largely German-American religious sect that settled in Pennsylvania and North Carolina during the 1740s and 1750s, earned a reputation for artwork distinctive in style and quality. The development of their ornamental arts in the early 1800s attests to this. The Moravians even taught special artistic skills in schools founded solely for the education of Moravian youth. Later these schools were open to the public, and between 1785 and 1840 the Bethlehem Seminary alone enrolled over 2,000 girls from 24 states and six countries. Similar schools were situated in Lititz, Pennsylvania, and Salem, North Carolina.

Although not always recognized as such, Moravian-style needlework and painting is found in museums, private collections, and antique shops all across the country. Art bearing the Moravian imprint left Pennsylvania and North Carolina with students returning home and with 19th-century tourists who purchased handmade souvenirs in Moravian communities. Thus, Moravian art created mainly by the teachers and students of the three schools spread nationwide.

Kathleen Eagen Johnson is the registrar at Sleepy Hollow Restorations, in Tarrytown, New York.

> *Through their mastery of needlework and other popular arts, the Moravians helped to enrich 19th-century American life.*

Moravians were a simple-living, plain-dressing sect, so the emphasis they placed on painting and needlework might seem surprising. Yet mastery of ornamental arts was held in high esteem among the intellectuals in the sect; they considered such attainments part of a solid and well-rounded education. In contrast, some outsiders felt it appropriate that a young woman's education consist mainly of decorative accomplishments. This was thought attractive to her suitors. Many wealthy young American women in the early republic spent the years before marriage involved in activities no more strenuous than visiting friends, receiving callers, and dabbling in the ornamental arts. In Moravian culture ornamental arts did not function as "man-traps," since courtship was nonexistent. Their ornamental arts expressed thanks to God for the skills He gave them to create beauty. Friendship and loyalty were favored themes. The group hoped that the art produced at the female seminaries would remind outsiders that a refined life-style need not be wasteful nor dissipated.

Opposite: The Moravians, a German-American religious sect, ran schools in which they taught needlework and other arts. The pupils of the Seminary for Female Education at Bethlehem, Pennsylvania, stitched this memorial wreath of ribbon-work in honor of the First Lady of the United States. 1826; 26″ wide. United States Department of Interior, National Park Service, Adams National Historic Site, Quincy, Massachusetts. Above: Themes such as *Love and Friendship* are common in Moravian art work. This watercolor is on a loose sheet of paper, but often they appear in memory books kept by schoolchildren. 1820-35; 5″ x 8¾″. Moravian Museum, Bethlehem, Pennsylvania; photo Greg Johnson.

Ribbon work

Moravians introduced the art of ribbon work to America in 1818. Ribbon-worked souvenirs from worldwide Moravian headquarters in Herrnhut, Germany, so impressed Bethlehem school officials that they instituted a course in this novel needlework. The Moravians incorporated two techniques within their ribbon-work creations. They fashioned three-dimensional flowers and leaves from lengths of ribbon and sheer silk crepe, accenting these constructions by means of embroidery with ribbon, silk floss, and chenille. *Mrs. Royall's Pennsylvania* (1829) described the art at Bethlehem:

> The young ladies showed me their frames with the unfinished work, which surpassed beauty. They have introduced what is called ribbon work, recently taught by a German lady. This is very ingenious, and has still a richer appearance than the common way with floss silk. The ribbon work is shaped like the floss, very narrow and curiously worked into flowers and figures of all sorts and shapes; it is richer and much easier done.

School officials, quite conscious that only female Moravian seminaries taught ribbon work during the 1820s and 1830s, publicized this fact through the creation of "monumental" framed needlework pieces. To give the public the best impression of needlework executed at the Bethlehem Seminary, one principal called on the ribbon-work instructor to create a masterpiece destined to be hung at the 1827 Mechanic Arts Exhibition in Philadelphia. But teachers did not make all the ceremonial ribbon work. The students presented a large floral wreath of crepe, ribbon, silk floss, and chenille to First Lady Mrs. John Quincy Adams. Mrs. Adams evidently cherished this piece of ribbon work, since she kept it after moving out of the White House.

Of course, not all ribbon work was made on such a grand scale. Students created smaller and less elaborate versions of the Adams wreath, sometimes embroidering their names or a biblical verse in the center. Others decorated dresser scarves, pocketbooks, and boxes with ribbon work. An easier and flashier needlework technique, ribbon work replaced silk-floss embroidery in national popularity after 1840.

Worsted work

Worsted work, also known as Berlin work, was another "addictive" needlework that captivated the Moravians and their students from the 1810s through the '30s. Although archival sources reveal many utilitarian artifacts made of worsted work, including hearth rugs, footstool and piano-seat covers, table mats, and lamp and pitcher stands, only those

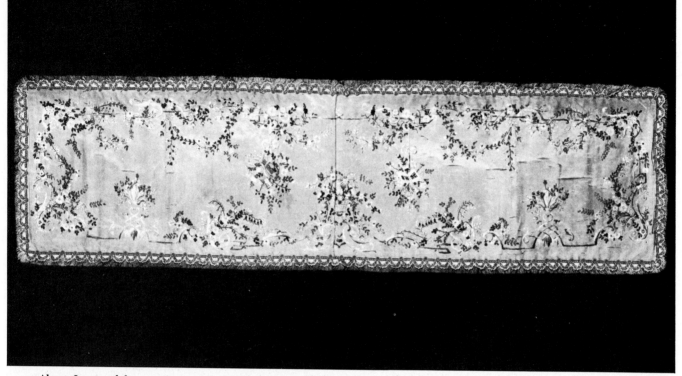

Above: Lyres and sheet music appear in this floral cotton embroidery. Silk on silk and cotton, 15⅜″ x 54″. Winterthur Museum; gift of Mrs. William Allen Jordan. Opposite page, center: The floral border around an oval picture is common in Moravian painting; here the combination appears on an ebonywork candlescreen. Paint and gilt on wood, 1820-1840; 12½″ high. Opposite page, left: A page from a memory book of watercolors. 1830-1840; 3¾″ x 2½″. Opposite page, right: Innovation was not encouraged in Moravian art. At the turn of the 19th-century Moravians began to stitch worsted work on mass-produced grids that came with designs and color directions already sketched on. An example from around 1820-1850 is shown here. Wool and linen canvas, 6⅜″ x 5¼″. All items opposite, the Moravian Museum; photos Greg Johnson.

objects created as pictures, framed and hung, survive in any numbers today.

At the turn of the 19th century, A. Philipson, a printseller in Berlin, Germany, invented gridded charts with designs on them corresponding to the holes in needlework canvas. By counting the holes and comparing the Berlin pattern to the canvas, a woman could re-create the Berlin work design in worsted wool. Even the colors of yarn were supplied on the pattern so the imagination of the needlewoman did not enter into "the picture."

Not everyone shared the nation's excitement over worsted work. J. D. Drinker, father of two Bethlehem schoolgirls, bitterly complained to principal Lewis de Schweinitz:

> I observe the materials for a Hearth Rug are charg'd $12, which is more than double the price I paid for a ready manufacturid [sic] one, now in my possession, similar in material, richness & variety in colours. ... The attainment of the art of worsted working is perfectly useless, and the time employed in acquiring it more than thrown away.

The Moravians did not heed Mr. Drinker's advice. With the advent of mass-produced Berlin patterns, Moravian needlework lost its distinctive flavor. Moravian teachers ordered commercially made patterns even though they were capable of creating their own and did so for several years. Caught up in the Berlin-work craze, the Moravians disregarded the loss of individuality in their needlework.

Watercolor drawing

Like worsted work, painting—or "drawing in watercolors," as it was known—was a very popular art for 19th-century women. Because elementary art instruction during this period consisted largely of copywork, students reproduced their instructors' paintings. This practice led to the development of stock Moravian motifs, including: stone monuments and urns, often topped by eternal flames or hearts, commemorating love and friendship; bluebirds with long, delicate wings, symbolizing happiness; circular horns entwined around sheet music; and puffy pink roses that look more like cabbages.

Two themes run through the paintings created at the Moravian seminaries: religious joy and the close ties among friends, which Moravians encouraged. The girls and their teachers celebrated Christmas and other holidays by painting and displaying watercolor religious scenes. They also kept schoolgirl memory books filled with painted remembrances, and exchanged decorated paper and silk watch papers, which

Above: The painted velvet lid on this distinctively Moravian work bag opens to reveal a pincushion. It was probably made in Bethlehem, Pennsylvania between 1820 and 1840. Silk, velvet, paint, and felt; 4″ x 3″. Below: The filigree work on the Moravian boxes and basket is done by gluing together bits of rolled paper. The lids are painted with watercolors. All date from 1790-1810; heart box, 2¼″ high; round box 2½″ diameter. All, Moravian Museum; photos Greg Johnson

Examples of watchpapers made and sold as souvenirs by the Moravians. These decorative and useful objects were placed in the backs of watches to keep the works free of dust. Watercolor on paper; 1⅞″ to 2⅛″ diameter. Moravian Museum.

were placed in the back of timepieces to keep the works free of dust.

Velvet painting and ebony work

It was a natural move for the Moravians to transfer their painting skills to surfaces other than paper. Account books and receipts indicate the purchase of velvet-painting materials as early as the 1810s, making the Bethlehem Seminary one of the first schools to teach the fashionable art in this country. From these materials schoolgirls decorated handscreens, pocketbooks, and workbags. While much 19th-century velvet painting was accomplished through the use of stencils, the Moravians preferred to apply the paint to the velvet freehand.

Mrs. Royall pronounced in 1829 that ebony work, another form of painting taught at the Bethlehem Seminary, was "a very useful art and a great curiosity, everything almost is made of it." The art of ebony work resulted from the popularity of papier-mâché objects during the 19th century. To achieve the look of painted or inlaid papier-mâché, the Moravians devised a way of embellishing wood- and paper-based artifacts with paint, and in this manner they made work, shaving, and dressing boxes, writing desks, hand-screens, and mantle ornaments. Papier-mâché furniture often was painted in elaborate rococo floral patterns on a black background or inlaid with mother-of-pearl on a black ground. In ebony work, which has nothing to do with ebony wood, the paintings often were done on a black ground to imitate papier-mâché furniture.

The exacting work of filigree is typical of the care Moravians took in executing their ornamental arts. After rolling thin strips of paper around a needle, the Moravians joined these little cylinders to construct boxes, both round and heart-shaped, and baskets, which were then decorated with ribbon and painted medallions bearing verses of love and friendship. Eliza Southgate recorded in her 1887 diary that the Moravian women sold paper baskets in the 19th century and that Candace Wheeler, the woman so instrumental in reviving interest in early American needlework, displayed a Moravian "paper box done with needle in filigree" at an 1883 fair to raise money for the Statue of Liberty.

The Moravians may have "shunned the follies of the fashionable life" but they practiced the popular ornamental arts with precision and skill and viewed this pursuit as a scholarly endeavor and a sign of a refined life-style. Through their mastery of ribbon work, worsted work, velvet painting, and the unusual arts of filigree and ebony work, the Moravians helped to enrich 19th-century American life. ■

53a

53 and 53a. Jane Shearer, Pennyslvania or New Jersey (?),
1806. *Inscription:* "Jane.Shearer.her.Work.1806." *Stitches:*
cross, rococo (queen), stem. Silk on linen, 21¼″ h. x 21½″ w.
Note: The reclining stag is a variation of a pattern in *Das
Neüe Modelbuch* . . . of Rosina Helena Fürst, Nürnberg,
1666.

54

54. Ruth Tilden Daman, Scituate, Massachusetts, 1807. *Inscription:* "Ruth T Daman's Sampler/ Wrought by her in 1807." *Stitches:* cross, eyelet, hem, daisy, outline, satin, Oriental. Silk on linen, 19¾" h. x 16½" w. See Desire E. Daman's sampler (fig. 51).

55

*55. Horton Family Register, Portland, Maine, 1807. *Inscription:* "THE GENEALOGY OF RUFUS/and ABIGAIL HORTON/ PORTLAND 1807." *Stitches:* cross, double running, satin, rococo (queen). Silk on linen, 20½" h. x 16¾" w.

56. Cordelia Latham Bennet, New York, c. 1807. *Inscription:* "Cordelia Latham Bennet Was Born/ March The 19 In The Year Of Our L/ord 1798 This I Do To Let You See/What Care My Parents Took Of Me." *Stitches:* cross, herringbone, satin, eyelet. *Colors:* blue-green, tan, salmon, yellow-green, yellow, viridian, cream, medium chrome green. Silk on linen, 14¾" h. x 19⅝" w.

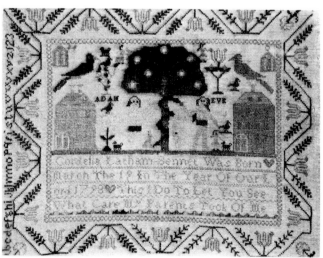

56

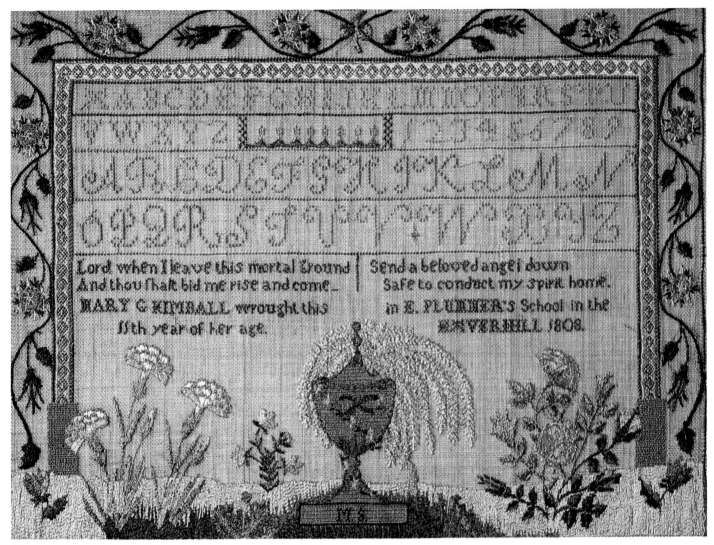

57

57 and 57a. Mary Graves Kimball, Haverhill, Massachusetts, 1808. *Inscription:* "MARY G. KIMBALL wrought this in E. PLUMMER'S School in the/11th year of her age HAVERHILL 1808." *Stitches:* cross, tent, satin, split, Oriental, bullion, straight, outline. Silk on linen, 12½″ h. x 16⅞″ w. *Note:* Mary's teacher was probably Elizabeth White Plummer, born August 22, 1789.

57a

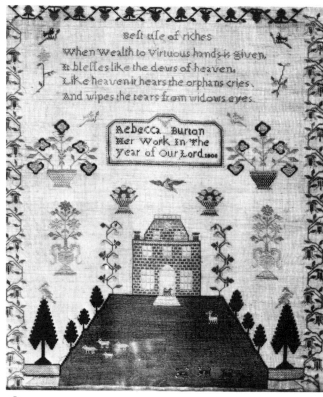

58

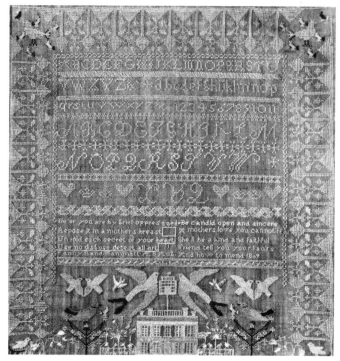

59

59. and 59a. Fanny Rand Hammatt, Boston, Massachusetts, 1809. *Inscription:* "Fanny Rand Hammatt .AE .8 .August [11] 1809." *Stitches:* cross, satin, herringbone, straight, stem. *Colors:* white, pale blue, brown, black, golden ochre, tan, yellow, peach. Silk on linsey-woolsey, 17½" h. x 17" w. Note the two small birds worked in satin stitch over stiff paper filler.

58. Rebecca Burton, Pennsylvania (?), 1808. *Inscription:* "Rebecca Burton/ Her Work In The/ Year of Our Lord 1808." *Stitches:* cross, satin. *Colors:* medium green, cream, viridian, ochre, white, russet, peach, two shades of blue, black, rose, yellow-green, indigo blue. Silk on linen, 24¼" h. x 20½" w.

59a

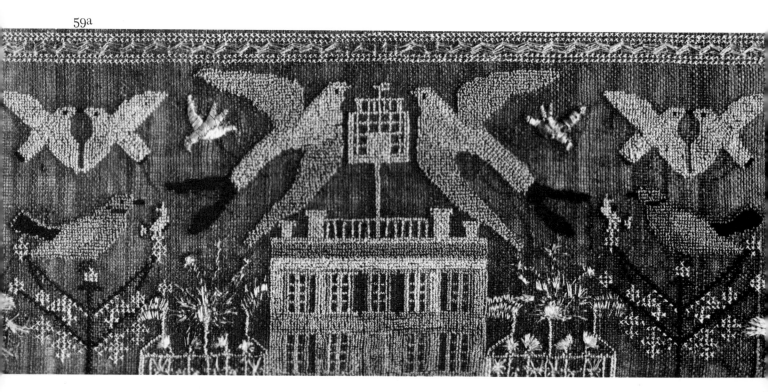

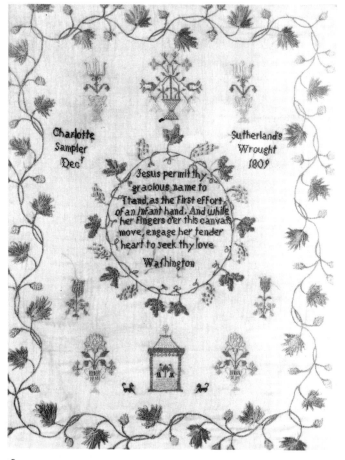

60

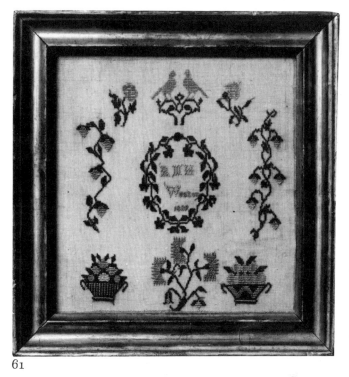

61

60. Charlotte Sutherland, Washington, 1809. *Inscription:* "Charlotte Sutherland's/Sampler Wrought/Dec^r 1809/ Washington." *Stitches:* cross, chain, seed, satin, straight. *Colors:* two shades of chrome green, black, peach, rose, cream, brown. Silk on gauze, 17¼" h. x 13" w.

°62. Deborah Laighton, Portsmouth, New Hampshire, 1810. *Inscription:* "Deborah Laighton. . .Worked at Mary Ann Smith's School Portsmouth October 15 1810." *Stitches:* cross, hem, eyelet, satin, stem. *Colors:* yellow, white, black, cream. Silk on linsey-woolsey, 17½" h. x 23¼" w. *Note:* This is the earliest sampler from the Portsmouth area using a design that is employed on five known pieces from 1810 to 1832. See figure 84, Adaline M. Ferguson, for a similar example.

61. Rebecca M. Haines, Westtown School, Westtown, Chester County, Pennsylvania, 1809. *Inscription:* "RMH/ Weston/ 1809." *Stitch:* cross. *Colors:* two shades of yellow, ochre, olive, pale blue. Silk on gauze, 6½" h. x 6½" w. *Note:* Rebecca M. Haines was born in Evesham, New Jersey, in 1801. She was at school in 1815, but her sister Jane attended here in 1809.

°63. Rachel James, Philadelphia, Pennsylvania, 1811. *Inscription:* "NORTH-SCHOOL/ RACHEL JAMES/ 1811." *Stitches:* cross, outline. *Color:* dark teal blue. Silk on linen, 11¾" h. x 11⅝" w.

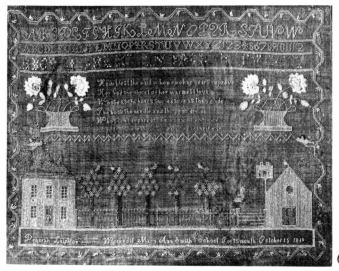

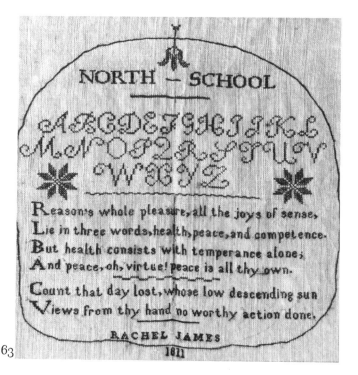

63

47

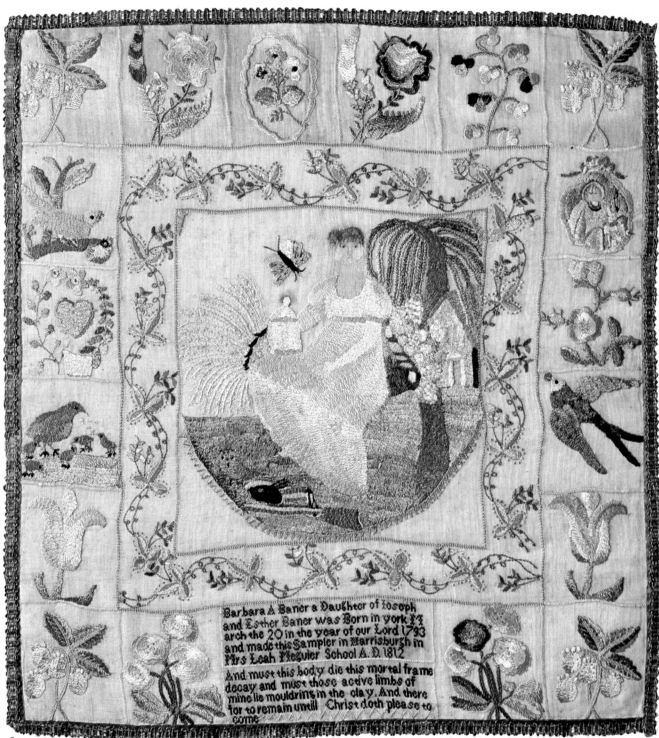

64

°64. Barbara A. Baner, Harrisburg, Pennsylvania, 1812. *Inscription:* "Barbara A. Baner a Daughter of Joseph/ and Esther Baner was Born in york M/arch the 20 in the year of our Lord 1793/and made this Sampler in Harrisburgh in/Mrs. Leah Meguier School A.D. 1812." *Stitches:* cross, satin, stem, outline, buttonhole, seed, slanting Gobelin, encroaching satin, straight, punch work, flat. Silk on fine gauze; hair, opaque paint, border ribbon of green silk with applied gold braid and metal strips on top, 18½" h. x 17¾" w. See page 2 for enlarged detail showing central panel.

65. Elizabeth J. Demeritt, Rochester (New Hampshire or Massachusetts), 1st quarter of 19th century. *Inscription:* "Elizabeth J. Demeritt aged 10 years Rochester Feb 1." *Stitches:* cross, French knot, herringbone, split, straight, seed, satin, rococo (queen), chain, back, hem, eyelet, long-armed cross. Silk on linsey-woolsey, 20" h. x 16¾" w. See page 5 for enlarged detail showing bottom panel.

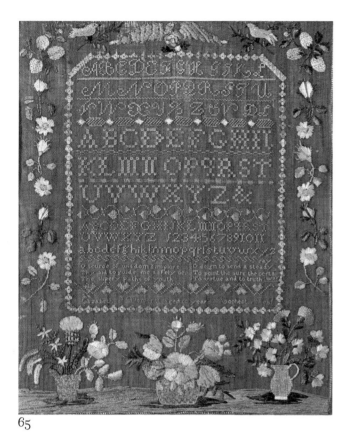

65

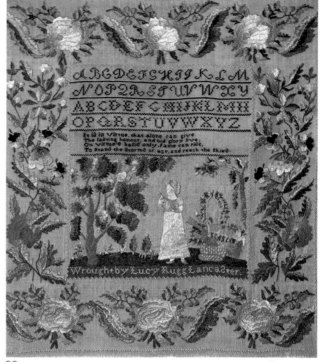

66

66 and 66a. Lucy Rugg, Lancaster, Massachusetts, n.d. (1st quarter of 19th century). *Inscription:* "Wrought by Lucy Rugg Lancaster." *Stitches:* cross, split, straight, chain, French knot, satin, couching, Oriental. Silk on linen, 18¾″ h. x 17¼″ w. *Note:* Paper face with touches of watercolor for facial details.

66a

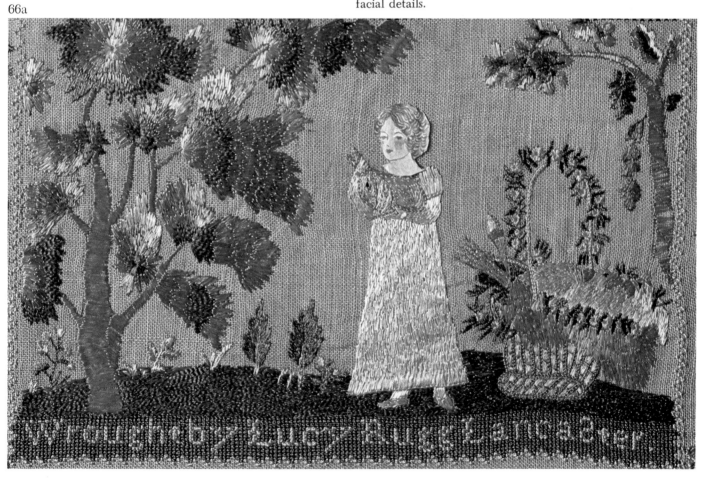

49

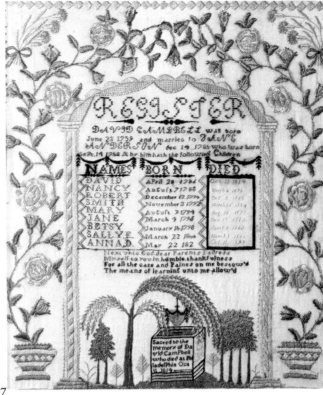

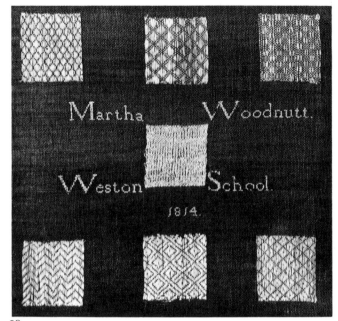

*68. Martha Woodnutt, Westtown School, Chester County, Pennsylvania, 1814. *Inscription:* "Martha Woodnutt Weston School 1814." *Stitches:* cross, pattern darning, and chain to simulate knitting in the center square. *Color:* white. Cotton on linsey-woolsey, 9¾" h. x 10½" w.

*67. Anna D. Campbell Family Register, Philadelphia, Pennsylvania(?), c. 1814. *Ink frame inscription:* "Register worked by Anna D. Campbell/ when a school girl/ Grandmother of Anna and Louisa M. Blanchard." *Stitches:* satin, cross, outline, French knot, eyelet, hem. Silk on gauze, 22½" h. x 19¾" w.

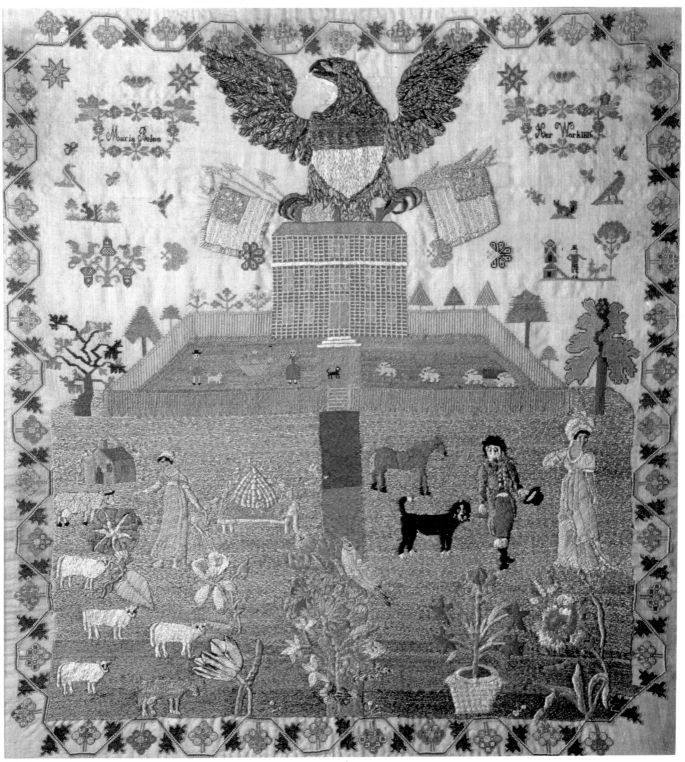

70

*70. Maria Bolen, Philadelphia, Pennsylvania, 1816. *Inscription:* "Maria Bolen Her Work 1816." *Stitches:* cross, satin, stem, outline, French knot, eyelet, tent, slanting Gobelin, Oriental, split. Silk on wool, 20⅛″ h. x 19″ w.

69. Catharine Schrack, Philadelphia, Pennsylvania, 1815. "*Inscription:* "Catharine Schrack/ Her Work Aged 14/ Years April 3, Philad/ 1815." *Stitches:* cross, straight, satin, outline, daisy, encroaching satin, couching. Silk and silk chenille on linen, 18½″ h. x 18½″ w. See figures 8 and 9 for etching and engraving sources of design used.

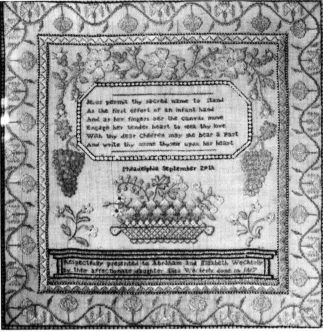

72

°71. Maria Anderson, New England (probably Massachusetts), 1817. *Inscription:* "Maria Anderson Samplar Workd In the 12 Year Of her Age 1817 Mrs. Mulhall NM." *Stitches:* cross, satin, chain, long-armed cross, slanting Gobelin, eyelet, straight. Silk on linen, 21¼″ h. x 23¾″ w.

°72. Eliza Weckerly, Philadelphia, Pennsylvania, 1817. *Inscription:* "Philadelphia September 29th/ Respectfully presented to Abraham and Elizabeth Weckerly/ by their affectionate daughter Eliza Weckerly done in 1817." *Stitches:* rococo (queen), cross, satin, outline, chain, French knot. *Colors:* lavender, dull brown, black, white, peach, deep yellow, yellow-green, medium green, pale pink, blue, cream. Silk on linen, 17¼″ h. x 17¾″ w.

73. Mary Linstead, Barrington, Massachusetts, 1818. *Inscription:* "Mary Linstead/ Aged 11 years 1818." *Stitches:* cross, satin, split, French knot, bullion, couching, eyelet, straight, encroaching satin, outline over satin. Silk and silk chenille on wool, 16½″ h. x 12⅝″ w.

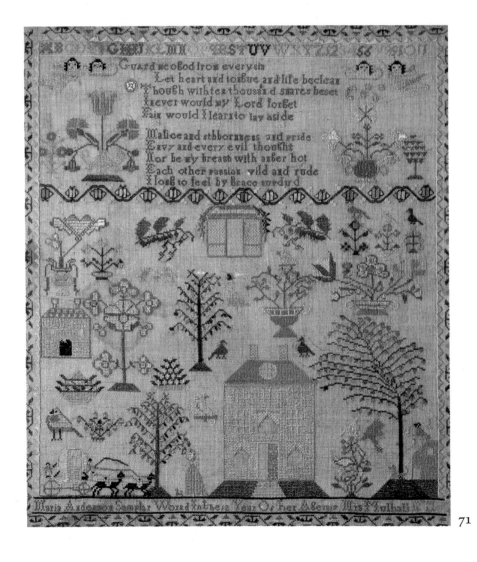

71

Awake or sleeping still eternal love
... bids thee ... man the present time improve
... immediate now is thine when that is o'er
... is ... gone and will return no more

Mary Linstead
Aged ... years 1815

74

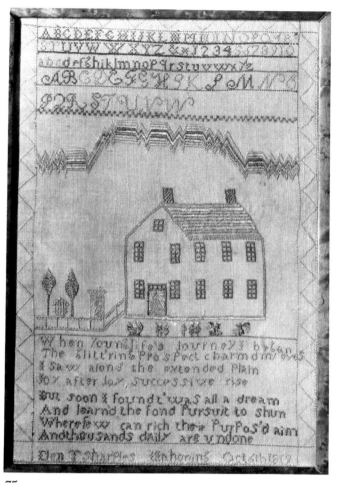

*74 and 74a. Hannah F. Thayer, Randolph, Massachusetts, 1818. *Inscription:* "Wrought by Hannah F. Thayer Randolph/Aged 11 years 1818." *Stitches:* cross, satin, outline, straight, split, chain. Silk on linen, 16½" h. x 15½" w. Notice the three standing figures, the bird in the tree, the seated lady, and the barking dog—all engravings on paper that have been applied to the surface of the landscape. Ink drawing lines are visible in the border foliage.

75

75. Elen T. Sharples, Mahoning, Pennsylvania, 1819. *Inscription:* "Elen T. Sharples Mahoning Oct 6th 1819." *Stitches:* cross, eyelet, outline, satin, straight, Irish (Florentine), slanting Gobelin. *Colors:* pink, cream, white, yellow-green, green, saffron yellow, pale blue, tan. Silk on linen, 16" h. x 11" w.

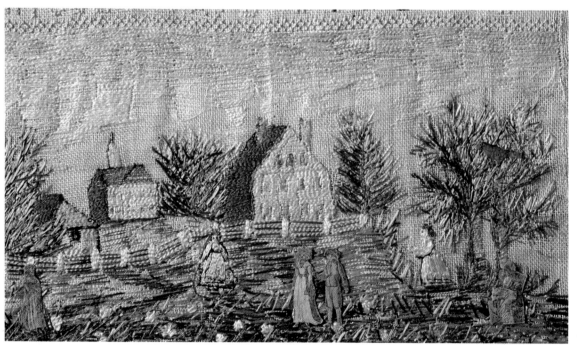

74a

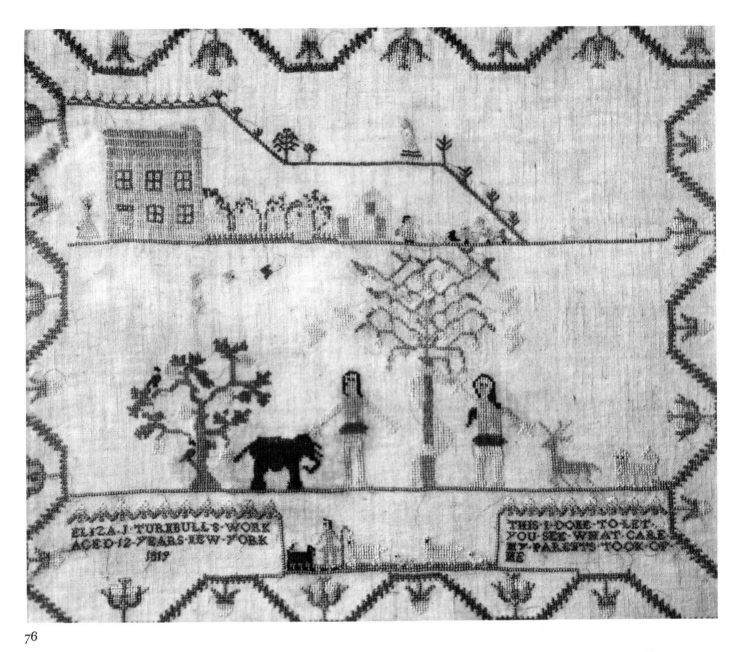

76

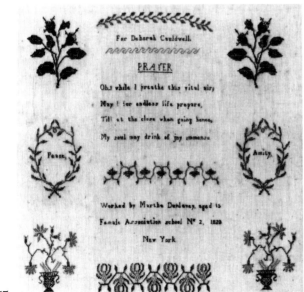

77

76. Eliza J. Turnbull, New York, 1819. *Inscription:* "ELIZA. J.TURNBULL.S WORK/ AGED.12.YEARS. NEW YORK/ 1819 THIS.I.DONE.TO.LET./ YOU.SEE.WHAT.CARE/ MY.PARENTS.TOOK.OF.ME." *Stitches:* cross, rococo (queen). *Colors:* peach, two shades of brown, cream, blue-green, indigo, yellow, olive green, black, tan, pink, rose. Silk on linen, 17″ h. x 27″ w. Note the elephant in the Garden of Eden.

*77. Martha Dunlavey, New York, New York, 1820. *Inscription:* "For Deborah Cauldwell/ Worked by Martha Dunlavey, aged 15/ Female Association school No.2, 1820/ New York." *Stitch:* cross. *Colors:* red, pink, lavender, yellow, yellow-green, black, viridian, chrome green. Silk on fine gauze, 7¾″ h. x 7⅞″ w.

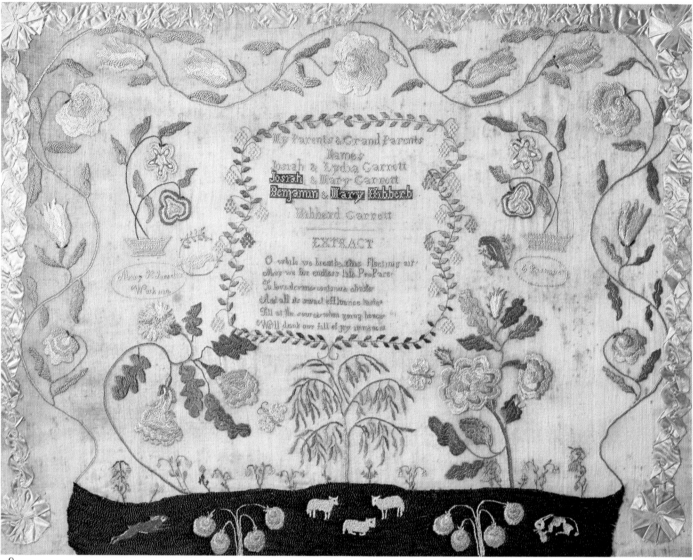

78

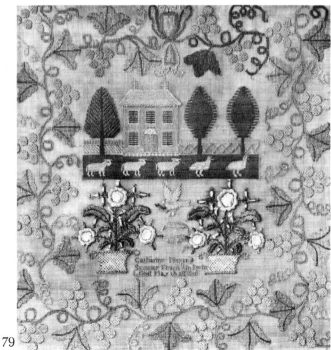

79

78. Mary Hibberd Garrett, Chester County, Pennsylvania, 1820. *Inscriptions* (top): "My Parents & Grand Parents/ Names/Josiah & Lydia Garrett/Josiah & Mary Garrett/Benjamin & Mary Hibberb/Hibberd Garrett"; (left): "Mary H. Garrett's/Work 1820"; (right): "E. Passmore" (the instructress). *Stitches:* cross, tent, chain, split, bullion, French knot, stem, satin, outline, rococo (queen). Silk on gauze, bordered with quilled cream silk ribbon with four corner rosettes, 22″ h. x 27½″ w. *Note:* Those names surrounded by black are deceased members of the family. Note the great similarity of figure 83 (Rachel Denn Griscom, 1821) in the border vine, sheep, strawberry plants, tree and flower units, etc.

79. Catharine Meyer, Springfield, Pennsylvania, 1820. *Inscription:* "Catharine Meyer's/Sampler Finsh'd in Sprin/g-field May th 28 1820." *Stitches:* rococo (queen), tent, outline, satin, cross, stem, daisy, turkey work. *Colors:* peach, olive green, blue-green, two shades of chrome green and blue, three shades of yellow. Silk on linen, 18¼″ h. x 17⅜″ w.

*80. Ann E. England, White Clay Creek, Mill Creek Hundred, New Castle County, Delaware, 1820. *Inscription:* "Ann E. England/1820." *Stitches:* cross, outline, stem, straight, eyelet, rococo (queen), satin, long and short, flat, seeding. Silk on linen, 25″ h. x 20″ w.

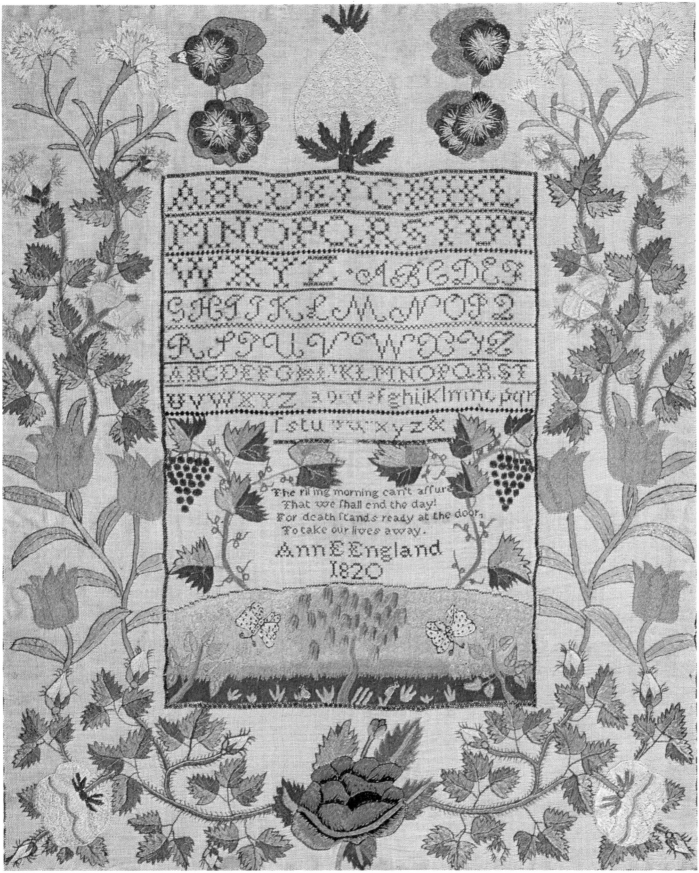

The riling morning can't assure
That we shall end the day!
For death stands ready at the door,
To take our lives away.

Ann E England
1820

80

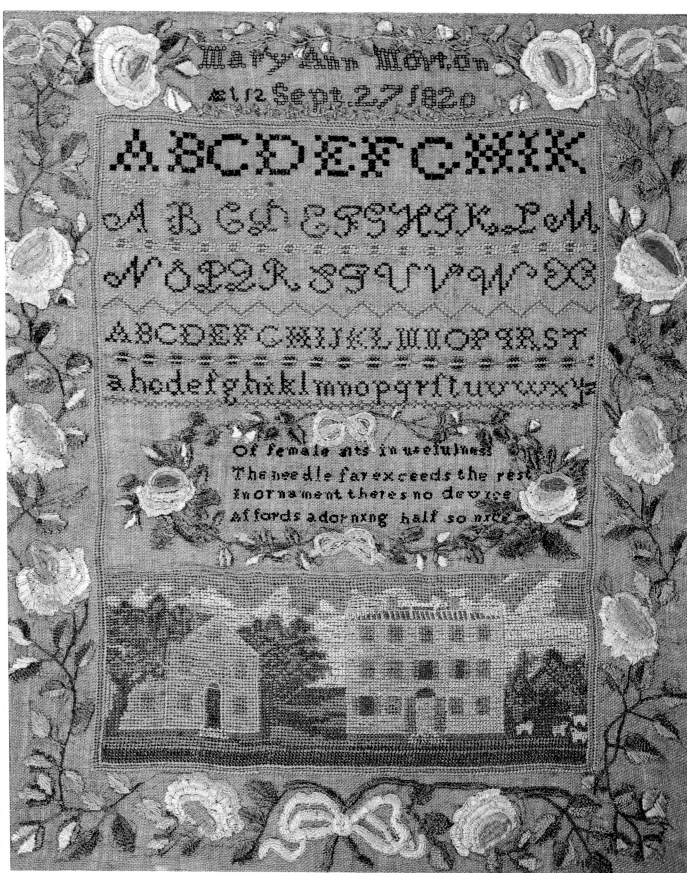

81

58

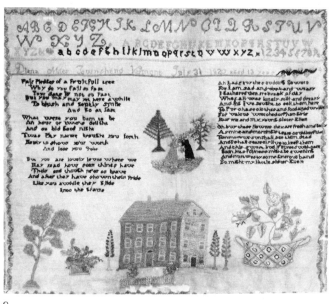

82

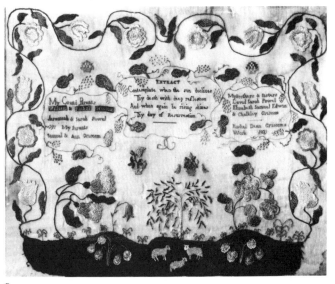

83

82. Diana Miles, Townshend, Vermont, 1820. *Inscription:* "Diana Miles Townshend Vermont July 31 1820 aged 13 years." *Stitches:* cross, stem, satin, couching. *Colors:* blackish-brown, blue, beige, salmon, shades of green. Silk on linen, 16″ h. x 18″ w.

81. Mary Ann Morton, Portland, Maine, 1820. *Inscription:* "Mary Ann Morton/AE t. 12 Sept. 27 1820." *Stitches:* cross, buttonhole, double running, chain, split, eyelet, satin, slanting Gobelin. Silk on linen, 20¼″ h. x 16¼″ w. *Note:* Another handsome sampler of this type with similar borders, buildings depicted, and stitches was made in 1819 by Sophia Dyer, aged 14, Portland, Maine.

84. Adaline M. Ferguson, Portsmouth, New Hampshire, 1822. *Inscription:* "Adaline M. Ferguson Aged . 13.years Worked at E. Waldens School March 23 . 1822." *Stitches:* cross, punch work, satin, straight, outline. Silk on linsey-woolsey, 16″ h. x 17¾″ w. *Note:* Compare the sampler of Deborah Laighton (fig. 62) of Portsmouth, 1810, for the use of a similar design, the earliest of five known examples worked between 1810 and 1832.

83. Rachel Denn Griscom, Chester County, Pennsylvania, 1821. *Inscription* (at left): "My Grand Parents/William & Rachel Griscom/Jeremiah & Sarah Powel/My Parents/Samuel & Ann Griscom"; (right): "My Brothers & Sisters/David Sarah Powel/Elizabeth Samuel Edwin/& Chalkley Griscom/Rachel Denn Griscoms Work 1821." *Stitches:* cross, outline, stem, chain, French knot, bullion, split, twisted chain, satin. *Colors:* teal blue, medium blue, cream, pale green, white, black, yellow. Silk on gauze, 17¼″ h. x 21½″ w. Rachel was born November 5, 1808, at Salem, New Jersey, but the family moved to Philadelphia about 1812. Note the design similarities to figure 78, Mary Hibberd Garrett's sampler.

85. Ann Eliza Cooper, Sag Harbor, Long Island, New York, 1822. *Inscription:* "Ann Eliza Cooper/Aged 7 Years/ Sag Harbor February the 26th/1822 A E W Tutoress." *Stitches:* cross, Oriental, French knot, chain, tent, split, daisy, buttonhole, satin, fishbone. *Colors:* tan, blue-green, rose, viridian, white, blue. Silk on linen, with face and neck areas thickly padded with silk, painted facial details, 16½″ h. x 16⅜″ w. *Note:* A E W may be the initials of Anna E. Westfall, born August 11, 1800, died March 1, 1888, at Sag Harbor.

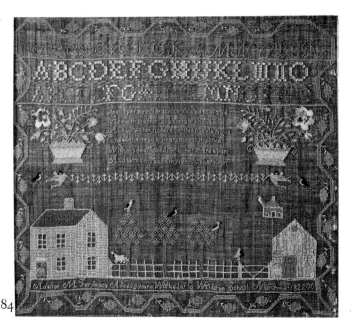

84

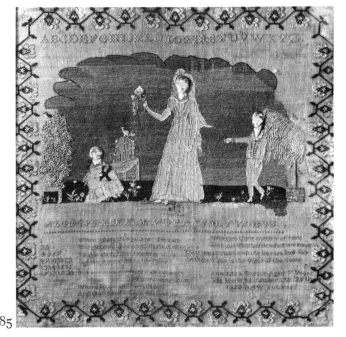

85

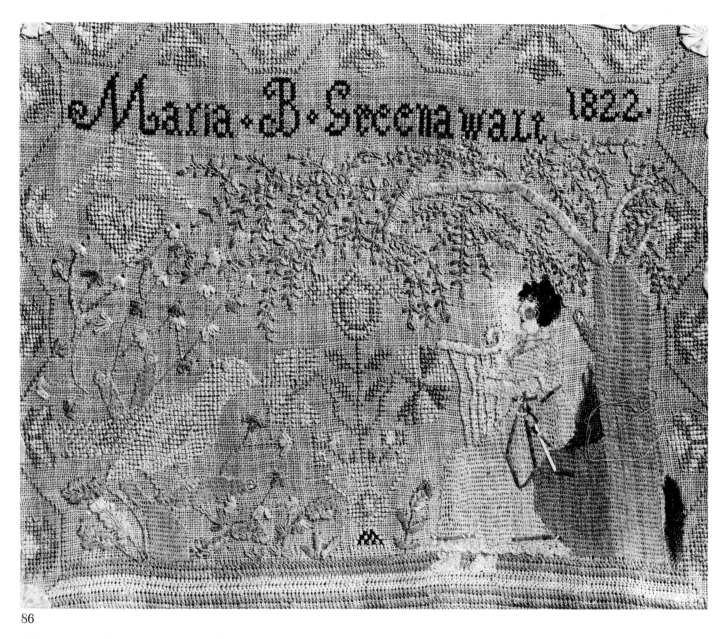

86

°86. Maria B. Greenawalt, Lehigh Valley, Pennsylvania, or Frederick County, Maryland, 1822. *Inscription:* "Maria.B. Greenawalt 1822." *Stitches:* cross, encroaching Gobelin, herringbone, satin, stem, straight, outline, daisy, French knot, couching, chain. *Colors:* pale green, cream, pale yellow, peach, medium blue, black. Silk on linen, with quilled salmon pink ribbon border and four corner rosettes, 9½" h. x 11⅜" w. Opaque painted face, white with dab of red on cheek, and black hair. Couched paper strips form a sash at the waist and decorate the hem of the harpist's dress.

°87. Elizabeth A. Thompson, New York, 1822. *Inscription:* "Executed.March ᵗʰ 30.1822. By.Miss.Elizabeth.A.Thompson. Aged.11.Years/Innocence in Youth Excels the fragrance of roses.New.York'/(in octagonal cartouche): "C.A. Cameron/ Teacher." (on plinth): "In Memory of/Charles.A.Th/ompson. Died/Jan.ʸ.19.1822/Aged.2.years.& 3 Mo.ᵗʰ." *Stitches:* cross, daisy, chain, outline. Silk on linen, 16½" h. x 17½" w.

88. Sarah Ann Hartman, Mount Holly, New Jersey, 1823. *Inscription:* "Sarah Ann Hartmans work wrought in/The sixteenth year of her age 1823./The daughter of S Hartman & Martha his wife." *Stitches:* cross, satin, straight, split, outline, back, stem. Silk on linen, 21½" h. x 24¾" w. Note the similarity of swan, rooster, and outer rose-vine motifs in this and figure 99, Martha C. Hooton's 1827 sampler. Both may have attended a local seminary or one somewhere else in Burlington county.

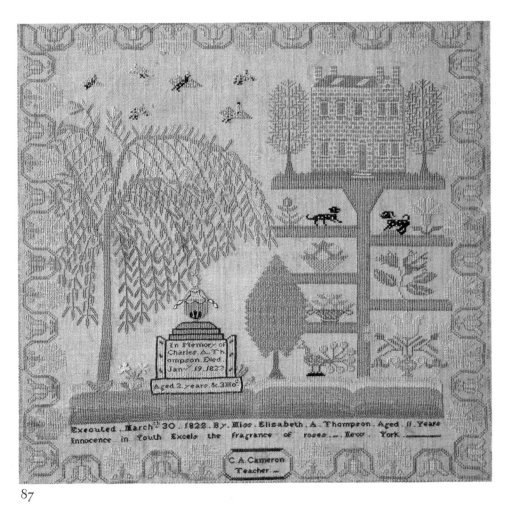

87

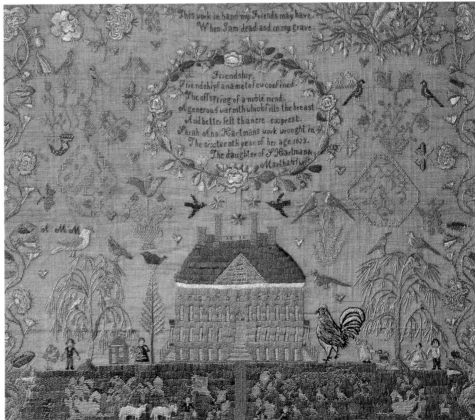

88

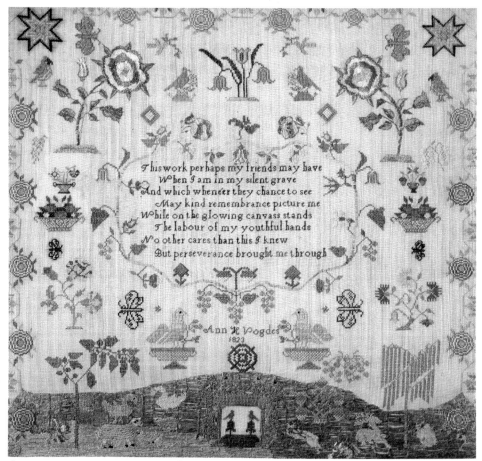

89

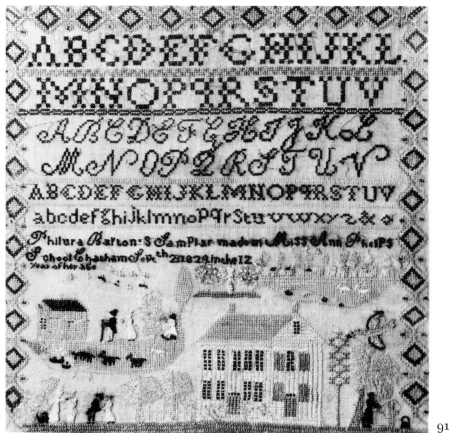

91

90

°89. Ann H. Vogdes, Willistown, Chester County, Pennsylvania, 1823. *Inscription:* "Ann H. Vogdes/ 1823." *Stitches:* rococo (queen), tent, satin, bullion, French knot, outline. Silk on linen, 23½" h. x 25½" w.

°91. Philura Barton, Chatham, Connecticut, 1824. *Inscription:* "Philura Barton's Samplar made in Miss Ann Phelps/ School Chatham Sept th 21 1824 in the 12/ year of her age." *Stitches:* cross, satin, eyelet, straight, outline. *Colors:* black, dark brown, medium green, cream, tan, ochre, gray, ultramarine blue. Silk on linen, 16" h. x 16" w. *Note:* Chatham was incorporated into Portland, Connecticut, May 1841.

°90. Mahala Marein, Harpswell, Maine, 1824. *Inscription:* "Mahala Marein Harpswell Maine 1824." *Stitches:* cross, hem, eyelet, satin, double running. Silk on linen, 16¾" h. x 17¼" w.

92

°92. Clarinda Parker, Massachusetts or New Hampshire(?),
1824. *Inscription:* "Wrought by Clarinda Parker aged 13
years August 31 Anno Domini 1824." *Stitches:* satin, straight,
cross, buttonhole, outline, Oriental. Silk on gauze, 19¼″ h.
x 22¾″ w.

°93. Eveline Freeman Wheeler, Morristown, New Jersey,
1824. *Inscription:* "August 19th 1824/ Eveline Freeman
Wheeler Age 9/ Morristown Love Peace." *Stitches:* cross,
herringbone, outline, tent, punch work, satin, straight, split,
French knot, rice. *Colors:* pale blue, soft brown, viridian,
olive green, pink, salmon, yellow, black, tan, buff. Silk on
linen, 17¼″ h. x 15½″ w. Note the padding of the female
figure at left and the blue glass bead eye of the seated figure
below.

94. Polly Giles Family Record, Groton, Massachusetts,
c. 1825. *Inscription:* "Family Record/ Wrought by P. Giles/
Groton/ Semy. Mass." *Stitches:* cross, tent. *Colors:* shades of
brown, tan, black, peach, gray, blue-green, cream, white,
ochre, rose-red, yellow-green, chrome green, red-brown,
viridian, cerulean. Silk on linen canvas, 20½″ h. x 16″ w.

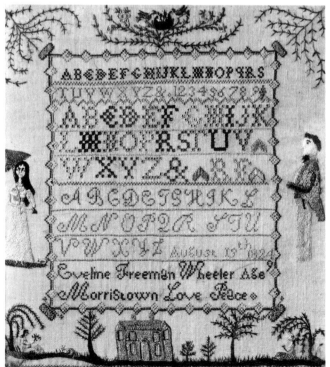

93

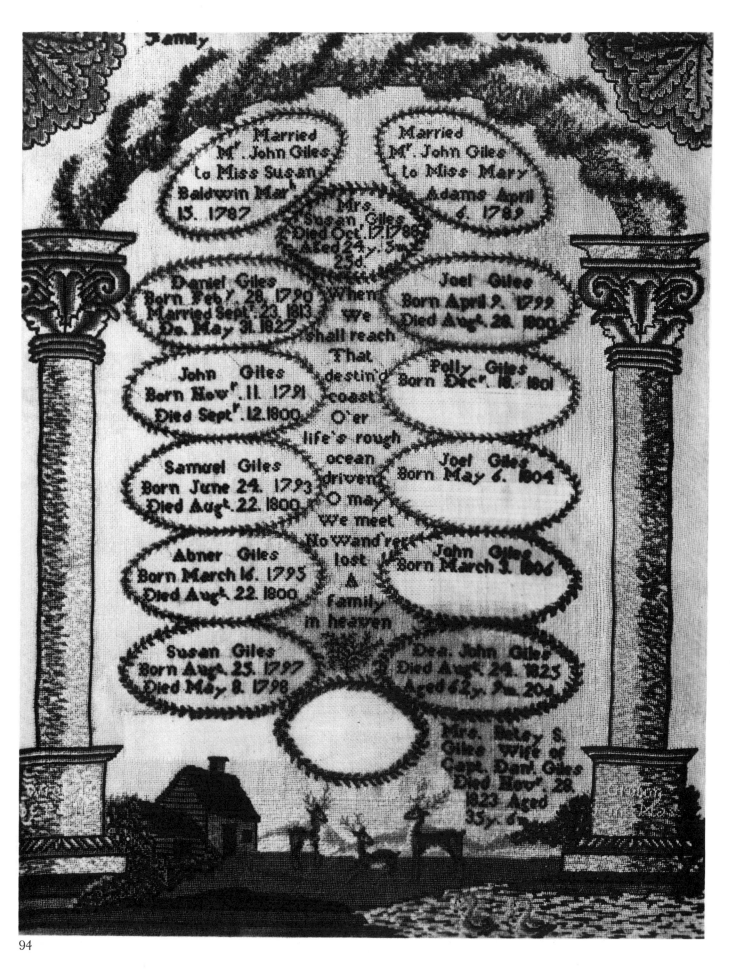

Married
Mr. John Giles
to Miss Susan
Baldwin Mar.
13. 1787

Married
Mr. John Giles
to Miss Mary
Adams April
6. 1789

Mrs.
Susan Giles
Died Oct. 17 1788
Aged 24 y. 3 m.
25 d.

Daniel Giles
Born Feby. 28. 1790
Married Sept. 23. 1813
Do. May 31. 1827

Joel Giles
Born April 2. 1799
Died Augt. 22. 1800

When
We
shall reach
That
destin'd
coast
O'er
life's rough
ocean
driven
O may
We meet
No Wand'rer
lost
A
family
in heaven

John Giles
Born Novr. 11. 1791
Died Sept. 12. 1800

Polly Giles
Born Decr. 18. 1801

Samuel Giles
Born June 24. 1793
Died Augt. 22. 1800

Joel Giles
Born May 6. 1804

Abner Giles
Born March 16. 1795
Died Augt. 22. 1800

John Giles
Born March 3. 1806

Susan Giles
Born Augt. 25. 1797
Died May 8. 1798

Dea. John Giles
Died Augt. 24. 1823
Aged 62 y. 7 m. 20 d.

Mrs. Betsy S.
Giles wife of
Capt. Danl Giles
Died Novr. 28.
1823 Aged
35 y. 6 m.

94

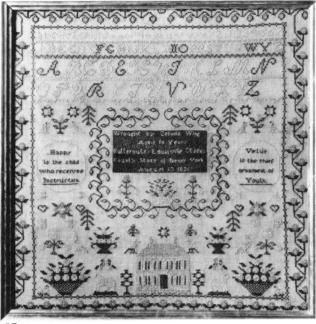

95

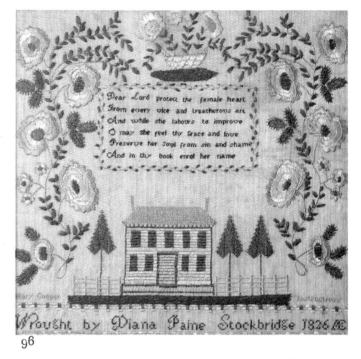

96

95. Zelinda Wing, Butternuts, New York, 1826. *Inscription:* "Wrought by Zelinda Wing/Aged 10 Years/Butternuts Louisville Otsego/County State of New York/August 13, 1826." *Stitch:* cross. *Colors:* two shades of blue-green, white, rose, pale green, dark blue, viridian. Silk on linen, 16½" h. x 16½" w.

96 and 96a. Diana Paine, Stockbridge, Massachusetts, or New York(?), 1826. *Inscription:* "Mary Cooper Instructress/Wrought by Diana Paine Stockbridge 1826 AE 9." *Stitches:* cross, tent, satin, buttonhole, split, outline, couching, slanting Gobelin. Silk on linen, 16¼" h. x 17" w.

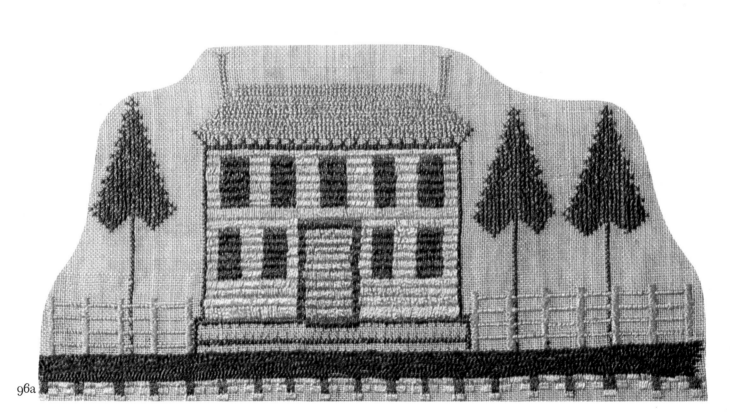

96a

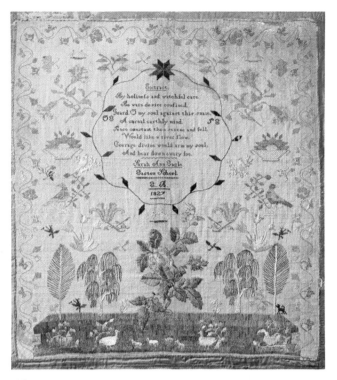

97

97 and 97a. Sarah Ann Engle, Easton, Pennsylvania, 1827.
Inscription: "Sarah Ann Engle./Easton School./E.B./1827."
Stitches: cross, split, satin, outline, encroaching satin. Silk on linen, with flat, green silk ribbon border with mitered corners, 25¼″ h. x 23″ w.

97a

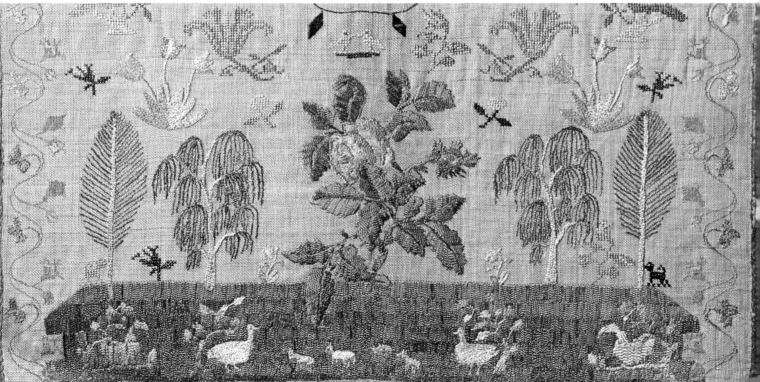

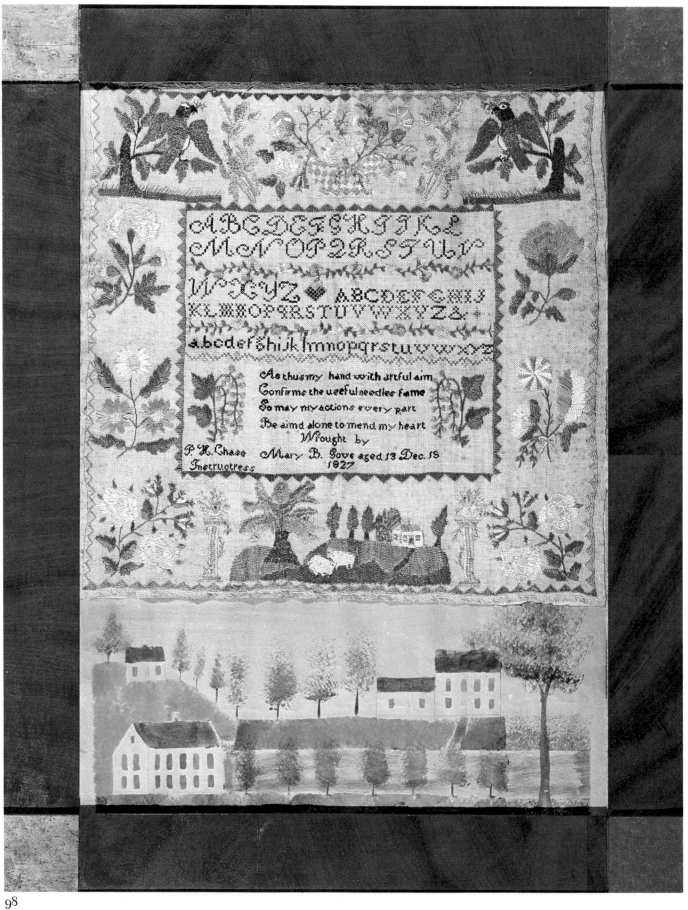

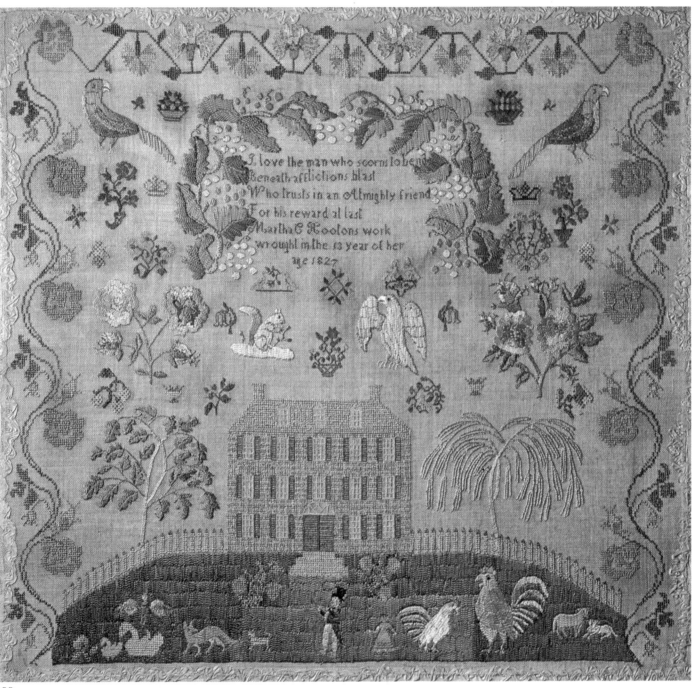

99

°99. Martha C. Hooton, probably Burlington County, New Jersey, 1827. *Inscription:* "Martha C. Hootons work / wrought in the 13 year of her / age 1827." *Stitches:* cross, stem, chain, satin, split, outline, rococo (queen). Silk on linen, with border of cream-colored quilled ribbon on four sides, 23″ h. x 23¾″ w. Ex collections Alexander W. Drake and Henry Francis du Pont.

°98. Mary Breed Gove, Weare, New Hampshire, 1827. *Inscriptions:* "Wrought by/Mary B. Gove aged 13 Dec. 15/ 1827"; (at left): "P.H. Chase/ Instructress." *Stitches:* cross, seeding, straight, satin, buttonhole, French knot, stem, outline. Silk on linen, 16″ h. x 17″ w. Watercolor landscape, 7″ h. x 17″ w. Mary B. Gove's teacher was Phebe Hoag Chase, her first cousin.

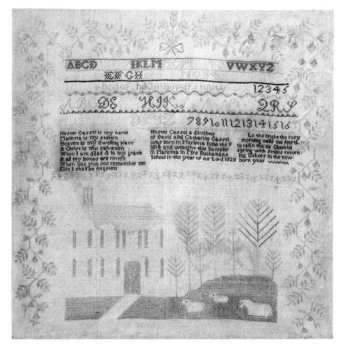

100. Mary Ann Hollinshead, Pennsylvania(?), 1827. *Inscription:* "Mary Ann Hollinshead's work wrought in the/ Fifteenth years of her age in the year of our Lord/ 1827 Under the tuition of Eleanor T. Stephens." *Stitches:* cross, rococo (queen), satin, French knot, split, encroaching satin, flat, outline. *Colors:* white, black, cream, yellow, tan, cerulean blue, viridian, two shades of olive green. Silk on linen bound with cream silk ribbon border, 17½" h. x 17" w.

°101. Hester Cassel, Marietta, Pennsylvania, 1828. *Inscription:* "Hester Cassel a daughter/ of David and Catharine Cassel/ Was born in Marietta Iune the 9/ 1814 and wrought this Sampler/ in Marietta in Mrs. Buchanan's School/ in the year of our Lord, 1828." *Stitches:* cross, rococo (queen), satin, double running, eyelet. *Colors:* white, brown, black, green, beige, pink. Silk on linen, 21" h. x 20¼" w.

102a

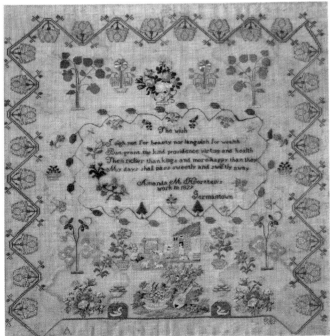

102

°102 and 102a. Amanda Malvina Hortter, Germantown, Pennsylvania, 1829. *Inscription:* "Amanda M. Hortter's/ Work in 1829/ Germantown." *Stitches:* cross, satin, chain. Silk on linen, 22″ h. x 22″ w. *Note:* Amanda Malvina was born August 8, 1818, daughter of Jacob and Anna Hortter, and was baptized in St. Michael's Church, Philadelphia, Pennsylvania.

103

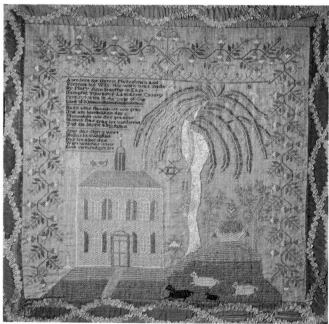

104

°103. Achsah Carter, Smithfield, Ohio, 1830. *Inscription:* "William and Ruth Carter Ann H. Thorn Preceptor/ Achsah Carter aged 10 Smithfield, Ohio 1830." *Stitches:* cross, satin, outline, tent, split, rococo (queen), long chain, Holbein (double running). Silk on linen, 21½″ h. x 22½″ w. Ex collection Mrs. Earl J. Knittle.

°104. Mary Ann Stauffer, East Hempfield, Pennsylvania, 1830. *Inscription:* "A present for Henry Musselman and/ Veronica his Wife this work was made/By Mary Ann Stauffer in East/Hampfild Township Lancaster County/Pennsylvania in the year of Our/ Lord 1830." *Stitches:* cross, rococo (queen), split, outline, satin, slanting Gobelin. Silk on linen, 23¾″ h. x 25¼″ w. Bound on four sides with flat, green silk ribbon that has on it two rows of pink silk ribbon, quilled and intertwined, then sewn down to form five ellipses on each side.

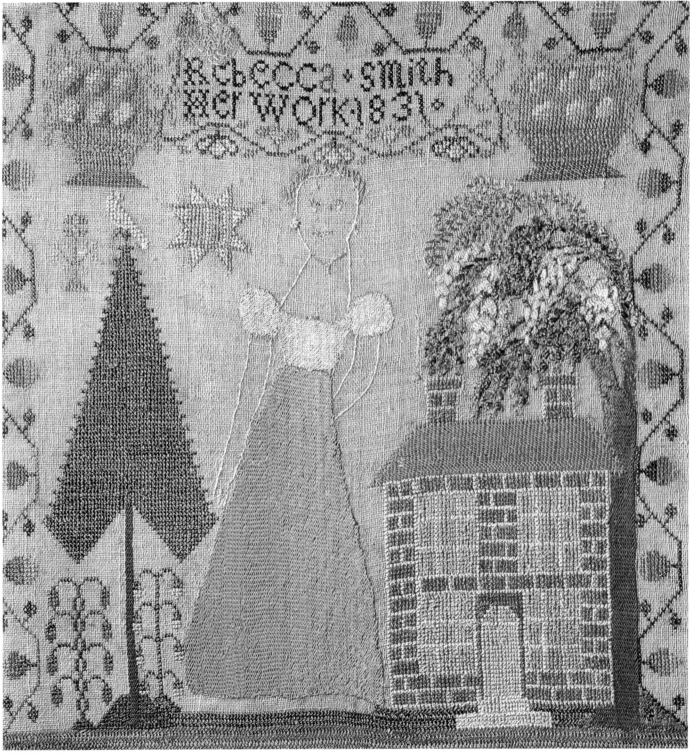

105

°105. Rebecca Smith, Pennsylvania (possibly Lancaster),
1831. *Inscription:* "Rebecca Smith/Her Work. 1831."
Stitches: cross, outline, daisy, herringbone, slanting Gobelin.
Silk on linen, 14½″ h. x 14″ w.

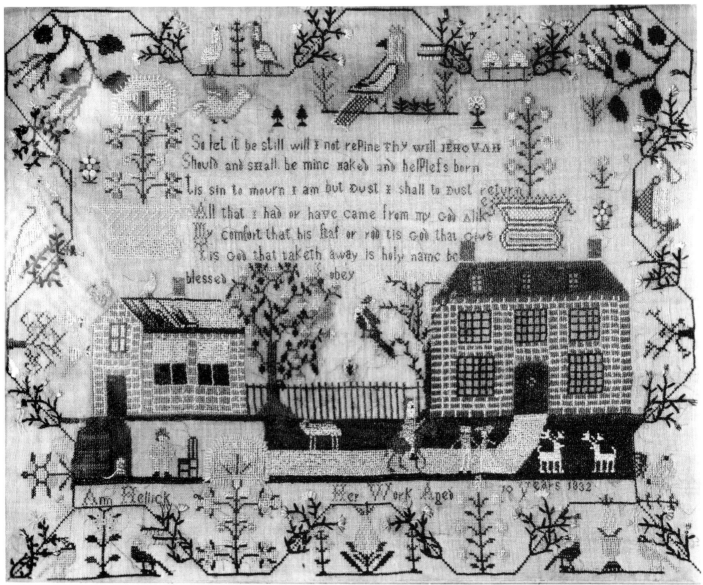

106

106. Ann Hellick, Pennsylvania or New Jersey(?), 1832.
Inscription: "Ann Hellick Her Work Aged 10 Years 1832."
Stitches: cross, satin, straight, chain, daisy. *Colors:* tan,
cream, olive, viridian, yellow, two shades of brown. Silk on
linen, 17″ h. x 21⅝″ w.

107

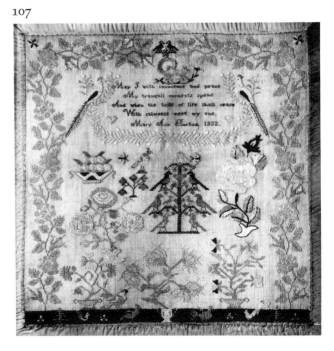

107. Mary Ann Borton, Pennsylvania, 1832. *Inscription:*
"Mary Ann Borton 1832." *Stitches:* cross, satin, outline,
straight, French knot, tent. *Colors:* viridian, ochre, cream,
white, pale green, blue-green, two shades of brown, buff,
peach, ultramarine blue, red. Silk on linen, bound with
mitered green silk ribbon binding on all four sides, 19¾″ h.
x 19¾″ w.

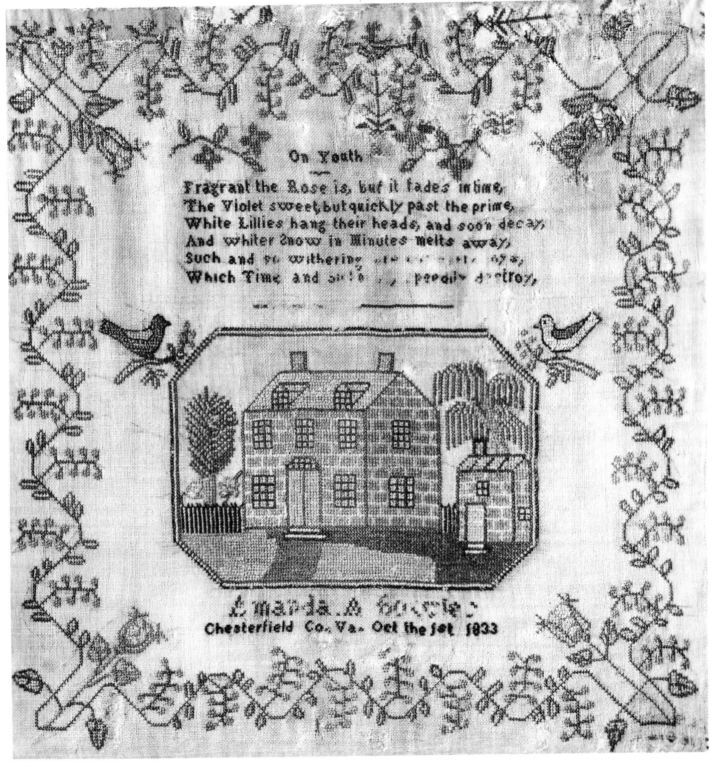

On Youth

Fragrant the Rose is, but it fades in time,
The Violet sweet, but quickly past the prime,
White Lillies hang their heads, and soon decay,
And whiter snow in Minutes melts away,
Such and so withering are our early joys,
Which Time and sickness speedily destroy,

Amanda A Bowles
Chesterfield Co. Va. Oct the ist 1833

108

108. Amanda A. Bowles, Virginia, 1833. *Inscription:*
"Amanda A. Bowles/ Chesterfield Co. Va. Oct. the ist 1833."
Stitches: cross, overcast hem. *Colors:* medium blue, yellow,
peach, green, tan, light brown, black, celery green. Silk on
linen, 17⅝″ h. x 17″ w.

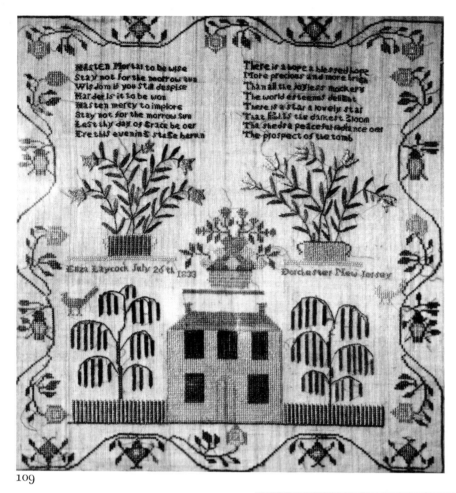

109

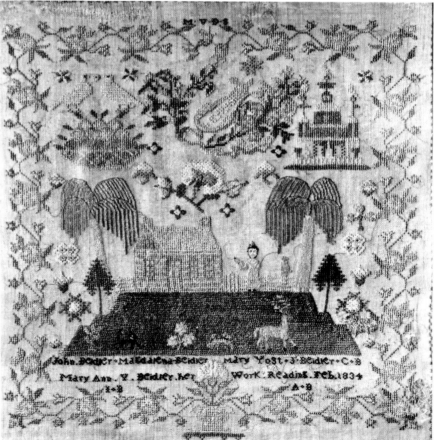

110

109. Eliza Laycock, Dorchester, New Jersey, 1833. *Inscription:* "Eliza Laycock July 26th 1833 Dorchester New Jersey." *Stitches:* cross, herringbone, outline, daisy. *Colors:* pink, rose, brown, blue-green, light blue, chrome green. Silk on linen, 17½" h. x 17½" w.

110. Mary Ann Yost Beidler, Reading, Pennsylvania, 1834. *Inscription:* "John Beidler.Magdalena Beidler Mary Yost.J. Beidler.C.B./ Mary Ann.Y. Beidler.her Work. Reading. Feb. 1834/ I.B A.B." *Stitches:* cross, rococo, straight. *Colors:* yellow, rose, lavender, cream, two shades of brown and blue, cerulean, pink, blue-green, yellow-green, medium green, two shades of tan, ultramarine blue. Silk on linen, 17¾" h. x 17½" w.

*111 and 111a. Amy Mode, Chester County, Pennsylvania, 1834. *Inscription* (left): "William Mode/Elizabeth Mode/"; (right): "Amy Mode's work in the/11th year of her age 1834"; "Hannah C. Maitland Mrs." *Stitches:* straight, cross, tent, chain, satin, daisy, rococo (queen). Silk on linen, 17⅞" h. x 20" w.

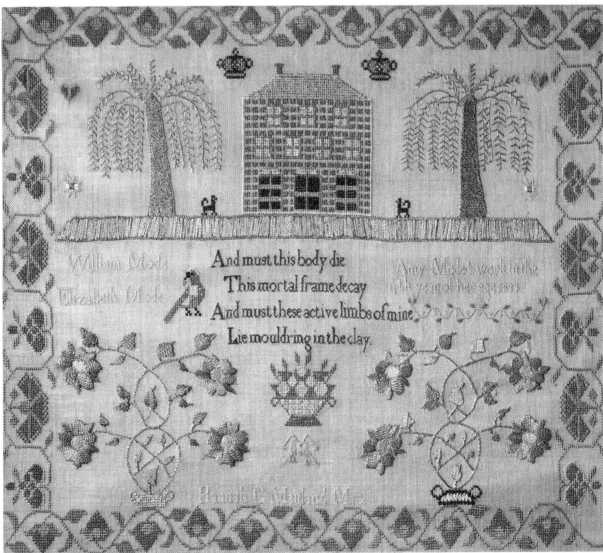

111a

111

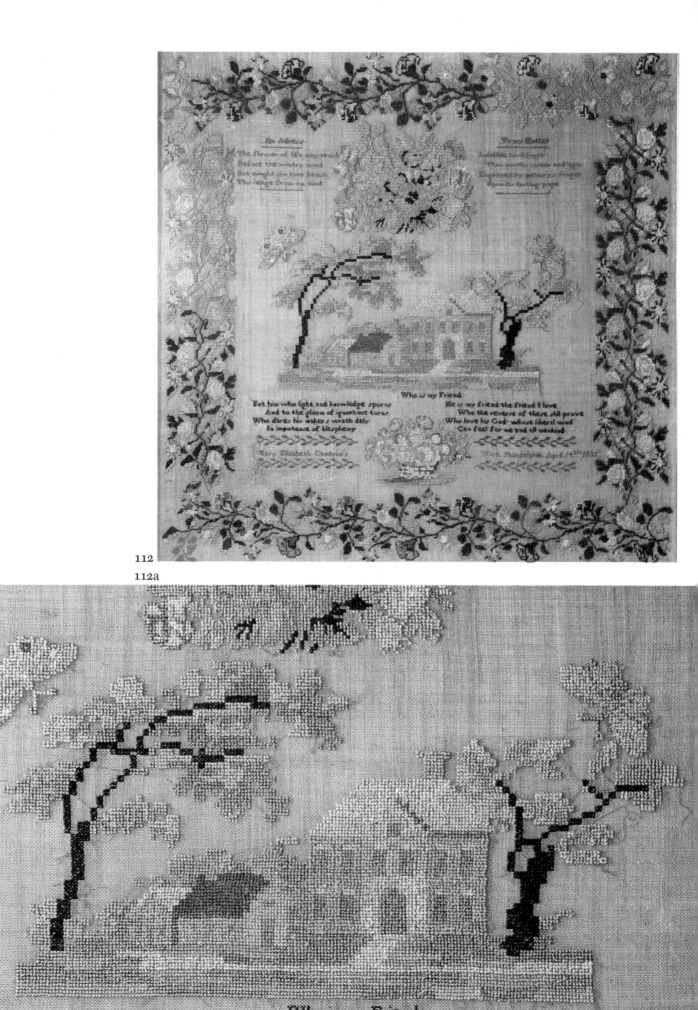

112

112a

112 and 112a. Mary Elizabeth Cameron, Philadelphia, Pennsylvania, 1835. *Inscription:* "Mary Elizabeth Cameron's Work Philadelphia April 14th 1835." *Stitch:* entirely cross-stitch. *Colors:* celery green, white, black, peach, tan, viridian, dark olive green, yellow, medium green, two shades of brown, four shades of blue. Silk on linen, 25⅛" h. x 25⅛" w.

113. Mary L. Little, Cape May, Dennis Creek, New Jersey, 1835. *Inscription:* "Mary L. Little Cape May Dennis Creek October 5th 1835." *Stitches:* cross, satin. *Colors:* brown, cream, yellow, peach, medium green (silks), rust, ochre, gray, cream (wool). Silk and wool on linen, 20½" h. x 20½" w.

113

114

114. Caroline Eliza Sayre, Newark, New Jersey, 1835. *Inscription:* "Caroline Eliza Sayre's work aged 10 yʳ / Newark New Jersey June 30th 1835." *Stitches:* cross, rococo (queen), eyelet, fine chain. *Colors:* black, brown, viridian, light green, light gray, pink, white, blue-green, medium green, cerulean, celery green, cream, rose. Silk on linen, 17" h. x 17½" w. *Note:* Three bronze-colored metal beads have been sewn on the finial caps of the stair newel posts in front of the building depicted. Caroline E. Sayre was born June 11, 1824.

115

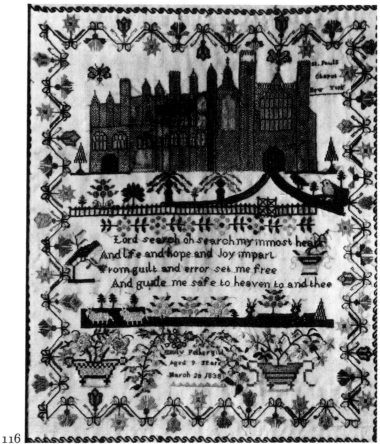

116

115. Rebecca Sowers, Lebanon, Pennsylvania, c. 1836. *Inscription:* "Rebecca Sowers Work Born on the/ 13th December 1824 Lebanon Penn." *Stitches:* cross, satin, rice, daisy. *Colors:* cream, brown, dark green, pale blue, brick red, tan, blue-green. Silk on linen, 16¼" h. x 16¾" w. Note the two remaining pink silk ribbon rosettes.

116. Emily Fothergill, New York, 1838. *Inscription:* "Emily Fothergill/Aged 9 Years/March 20 1838." *Stitches:* cross, satin, straight, eyelet, outline, chain. *Colors:* crimson, blue, olive green, brown, viridian, medium green, pale pink, cream, Prussian blue, yellow, light brown. Silk on wool, 12¾" h. x 15¾" w. Saint Paul's Chapel, New York, is shown, complete with label, above the verse.

117 and 117a. Ann Amelia Mathilda Borden, possibly Pennsylvania, 1839. *Inscription:* "Ann Amelia Mathilda Borden was born Jan.1. Year. 1825./mark'd this in 1839." *Stitches:* cross, flat, satin, buttonhole, tent, rococo, seed, outline, straight, herringbone. *Colors:* rose-red, bright pink, olive, pale blue, green, viridian, cream, dark brown, russet, yellow, orange, red-orange, lavender. Wool and silk on linen, 16¾" h. x 16¾" w.

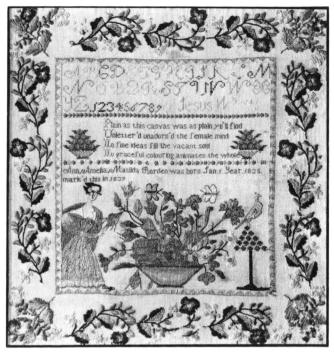

117

117a

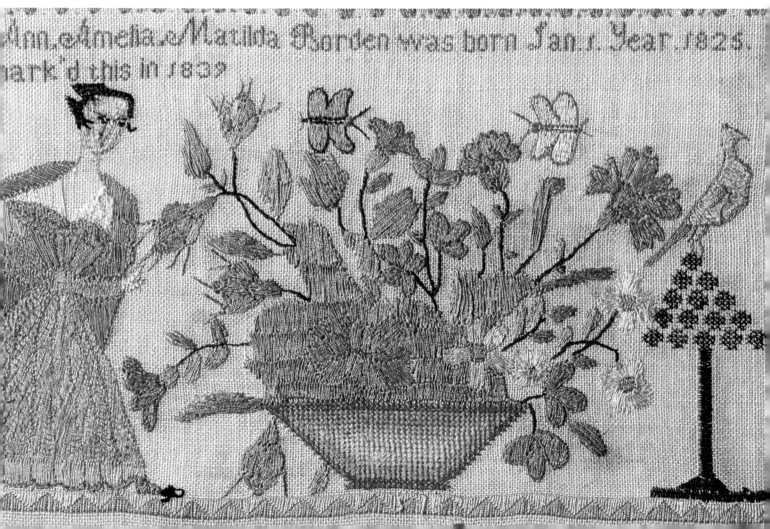

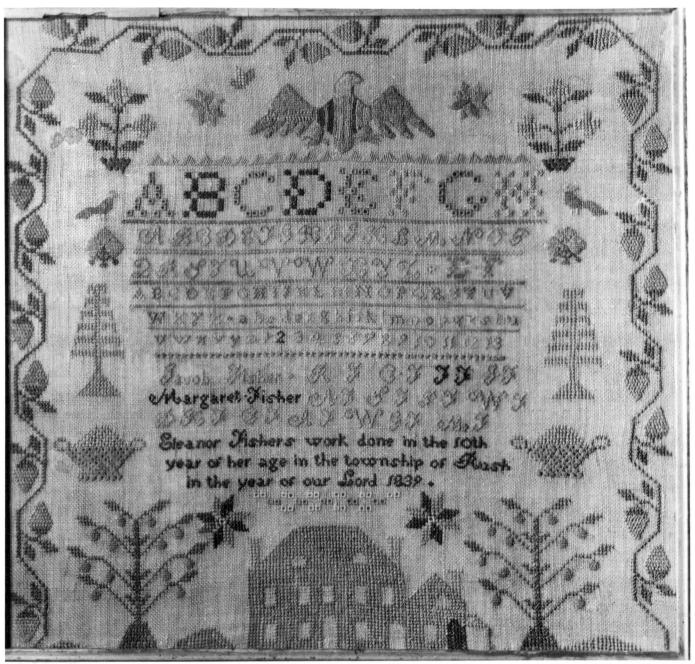

118. Eleanor Fisher, Rush, Pennsylvania, 1839. *Inscription:* "Eleanor Fishers work done in the 10th/ year of her age in the township of Rush/ in the year of our Lord 1839." *Stitches:* cross, rococo (queen), eyelet, rice, satin, double running, long-armed cross, outline, herringbone. *Colors:* pale blue, peach, lavender, tan, cream, brown, ochre, teal blue, medium chrome green, pale olive green. Silk and cotton(?) on linen, 15¾″ h. x 16½″ w.

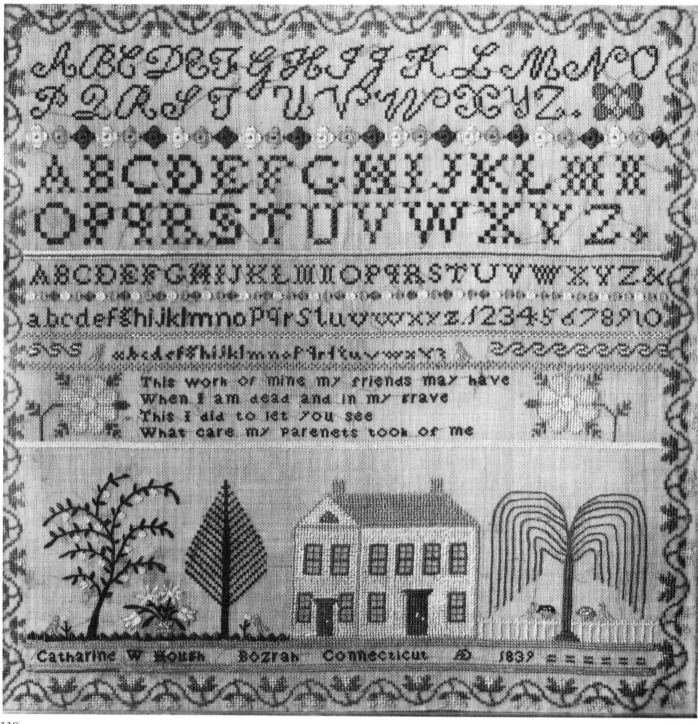

119

119. Catharine Westcot Hough, Bozrah, Connecticut, 1839.
Inscription: "Catharine W. Hough Bozrah, Connecticut AD
1839." *Stitches:* cross, eyelet, herringbone, daisy, outline,
French knot, rococo, long-armed cross. *Colors:* cream, yel-
low, red, two shades of brown, medium chrome green, tan,
pale green. Silk on linen, 17½″ h. x 17¼″ w. *Note:* Catha-
rine, daughter of William and Philena Hough, born May 14,
1825.

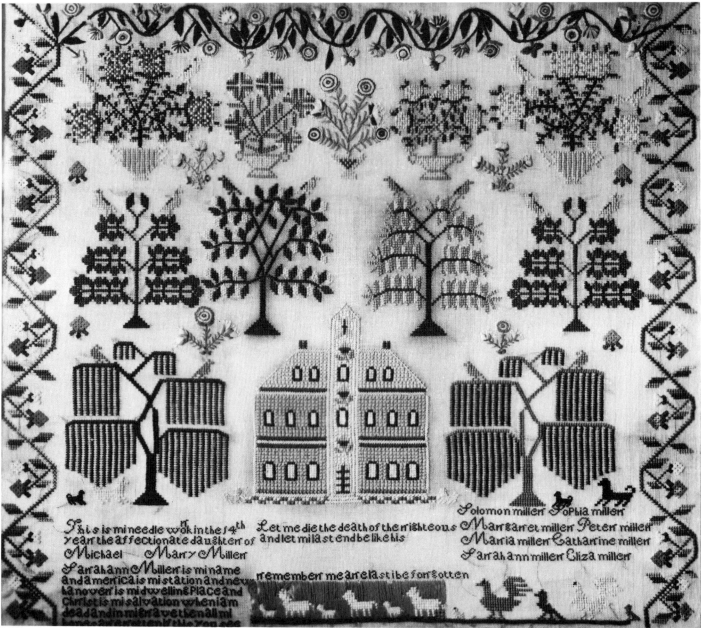

120

120. Sarah Ann Miller, New Hanover, Montgomery County, Pennsylvania, c. 1840. *Inscription:* "This is mi needle woʳk in the 14ᵗʰ/year the affectionate daughter of/Michael Mary Miller/Sarah ann Miller is mi name/and america is mi station and new hanover is mi dwelling Place and/Christ is mi salvation when i am/dead and in mi grave then all mi/bones are rotten if this you see/remember me are ia stibe forgotten: Family Names: Solomon miller Sophia miller/Margaret miller Peter miller/ Maria miller Catharine miller/Sarah ann miller Eliza miller/." *Stitches:* cross, rococo (queen), stem, satin, straight. *Colors:* pale blue, red, ochre, khaki, pale pink, peach, black, rust, blue-green, two shades of brown. Wool with silk on canvas, 22¼" h. x 26" w.

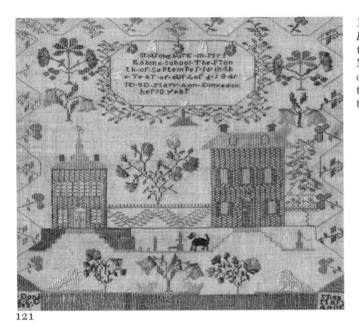

121

121. Mary Ann Dinyes, Stouchsburg, Pennsylvania, 1841. *Inscription:* "StoUchsburg.in.Mrs/Robins.School.The.Mon/th.of.Septemper.15.in.th/e.Year.of.oUr.Lord,1841/JD.SD. Mary Ann Dinyes.in/her 10 year." *Stitches:* cross, satin. Silk on linen, with five pale blue silk ribbons attached to cartouche where inscription is, 15½″ h. x 17¾″ w. Ex collection Mr. and Mrs. Paul F. Flack.

°122. Mary Butz, Kutztown, Pennsylvania, 1842. *Inscription:* "Mary Butz/her Work/In 1842." *Stitches:* cross, tent. Wool, with silk (inscription) on linen, 17¼″ h. x 24⅛″ w. *Note:* Red sketch lines are visible below wool embroidery.

122

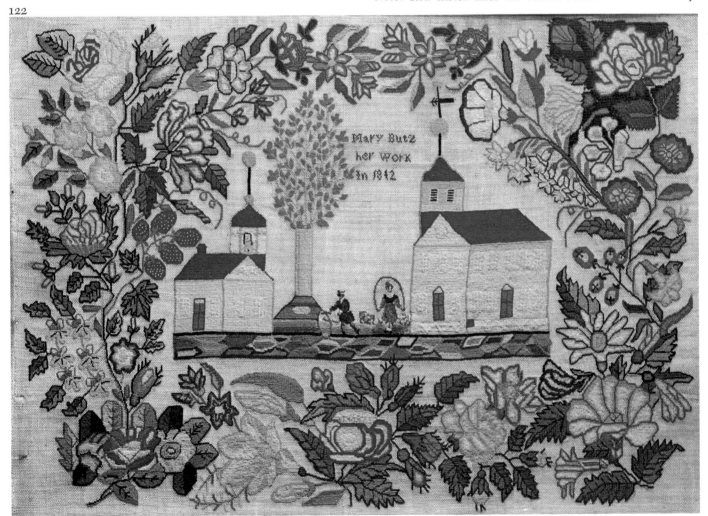

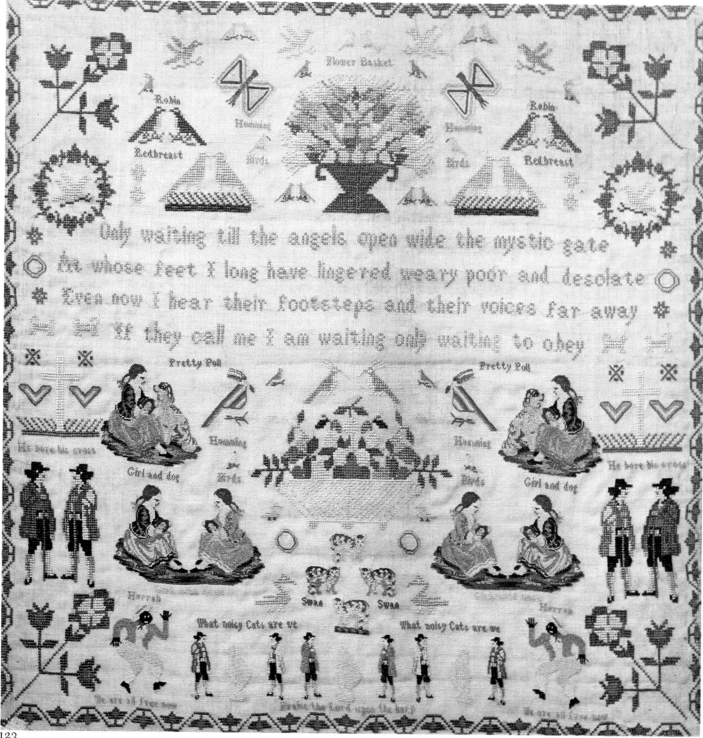

123

123. Elizabeth Jane Hawkes, Salem, North Carolina, c. 1865.
Inscription: "Elizabeth Jane Hawkes aged 13 Salem, North
Carolina." Originally noted on former frame. *Stitches:* cross,
tent. Silk on wool, 12¾" h. x 12¾" w.

124

124 and 124a. Mary Lou Hawkes, Salem, North Carolina, c. 1865. *Inscription:* "Mary Lou Hawkes aged 12 years Salem, North Carolina." Originally noted on former frame. *Stitches:* cross, tent. Silk on wool, 12¾″ h. x 12¾″ w.

124a

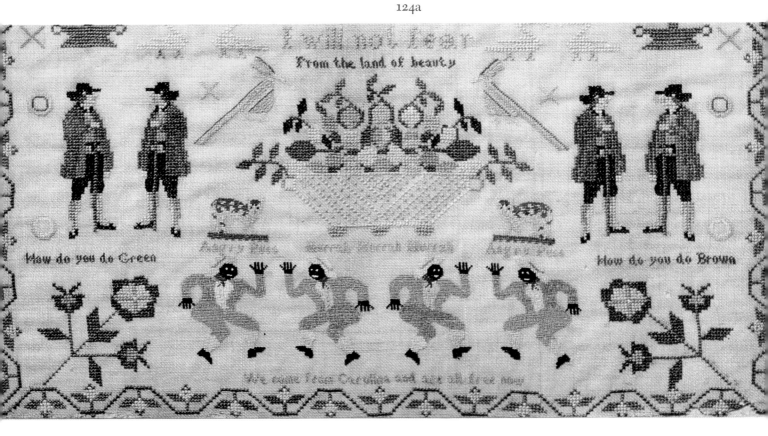

NOTES

1. Anna-Maja Nylén, *Swedish Handcraft,* trans, Anne-Charlotte Hanes Harvey (New York: Van Nostrand Reinhold, 1977), pp. 211–217; Donald King, *Samplers* (London: The Victoria and Albert Museum, 1960), pp. 3–9; pls. 20, 24, 30; Averil Colby, *Samplers* (Newton Centre, Mass.: Charles T. Branford, 1965), pp. 17–30; Arthur Lotz, *Bibliographie der Modelbücher* (Leipzig: Karl W. Hiersemann, 1933); Hope Hanley, *Needlepoint in America* (New York: Charles Scribner's Sons, 1969), pp. 15–19; Rosina Helena Fürst, *Das Neüe Modelbuch von Schönen Nädereyen Ladengewürck und Paterleinsarbeit* (Nürnberg: Bey Paülüs Fürsten, 1666), pl. LIX.

2. Nylén, *Swedish Handcraft,* p. 214.

3. Colby, *Samplers,* p. 20.

4. King, *Samplers,* p. 7.

5. Barbara C. Holdridge and Lawrence B. Holdridge, *Ammi Phillips: Portrait Painter 1788–1865* (New York: Clarkson N. Potter, for the Museum of American Folk Art, 1969), p. 50, no. 198, p. 19.

6. John Palsgrave, *Lesclarcissement de la Langue Francoyse,* 1530, as quoted in Averil Colby, *Samplers,* p. 17; Donald King, *Samplers,* p. 2.

7. Samuel Johnson, *A Dictionary of the English Language,* V (London, 1799 ed.).

8. Noah Webster, *A Compendious Dictionary of the English Language* (Hartford, Conn., 1806), p. 265.

9. John Walker, *A Critical Pronouncing Dictionary, and Expositor of the English Language* (Philadelphia: Benjamin Warner and William Bradford, 1822), p. 317.

10. John Walker, *A Critical Pronouncing Dictionary, and Expositor of the English Language* (New London, Conn.: W. & J. Bolles, 1836), p. 465.

11. J. D. Mayorcas, "English Stumpwork," *Connoisseur* (April 1975), pp. 254–259; fig. 2, p. 255; Margaret H. Swain, *Historical Needlework: A Study of Influences in Scotland and Northern England* (New York: Charles Scribner's Sons, 1970), pp. 64–65, 79.

12. Rita Susswein Gottesman, comp., *The Arts and Crafts in New York 1726–1776,* 3 vols. (New York: The New-York Historical Society, 1938–1965), I (1938), p. 277.

13. J. H. Plumb, "America and England: 1720–1820 The Fusion of Cultures," *American Art: 1750–1800 Towards Independence,* Charles F. Montgomery and Patricia E. Kane, eds. (Boston: New York Graphic Society for Yale University Art Gallery and The Victoria and Albert Museum, London, 1976), p. 16.

14. *Connecticut Mirror,* December 18, 1826; *Providence Patriot and Columbian Phenix,* April 12, 19, 1826.

15. *Connecticut Courant,* July 6, 1808.

16. Jonathan Tucker, "Old Schools and School-Teachers of Salem," *Historical Collections of the Essex Institute,* 7 (Salem, December 1865), pp. 241–243.

17. *Massachusetts Gazette and the Boston Weekly News-Letter,* January 14, 28; March 25, 1773.

18. *Salem Gazette,* May 15, 22, 25, 29; June 1, 8, 1798.

19. *Virginia Gazette,* December 16, 1773, as quoted in Julia Cherry Spruill, *Women's Life and Work in the Southern Colonies* (Chapel Hill, N.C.: The University of North Carolina Press, 1938; reprint ed., New York: W. W. Norton, 1972), pp. 269, 274.

20. *The Newport Mercury,* September 20, 27; October 4, 1773.

21. Diary of William Bentley, D.D. II (Salem, Mass.: Essex Institute, 1907), p. 25; Robert Francis Seybolt, *The Private Schools of Colonial Boston* (Cambridge, Mass.: Harvard University Press, 1935; reprint ed., New York: Arno Press and The New York Times, 1969), p. 11.

22. *Providence Gazette,* April 2, 1808; March 10, 17, 1810; March 9, 16, 1811; *The Providence Gazette and Country Journal,* January 2, April 3, September 11, 1813; September 10, 17, 1814; *Rhode Island American and General Advertiser,* April 21, 1815; March 12, 16, 19, 23, 1819.

23. A.L.S. of James Howard to his sister Lucy at Providence, Rhode Island, July 17, 26, 1805 (Private collection).

24. *Oracle of Dauphin and Harrisburgh Advertiser,* August 7, 14, 21, 28, 1799.

25. William C. Reichel and William H. Bigler, *A History of the Rise, Progress, and Present Condition of the Moravian Seminary for Young Ladies, at Bethlehem, Pennsylvania with a Catalogue of Its Pupils 1785–1858,* 2d ed. (Philadelphia: J.B. Lippincott, 1870), pp. 18, 20, 29; Thomas Woody, *A History of Women's Education in the United States,* 2 vols. (Lancaster, Pa.: Science Press Printing Co., 1929), p. 216; Margaret Berwind Schiffer, *Historical Needlework of Pennsylvania,* (New York: Charles Scribner's Sons, 1968), p. 105.

26. Reichel and Bigler, *A History of the Rise, Progress, and Present Condition of the Moravian Seminary for Young Ladies,* p. 111; quoted in Schiffer, *Historical Needlework of Pennsylvania,* p. 107.

27. Reichel and Bigler, *A History of the Rise, Progress, and Present Condition of the Moravian Seminary for Young Ladies,* p. 326.

28. *Ibid.,* pp. 79–81.

29. Watson W. Dewees, *A Brief History of Westtown Boarding School with a General Catalogue of Officers, Students, Etc.,* 3rd ed. (Philadelphia: Watson W. Dewees, 1884), pp. xi, xii.

30 *Ibid.,* p. 22.

31. Helen G. Hole, *Westtown Through the Years 1799–1942* (Westtown, Pa.: Westtown Alumni Association, 1942), pp. 100–101: examination of the darning sampler of "Hannah Nixon West Town 1817," and verification of others with Mrs. Doris Ashley, Conservator of Textiles, Philadelphia Museum of Art.

32. *Ibid.,* p. 347.

33. Susanna Smedley, comp., *Catalog of Westtown Through the Years, Officers, Students, and Others Fifth Month 1799 to Fifth Month 1945* (Westtown, Pa.: Westtown Alumni Association, 1945), p. 351.

34. *Ibid.,* p. 354.

35. Hole, *Westtown Through the Years,* pp. 172, 371.

36. Charles C. Andrews, *The History of the New York African Free-Schools, from their Establishment in 1787, to the Present Time* (New York: Mahlon Day, 1830; reprint ed., New York: Negro Universities Press, 1969), pp. 7–21.

37. *Ibid.,* p. 21.

38. *Ibid.,* p. 42.

39. *Ibid.,* p. 43.

40. William Oland Bourne, *History of The Public School Society of the City of New York . . .* (New York: George P. Putnam's Sons, 1873), p. 2.

41. *Ibid.,* p. 654.

42. *Ibid.*

43. *Ibid.,* pp. 654–655.

44. *Ibid.,* pp. 532, 656, 657.

45. *New-York Gazette and the Weekly Mercury,* April 16, 1770; quoted in Gottesman, comp., *The Arts and Crafts in New York 1726–1776,* I (1938), p. 279.

46. *Boston News-Letter,* July 2, 1772; quoted in George Francis Dow, comp., *Arts and Crafts in New England 1704–1775* (Topsfield, Mass.: The Wayside Press, 1927; reprint ed., New York: Da Capo Press, 1967), p. 276.

47. *Providence Gazette,* April 2, 1808, February 4, 1809, January 2, 1813, April 3, 1813, September 10, 1814.

48. *Columbian Centinel,* June 21, 1826, April 1, 1818, April 18, 1821.

49. A.L.S. of Benjamin Tallmadge of Litchfield, Connecticut, to the Hon. John Cushman, March 30, 1823. Litchfield Historical Society.

50. *The Newport Mercury,* January 18–25, 1768.

51. Francis G. Payne, *Guide to the Collections of Samplers and Embroideries* (Cardiff, Wales: National Museum of Wales and the Press Board of the University of Wales, 1939), p. 30; quoted in Colby, *Samplers,* p. 186.

52. George Fisher, *The Instructor, or American Young Man's Best Companion, Improved* (Philadelphia: John Bioren, 1812), p. 293; Isabel B. Wingate, ed., *Fairchild's Dictionary of Textiles* (New York: Fairchild Publications, 1970), pp. 590, 591; William Little, H. W. Fowler, and J. Coulson, C. T. Onions, comps., C. T. Onions, ed., *The Oxford Universal Dictionary on Historical Principles* (Oxford: Oxford University Press, 1955), p. 2,191; N. Bailey, *An Universal Etymological English Dictionary,* 16th ed. (London, 1755), unpaged.

53. David Park Curry, *Stitches in Time, Samplers in the Museum's Collection* (Lawrence, Kan.: The University of Kansas Museum of Art, 1975), fig. 35.

54. Glee F. Krueger, *New England Samplers to 1840* (Sturbridge, Mass.: Old Sturbridge, Inc., forthcoming).

55. Correspondence with the late Dr. Harold B. Burnham, Curator of the Textile Department of the Royal Ontario Museum, Toronto, Canada; examination of St. John's New Brunswick sampler (author's collection).

56. Correspondence with Mrs. Averil Colby, Langford, Bristol, England, who consulted Miss Santina Levey of The Victoria and Albert Museum for verification of fiber grounds in the collection.

57. Notes from exhibition at the Connecticut Historical Society; Cora Ginsburg, "Textiles in the Connecticut Historical Society," *Antiques*, 107 (April 1975), pp. 712–725, fig. 10.

58. Unpublished notes taken at the Valentine Museum, Richmond, Virginia, June 3, 1977. *Homes* is the way the child spelled it on the sampler.

59. Rita J. Adrosko, *Natural Dyes in the United States*, United States National Bulletin 281 (Washington, D.C.: Smithsonian Institution Press, 1968), p. 3.

60. *Ibid.*, p. 13.

61. *Ibid.*, p. 8.

62. *Ibid.*, p. 24.

63. *Ibid.*

64. *Ibid.*, p. 15.

65. *Ibid.*, p. 32.

66. Martha Genung Stearns, "Family Dyeing in Colonial New England," *Plants and Gardens*, 20, Brooklyn, N.Y.: Brooklyn Botanic Garden (December 1964), pp. 77–82.

67. Rose T. Briggs, "Plymouth Colony's Dye Plants," *Plants and Gardens*, 20, Brooklyn, N.Y.: Brooklyn Botanic Garden (December 1964), pp. 92–94.

68. George Fisher, *The American Instructor or, Young Man's Best Companion* (Philadelphia: B. Franklin and D. Hall, 1748), pp. 251–253.

69. F. G. Comstock, *A Practical Treatise on the Culture of Silk, Adapted to the Soil and Climate of the United States* (Hartford, Conn.: P.B. Gleason, 1839), pp. 89–93.

70. Krueger, *New England Samplers to 1840*, forthcoming.

71. Jonathan Fairbanks *et al.*, *Paul Revere's Boston: 1735–1818* (Boston: Museum of Fine Arts, 1976), pp. 60–61.

72. Ethel S. Bolton and Eva J. Coe, *American Samplers* (Boston: The Massachusetts Society of Colonial Dames of America, 1921), p. 367, pls. XL, XLI, XCIX; Betty Ring, "The Balch School in Providence, Rhode Island," *Antiques* (April 1975), fig. 5, p. 665, pl. V, p. 666, figs. 6, 7, p. 668; Judith K. Grow and Elizabeth G. McGrail, *Creating Historic Samplers* (Princeton, N.J.: The Pyne Press, 1974), fig. 3, p. 23; Susan Burrows Swan, *A Winterthur Guide to American Needlework* (New York: Crown Publishers, 1975), pl. II, p. 34; Susan Burrows Swan, *Plain and Fancy, American Women and Their Needlework, 1700–1850* (New York: Holt, Rinehart & Winston, 1977), fig. 16, p. 42; Krueger, *New England Samplers to 1840*, forthcoming.

73. Bolton and Coe, *American Samplers*, pls. LXII, LXIII, LXIV, LXV, LXVI; Georgiana Brown Harbeson, *American Needlework* (New York: Coward-McCann, 1938; reprint ed., New York: Bonanza Books, n.d.), p. 88, figs. 1, 2 facing p. 91; Hilda Kassell, *Stitches in Time, The Art and History of Embroidery* (New York: Duell, Sloan & Pearce, 1966), pp. 16–18; Schiffer, *Historical Needlework of Pennsylvania*, p. 52; Elizabeth Donaghy Garrett, "American Samplers and Needlework Pictures in the DAR Museum, Part I: 1739–1806," *Antiques* 105 (February 1974), fig. 10, p. 363; Elizabeth Donaghy Garrett, "American Samplers and Needlework Pictures in the DAR Museum, Part II: 1806–1840," *Antiques*, 107 (April 1975), pp. 695, 696, fig. 10, p. 699, figs. 11, 12, p. 700; Betty Ring, "Saint Joseph's Academy in Needlework Pictures," *Antiques*, 113 (March 1978), pl. II, p. 594; Krueger, *New England Samplers to 1840*, forthcoming.

74. *The American Weekly Mercury*, May 16–23, 1723; quoted in Thomas Woody, *A History of Women's Education in the United States* (Lancaster, Pa.: Science Press Printing Co., 1929), II, p. 223.

75. Samuel Kriebel Brecht, ed., *The Genealogical Record of the Schwenkfelder Families . . .* (Pennsburg, Pa.: The Board of Publication of the Schwenkfelder Church, 1923), pp. 1,558–1,559; *Pennsylvania Folk Art*, October 20–December 1, 1974 (Allentown, Pa.: Allentown Art Museum, 1974), no. 114, p. 41.

76. George Fisher, *The Instructor: or Young Man's Best Companion* (London: J. Fuller[?], W. Strahan, J. and E. Livingston, R. Baldwin, E. Johnston, E. Hawes, & Co., T. Caslon, G. Robinson, W. Woo——, W. Domville, and B. Collins, 1775), pp. 360–363; George Fisher, *The Instructor, or, Young Man's Best Companion* (Edinburgh: Gavin Alston, 1763), marking table in front of p. 313 per A.L.S. March 7, 1977, of Mr. Antony P. Shearman; George Fisher, *The Instructor; or, Young Man's Best Companion* (Edinburgh: Alexander Donaldson, 1773), table II, between pp. 316 and 317, p. 355.

77. George Fisher, *The American Instructor: or, Young Man's Best Companion* (1748), pp. 251–253; George Fisher, *The American Instructor: or, Young Man's Best Companion* (Philadelphia: B. Franklin and D. Hall, 1753), pp. 251–253.

78. George Fisher, *The American Instructor: or, Young Man's Best Companion* (Worcester, Mass.: I. Thomas; Boston: J. Boyle, E. Battelle, W. Green, B. Larkin, and J. Condy, 1785), pp. 373–375.

79. David McNeeley Stauffer, *American Engravers Upon Copper and Steel*, Part II (New York: The Grolier Club of the City of New York, 1907), no. 204, p. 37.

80. Fürst, *Das Neüe Modelbuch von Schönen Näderéyen*, pl. LIX; King, *Samplers*, p. 8, fig. 65; Nylén, *Swedish Handcraft*, p. 215; Ulrich Thieme and Felix Becker, *Allgemeines Lexikon der Bildenden Künstler von der Antike bis zur Gegenwart*, 12 (Leipzig: E. A. Seaman, 1930); translations of the Fürst book are the work of Dr. Christa Sammons, Librarian, Yale University Collections of German Literature and Professor George Schoolfield, Department of German, Yale University.

APPENDIX 1

Additional information about the samplers.

13. Sarah Stone, 1678. The arcaded clusters of grapes, Tudor rose, acorn, and S-form motifs used in horizontal bands are typical of early work abroad and are retained in American seventeenth- and early eighteenth-century work. English counterparts are illustrated in Donald King, *Samplers* (London: The Victoria and Albert Museum, 1960), figs. 11, 14.

15. Sarah Frishmuth, 1743. In contrast to figure 16, this sampler is almost square and has a sparse, modern appearance, as if it had been worked in the nineteenth century. It exhibits careful workmanship and uncluttered design.

16. Elizabeth Hext, 1743. Mary Hext advertised again in *The South-Carolina Gazette*, August 6–15, 15–22, 1741, "that young Misses might be boarded and taught Needle Work, of all sorts. This is also to give Notice, that for the Benefit of such Misses as their Parents shall think proper to board with the said Mary Hext, that Writing, Arithmetick, Dancing and Musick is also taught by Masters well qualified, who give due Attendance in the same House of Colonel Samuel Prioleau to Friend street, Charles-Town." It is likely that Elizabeth Hext was a pupil at this school, as it was conducted either in the house of her older sister, Providence, who was married to Colonel Samuel Prioleau II, or in the house of Providence's father-in-law, Colonel Samuel Prioleau. Both lived on Friend Street, today known as Legare. See Julia Cherry Spruill, *Women's Life and Work in the Southern Colonies* (Chapel Hill, N.C.: The University of North Carolina Press, 1938; reprint ed., New York: W.W. Norton, 1972), p. 198; A. S. Salley, Jr., "Hugh Hext and Some of His Descendants," *The South Carolina Historical and Genealogical Magazine* (Charleston, S.C.: South Carolina Historical Society, 1905), pp. 29–40; Correspondence with Mrs. James Alva Burkette, see Genealogical Notes.

17. Hannah Church, 1747. A number of Boston samplers of this period display the Spies of Canaan, Joshua and Caleb, here executed frontally, and in the work of Hannah Storer (1747) in the collection of the Massachusetts Historical

Society, and the work of Sarah Lowell (1750) in the author's collection. The mystic bunch of grapes they carry symbolize Christ. This motif was used in English and Continental work as well as in Swedish and Norwegian examples. See Jonathan L. Fairbanks *et al.*, *Paul Revere's Boston: 1735–1818* (Boston: Museum of Fine Arts, 1975), p. 222; Ethel S. Bolton and Eva J. Coe, *American Samplers* (Boston: The Massachusetts Society of Colonial Dames of America, 1921), pp. 28, 77; Alberta Meulenbelt-Nieuwburg, ed., *Embroidery Motifs from Old Dutch Samplers*, trans. Patrica Wardle, Gillian Downing (New York: Charles Scribner's Sons, 1975), pp. 22, 23, 29; Averil Colby, *Samplers* (Newton Centre, Mass.: Charles T. Branford, 1965), pp. 181, 183; Helen Engelstad, *Norske Navneduker* (Oslo: Forlagt Av H. Aschehoug, 1938), p. 15.

18. Sarah Silsbe(e), 1748. The Adam and Eve motif is used in American work in the eighteenth and nineteenth centuries. An English sampler of 1654 shows the Garden of Eden well populated with unicorn, leopard, peacock in pride, sun, cloud scroll, etc. Another English sampler of 1727 made by "a P" (author's collection) actually serves as a transition piece between the English example and the Boston sampler of 1748. The two eighteenth-century examples have Adam and Eve garbed modestly in oversized, applied fig leaves. In this example the arrangement of elements is a great deal more sparse than in its English forerunner. See G. Saville Seligman and Talbot Hughes, *Domestic Needlework* (London, 1920), pl. 3c.

19. Sarah Toppan, 1756. This is a design worked on many pieces by children from the Boston and Newbury areas, with centrally placed tree, grazing animals, romping rabbits, and oversized butterflies in the sky overhead.

20. Sarah Taylor, 1756. This piece represents a transition in design and shape from the early borderless cross-bands of stylized type to the more naturalized form. The central panel shows the altering of a floral arcade into a natural rose surrounded by birds eating cherries. The units above and below herald the future design complete with houses and figures.

23. Lucy Low, 1776. A Quaker child from Philadelphia treats the viewer to a colorful tableau showing two figures in a pastoral setting. Her keen interest in color and costume enlivens an otherwise restrained sampler.

24. Ruthey Putnam, 1778. This piece is one of eleven or more samplers known to have been made at the Sarah Stivour School (probably Salem, Massachusetts) between 1778 and 1786, which employ diagonal satin-stitch threads in very long stitches. This is almost identical to one worked by Nabby Mason Peele, also dated November 27, 1778. See Bolton and Coe, *American Samplers*, pl. XC, pp. 68, 383.

25. Mary Hafline, 178(?). This design is an amusing adaptation of the biblical story (Genesis 29:20). The costume is contemporary with the sampler.

26. Lydia Doggett, 1783. Probably the most appealing aspect of this work is the luscious color of the silks used to create this elevated pastoral setting and the carefully groomed shepherd and shepherdess residing there.

28. Rebecca Whitwell, 1785. This sampler is one of six worked in Newport, Rhode Island, between 1770 and 1795 that share common motifs and placement. Newport teacher Mary Gardner advertised in *The Newport Mercury*, May 4, 11, 18, 25, 1767, and later in March 6, 13, 20, April 1, 1786, and may be responsible for this general design. See Marcus B. Huish, *Samplers and Tapestry Embroideries* (London: Longmans, Green, 1913; reprint ed., New York: Dover Publications, 1970), pp. 101, 104; Rose Wilder Lane, *Woman's Day Book of American Needlework* (New York: Simon & Schuster, 1963), p. 55; Margaret Beautement, Eileen Lowcock, eds., *The Golden Hands Complete Book of Embroidery* (New York: Random House, 1973), p. 155; Bolton and Coe, *American Samplers* (reprint ed., New York: Dover Publications, 1973), pp. 35, 43; Betty Ring, "The Balch School in Providence, Rhode Island," *Antiques* (April 1975), pl. 1, p. 662; Glee F. Krueger, *New England Samplers to 1840* (Sturbridge, Mass.: Old Sturbridge Inc., forthcoming), photograph file of Hannah Burrill (author's collection).

30. Mary Miller, 1786. Mary's sampler is one of two re-

corded from Sarah Shoemeker's School near Pemberton, New Jersey. Esther Earl's work, 1797, is noted in Bolton and Coe, *American Samplers*, pp. 43, 385.

31. Unity Lewis, 1789. This sampler is particularly rich with its subtle coloring and deep crimson silk flowers. The wealth of lettering appears very busy because of the frequent value and color changes. Notice the wide borders.

34. Anonymous, probably Chester County, Pennsylvania, 1795. Beguiling rural vignettes are depicted in this freshly colored work. The spritely activities of a galloping horse, chatting ladies at the well, and the awkward handling of perspective combine to give a fresh, vital quality to this piece and to contrast it to earlier confined, restrained design. See Jean Lipman and Alice Winchester, *The Flowering of American Folk Art, 1776–1876* (New York: The Viking Press in cooperation with the Whitney Museum of American Art, 1974), fig. 133, p. 94.

37. Lydia Gladding, 1796. This handsomely designed sampler is typical of a number of surviving pieces worked between 1785 and 1797 that are attributed to the Balch School of Providence, Rhode Island. Its sophisticated color range, rococo-stitched flowers and strawberries, verse, inscription, and diagonal pattern darning of the background are some of the characteristics of this school. See Judith K. Grow and Elizabeth G. McGrail, *Creating Historic Samplers* (Princeton, N.J.: The Pyne Press, 1974), pl. II, fig. 3, pp. 26, 27; Ring, "The Balch School," pp. 660–671; Krueger, *New England Samplers to 1840*, forthcoming.

38. Rebecca Killeran, 1796. The following is a literal transcription of the verse featured in this sampler: "The Rural Scen" // Sweet contemplation to pursue / Behold a rural scene inview / The bleating herds the lowing kine / The spreading oak the tow'ring pine / The air from noxious vapours free / Whilst squirrels trip from tree to tee / And the sweet songsters hover round / Fruit herbs and flowers enrich the ground / And each their various fruit produce / Some for delight and some for use / Behold o youth this scene and see / What natures god hath given to the / With wonder view his great designs / In which superior wisdom shines / Revere his name admire his love / And raise thy thoughts to worlds above"

39. Eliza Whitman, 1796. Sisters Ruthe and Sally Baldwin, daughters of a Boston minister, used elements in the Whitman work. The wide border flowers, specific stitch choices, a spotted cow on a mound of grass, and singing bird on a tree stump appear to come from a common source. See Bolton and Coe, *American Samplers*, pl. XXXIX, p. 31; George L. Miner, "Rhode Island Samplers," *Rhode Island Historical Society Collections*, 13 (April 1920), p. 46; Krueger, *New England Samplers to 1840*, forthcoming.

42. Jane Margaret Andrews, 1800. This linsey-woolsey sampler with its gaily colored border and landscape suggested at the base has motifs common to pieces from Harpswell, Maine (fig. 90), and particularly to the work of Elizabeth Cutts (fig. 43) of Berwick, Maine. It is also similar to that of Hannah Nichols, c. 1800, in the Collection of McCall's Needlework and Crafts Magazine. See "Samplers Rich in Tradition," *The Best of McCall's Needlework and Crafts*, 1 (1975), pp. 24, 25, 150–154.

46. Ruth Locke, 1802. This child favored a design common to a number of Massachusetts and New Hampshire samplers worked between 1760 and the 1790s, each with very deeply arcaded borders of stylized motifs on three sides and with a central panel complete with an eighteenth-century house flanked by pairs of figures on either or both sides.

47. Sally Stubbs, 1802. A winsome sampler depicting a formal brick house, fenced-in gardens complete with singing birds, chatting ladies, potted flowers, and meandering strawberry vines, all neatly separated by a handsome herringbone brick garden walk.

50. Mary Todd, 1803. The Todd sampler resembles the work of Abigail Prince, AE 13, 1801, the daughter of Captain Joseph Prince of Boston. Abigail includes the same placement of paired figures, grapevine and arbor, an oval vine enclosing her verse, alphabets and inscription, with the bowknot above. She also used the naturalistic floral border, but Mary included the black holding the parasol and she

omitted the duck pond, etc., that Abigail used. See "The Editor's Attic," *Antiques*, 11, no. 3 (September 1941), pp. 161, 162.

51. Desire Ells Daman, 1804. Desire and her sister Ruth Tilden Daman (fig. 54) shared a common design but managed to achieve different effects through the choice of colors and variation in stitchery on the borders. Note the different spelling of their surname on the samplers.

55. Horton Family Register, 1807. This family record is typical of a number of rather large embroidered examples made in Portland, Maine, each with large floral borders worked in rococo stitch with the headings and capitals in Holbein. The lettering is usually black, and at the base is an appealing town view.

59. Fanny Rand Hammatt, 1809. Swallows and other birds are repeated in mirror-image fashion in combination with Federal architecture.

62. Deborah Laighton, 1810. See Bolton and Coe, *American Samplers*, pl. CIII, pp. 235, 377, 381; Krueger, *New England Samplers to 1840*, forthcoming.

63. Rachel James, 1811. This type of sampler may be seen with numerous variations in other Quaker schools. See Bolton and Coe, *American Samplers*, pl. XCVI, pp. 186, 386; Georgiana Brown Harbeson, *American Needlework* (New York: Coward-McCann, 1938), 53, illus. facing p. 52; Margaret Berwind Schiffer, *Historical Needlework of Pennsylvania* (New York: Charles Scribner's Sons, 1968), pp. 46–48.

64. Barbara A. Baner, 1812. This piece is one of four known examples worked at Mrs. Leah Meguier's School in Harrisburg, Pennsylvania. Mrs. Meguier, who is here identified as the wife of Isaac Maguire (or M'Guire), a tavern keeper and boot and shoemaker, lived and taught school at various addresses on Locust, Mulberry, and Second streets. She advertised in *The Oracle of Dauphin*, May 22, 1813, and *Pennsylvania Intelligencer*, April 5, 1822. The March 9, 1821, issue of the *Intelligencer* recorded Dauphin County expenditures and noted payments to "Leah Meguire, teaching poor children." She died February 1, 1830. The other examples are: Elizabeth Finney (1807), Cassandanna Hetzel (1823), and Ann E. Kelly (1825). See Schiffer, *Historical Needlework of Pennsylvania*, pl. II, pp. 40–42; Lipman and Winchester, *The Flowering of American Folk Art*, fig. 130, pp. 94, 101; Bolton and Coe, *American Samplers*, pl. XCVII, pp. 183, 386; Elizabeth Donaghy Garrett, "American Samplers and Needlework Pictures in the DAR Museum, Part II: 1806–1940," *Antiques*, 107, no. 4 (April 1975), fig. 5, pp. 688–701; Harbeson, *American Needlework*, p. 63.

67. Anna D. Campbell Family Register, c. 1814. Another register of the family of Captain William Bixby has the same charming delicacy as this one and contains similar carnations or pinks, roses, columns, type of drapery, swags, and small sprays, containers, etc. See *Antiques* (March 1978), illus. on p. 505.

68. Martha Woodnutt, 1814. Pattern darning was a specifically taught skill at the Westtown School in Pennsylvania, but may be found in examples in New York, New Jersey, etc. This technique may also be observed in American bed rugs and in some of the most elegant of American crewel embroideries. See Bolton and Coe, *American Samplers*, pl. CXVI, pp. 106, 162; Schiffer, *Historical Needlework of Pennsylvania*, p. 46; Susan Burrows Swan, *A Winterthur Guide to American Needlework* (New York: Crown Publishers, 1975), fig. 9, p. 18; Betty Ring, "Collecting American Samplers Today," *Antiques* (June 1972), fig. 2, p. 1,012; William Lamson Warren, *Bed Ruggs/1722–1833*, exhibition catalogue (Hartford, Conn.: Wadsworth Atheneum, 1972), pp. 32, 33, 44; Helen G. Hole, *Westtown Through the Years, 1799–1942* (Westtown, Pa.: Westtown Alumni Association, 1942), pp. 347, 383–388; Susan Burrows Swan, *Plain and Fancy, American Women and Their Needlework, 1700–1850* (New York: Holt, Rinehart & Winston, 1977), pl. 32, p. 147; an actual darning sampler is illustrated in figs. 27, 28.

70. Maria Bolen, 1816. This sampler focuses on a blend of the rigid cross-stitched pattern in small-scale units and combines this traditional exactness in the upper half of the sampler with a boldly scaled eagle and accouterments, which dwarfs the brick building below his clutching talons,

shield, spears, olive branch, and two flags. Beneath, in the foreground, is an informal colorful rendering of the rural estate, with promenading couple, their handsome horse and dog wagging his tail, a beehive, a solitary lady sprinkling her flowers, perching birds, and grazing livestock. This piece demonstrates the American qualities of spontaneity and a tendency to depart from a fixed design to create a still more animated and appealing stitchery. See Robert Bishop, *The All-American Dog* (New York: Avon, 1977), fig. 158; and a similar example by Margaret Moss in Bolton and Coe, *American Samplers*, pl. LXXIII, p. 199. Margaret Moss's has a bolder, larger-scaled border, but shares motifs such as eight-pointed stars, four butterflies, beehive, house, figures, and the ever-present eagle.

71. Maria Anderson, 1817. The handsome carriage and prancing horses and several floral units are almost identical to that made by Dorcas Stearns, Lexington, Massachusetts, 1792 (in a private collection), and others from Massachusetts and New Hampshire.

72. Eliza Weckerly, 1817. Similar Philadelphia examples may be seen in the work of Elizabeth Misky (1822), Martha N. Hewson, granddaughter of John Hewson the first American calico printer, and Margaret Hetzel, aged 14 (1818). See Bolton and Coe, *American Samplers*, p. 197; Harbeson, *American Needlework*, illus. facing p. 60, p. 52. Notes taken from the "Samplers in Time," Whitman traveling exhibition (October 16–November 13, 1977), Keeler Tavern, Ridgefield, Connecticut, November 9, 1977.

74. Hannah F. Thayer, 1818. A similar sampler wrought by Joanna W. Beal once had engravings attached to its linen surface, but only minute fragments remain. (Collection of Morris House Antiques, Stamford, Connecticut)

77. Martha Dunlavey, 1820. The Female Association School No. 2 was located on Henry Street in New York. Another sampler of superb workmanship was made at this school; it is inscribed "For Sarah Herbert/ . . . /Worked by Mary R. Wetmore, aged 13/ Female Association School No. 2, New York,/ March A D 1816" (Collection of Taylor B. Williams, Chicago, Illinois). See Advertisement in *Antiques* (September 1977), p. 392; Charles C. Andrews, *The History of the New-York African Free Schools* (New York: Mahlon Day, 1830; reprint ed., New York: Negro Universities Press, 1969), p. 21; William Oland Bourne, *History of the Public School Society of the City of New York* (New York: George P. Putnam's Sons, 1873), pp. 652–658.

80. Ann E. England, 1820. This sampler is attributed to Ann Eliza England, born 1804 at White Clay Creek, near Newark, Delaware. Her work, that of Susanna M. Holland, 1816 (Baltimore Museum of Art, Acc. No. 73.76.327), and that of Eliza J. Benneson, 1835 (Cooper–Hewitt Museum of Decorative Arts and Design, Smithsonian Institution, Acc. No. 1941-691-254) all indicate the design inspiration of a single school or teacher, which spanned the years from 1816 to 1835, and may possibly have been in Baltimore or Delaware. It may well have been a Quaker school or preceptress offering this remarkably sophisticated design.

86. Maria B. Greenawalt, 1822. See figure 105, Rebecca Smith, for a similar use of stem stitch on a large figure.

87. Elizabeth A. Thompson, 1822. This crisp little design may have been directed by a Catharine Ann Cameron, widow, listed at 17 Essex in the 1821–1822, 1822–1823 New York Directories. A Peter Cameron, teacher, had been listed earlier and failed to reappear. The widow may have taught in his absence.

89. Ann H. Vogdes, 1823. Many individual units of design familiar from Quaker examples are used. The stag near the weeping willow bears a resemblance to one depicted in figure 53, which was based on the Fürst example in figure 10.

90. Mahala Marein, 1824. Pairs of stylized cross-stitched pine trees and geometric and amorphous shapes may be seen in this sampler and in figures 42 and 43.

91. Philura Barton, 1824. Compare the work of Caroline M. Buell, 1824. See Krueger, *New England Samplers to 1840*, forthcoming.

92. Clarinda Parker, 1824. The strong rhythm of this graceful floral and vine border shows American sampler-making individuality and style at its best. Although the bal-

ance of the sampler design is a familiar one, the border maintains an elegance few samplers achieve.

93. Eveline Freeman Wheeler, 1824. One of the most engaging aspects of this sampler is the embroidery and padding of the two figures at the sides. Another less prominent feature are the young ladies seated under trees, a leisurely theme that appears even in American painted furniture. See Marshall B. Davidson, ed., *The American Heritage History of Colonial Antiques* (New York: American Heritage, 1967), illus. 65, 65a, pp. 57–58.

98. Mary Breed Gove, 1827. A touch of country charm emerges from this child's work in two media—embroidery and the watercolor landscape below that happily have remained together in what appears to be the original frame. Muted, rich colors blend together Mary Gove's two achievements.

99. Martha C. Hooton, 1827. Many similar design units are shared by this sampler and figure 88, such as tiny cornucopias, feeding squirrels as well as the obvious swans, crowing rooster, and the ever-present strawberries. Many of these are seen repeatedly in Quaker work. The crowns are probably present for a decorative reason rather than for a symbolic one. Exhibition: "The Flowering of American Folk Art, 1776–1876," the Whitney Museum of American Art, February 1–March 24, 1974. See Huish, *Samplers and Tapestry Embroideries,* p. 103; Lipman and Winchester, *The Flowering of American Folk Art,* fig. 134, p. 94.

101. Hester Cassel, 1828. Another handsome example from Mrs. Buchanan's School is that of Mary Ann Lucy Gries dated January 26, 1826. See Ring, "Collecting American Samplers Today," pl. I, p. 1,012, Compare Hester Cassel's sampler with that of Mary Ann Stauffer (fig. 104).

102. Amanda Malvina Hortter, 1829. In this sampler we see the use of shading in some of the designs, a technique that became very popular in Victorian needlework. Mary Elizabeth Cameron's 1835 sampler (fig. 112) shows similar shaded work.

103. Achsah Carter, 1830. This is one of the rare samplers originating in the Middle West, in this case ,the product of a Quaker heritage and a family that were also original settlers of Smithfield, Ohio. Exhibition: "American Midwest Collector's Choice" (October 14–November 27, 1960), Greenfield Village and Henry Ford Museum, Dearborn, Michigan. See Ethel Walton Everett, "Studies in Stitchery," *Antiques,* 35 (June 1939), fig. 11, p. 287, pp. 284–287; "American Midwest Collector's Choice" (October 14–November 27, 1960), Edison Institute, 1961, no. 718, p. 118.

104. Mary Ann Stauffer, 1830. Note the similar church, diagonal front path, three sheep, and the strawberry border in figure 101, the sampler of Hester Cassel, 1828, in Marietta, Pennsylvania, at Mrs. Buchanan's School. The German verse is taken from I Peter 1:24–25, which is an abbreviation of Isaiah 40:6–8: "For all flesh is like grass, / And all the beauty thereof. / Humankind is like flowers of the grass. / The grass withers, / And the flowers fall. / But the Word of the Lord / Endures forever. / This is the Word / Which is proclaimed to you."

105. Rebecca Smith, 1831. The enormous scale of the female figure, rich golden color, and simplified design elements combine to make this sampler striking. The garment and rooftop have been worked in the stem stitch, one popular even in a first-century A.D. Peruvian Paracas mantle. Maria B. Greenawalt's work (fig. 86) displays a similar use of the stem stitch in creating tree and costume. See Jacqueline Enthoven, *The Stitches of Creative Embroidery* (New York: Reinhold Publishing, 1964), illus. p. 65, pp. 65, 66.

111. Amy Mode, 1834. Mrs. Hannah C. Maitland is probably the preceptress who supervised this attractive sampler with its two types of borders and its cohesive design.

122. Mary Butz, 1842. Another sampler with an overwhelming border design is that of Helena Kutz, 1842, in which she also depicts Saint John's Lutheran Church, Kutztown. See Dr. John Joseph Stoudt, *Early Pennsylvania Arts* 28 (Allentown: Pennsylvania German Folklore Society, 1966), p. 351; Dr. John Joseph Stoudt, *Early Pennsylvania Arts and Crafts* (New York: A.S. Barnes, 1964), fig. 240, pp. 256, 258.

APPENDIX 2

Genealogical Notes

Fig. 13. Sarah Stone, Salem, Massachusetts, 1678. *Born:* 28: 12 month 1667, daughter of Robert Stone and Sara Shafflin (Essex County Court Records). *Married:* ? Jacob Manning.

Fig. 14. Ealli (Elizabeth) Crygier, New York, 1734. *B.:* 15 January 1721 (baptized), New Amsterdam, daughter of Sÿmon Kregier [*sic*] and Antje Van Oort. *M.:* 12 January 1743, Abraham Lam or (Lamb).

Fig. 16. Elizabeth Hext, Charleston, South Carolina, 1743. *B.:* c. 1734 in Charleston, 5th of issue of 5 daughters of David Hext and Anne Hamilton. *M.:* 1 January 1755, Robert Williams, Jr. esq. married by Rev. Richard Clark of St. Phillips Parish. *Died:* before 7 November 1769. Grandfather, Capt. John Hamilton, was Deputy Secretary of the Province. Father David Hext, "gentleman," was elected a member of the Commons House of Assembly from St. Johns Colleton, in November 1736 and was reelected from that county in 1739. He was elected from St. Phillips in 1746 and reelected in 1749.

Fig. 17. Hannah Church, Little Compton, Rhode Island, 1747. *B.:* 28 January 1734, Little Compton, Rhode Island, 3rd child of issue of 9, daughter of Edward Church and 2nd wife Mary Southworth. *M.:* 21 August 1754, Levi Irish, m. by Rev. Jonathan Ellis.

Fig. 18. Sarah Silsbe(e), Boston, Massachusetts, 1748. *B.:* ? 1739, daughter of Ephraim Silsbee and Esther Southwick (who married 9 November 1738). *M.:* 2 April 1777, John Galley, late of Boston.

Fig. 19. Sarah Toppan, Newbury, Massachusetts, 1756. *B.:* 16 May 1748, 3rd of issue of 12, daughter of Edward Toppan and Sarah Bailey. *M.:* 23 March 1770, Josiah Little. *D.:* 11 October 1823, at 75 years.

Fig. 20. Sarah Taylor, Hampton, New Hampshire, 1756. *B.:* 16 October 1743, 6th of issue of 12, daughter of John Taylor, a farmer, and Sarah Dearborn, Hampton, New Hampshire. *M.:* ? ?, Blake; lived in Kensington, New Hampshire. *D.:* ? June 1809.

Fig. 21. Abigail Byles, Boston, Massachusetts, 1757. *B.:* 21 November 1745, Boston, Massachusetts, daughter of Josias Byles junr. and Sara his wife. *M.:* 5 January 1774, James Sumner, in Boston.

Fig. 23. Lucia (Lucy) Low, Philadelphia, Pennsylvania, 1776. *B.:* ? 1764, Philadelphia, Pennsylvania, daughter of Hugh Low and Catharine (?), who married 26 June 1761. *1st M.:* 7 June 1797, John Davis, of Southwark at Pine Street Meeting House, Philadelphia. He died 9 July 1797. *2nd M.:* 4 February 1808, Asa Elkinton at the Mulberry Street Meeting House, Philadelphia. *D.:* 3 January 1867.

Fig. 24. Ruth (Ruthey) Putnam, Salem, Massachusetts, 1778. *B.:* 27 June 1768, Salem, Massachusetts, daughter of Bartholomew Putnam and Sarah Hodges (married 13 May 1760, at Salem). *M.:* 2 March 1789, Michael Webb. He died 17 November 1839. *D.:* 24 June 1790, at 22 years, of consumption; buried at Wadsworth Cemetery, Danvers, Massachusetts.

Fig. 26. Lydia Doggett, Attleboro or Newburyport, Massachusetts, 1783. *B.:* 14 January 1775, Attleboro, Massachusetts, daughter of Nathaniel Daggett and Beulah Dryer, or, *B.:* 14 October 1775, Newburyport, Massachusetts, daughter of Capt. Noah Daggett and Mary Clark. *D.:* 7 August 1815, Boston, Massachusetts.

Fig. 29. Catherine Hiester, Berks County, Pennsylvania, 1786. *B.:* 22 June 1772, daughter of Joseph Hiester and Elizabeth Witman. *M.:* 1 April 1798, John Spayd of Dauphin County. *D.:* 27 November 1833, her father, Joseph Hiester, was a member of the convention at Philadelphia, 1776, commissioned Lieutenant Colonel 4th Battalion Berks County Militia; a member of Congress 1797–1807; and Governor of Pennsylvania 1820–1823. John Spayd was a judge of the courts of Berks County 1806–1809.

Fig. 40. Martha Briggs, Halifax, Massachusetts, 1797. *B.:* 12 April 1784, Halifax, Massachusetts, 8th of issue of 12, daughter of Rev. Ephraim Briggs and Rebekah Waterman. *M.:* ? Zebadiah Thompson, esq., of Halifax. *D.:* 31 May 1844, Plymouth, Massachusetts.

Fig. 43. Elizabeth Cutts, Berwick, Maine, 1800. *B.:* 25 November 1787, Berwick, Maine, daughter of Richard Foxwell Cutts and Elizabeth (née) Cutts. *M.:* 17 September 1809, Tristram Hooper of Marblehead, Massachusetts. *D.:* 14 October 1882.

Fig. 46. Ruth Locke, Lexington, Massachusetts, 1802. *B.:* 6 June 1790, at Lexington, Massachusetts, daughter of Benjamin Locke and Betsey (Betsy) Wyman of Woburn. *M.:* 6 June 1811, Harvey Tileston, Jr., of Boston. *D.:* 11 September 1847. Benjamin Locke fought the British at Lexington Common, 9 April 1775.

Fig. 50. Mary Todd, Westfield, Massachusetts, 1803. *B.:* 15 October 1789, Westfield, Massachusetts, daughter of Rev. Asa Todd and Abigail Bishop. *M.:* c. 1810, Lewis Higgins, at Whately, Massachusetts. He was a farmer and resided at Chesterfield, Massachusetts. *D.:* 13 May 1874, Westfield, Massachusetts.

Fig. 51. Desire Ells Daman, Scituate, Massachusetts, 1804. *B.:* 7 October 1790, Scituate, Massachusetts, daughter of Calvin Daman and Mercy Eells [*sic*]. *M.:* 28 November 1816, Benjamin Stoddard, a farmer of Hingham, Massachusetts.

Fig. 54. Ruth Tilden Daman, Scituate, Massachusetts, 1807. *B.:* 3 December 1795, Scituate, Massachusetts, daughter of Calvin Daman and Mercy Eells. *M.:* 4 July 1819, Harris Damon [*sic*], a housewright, at Scituate, Massachusetts.

Fig. 57. Mary Graves Kimball, Haverhill, Massachusetts, 1808. *B.:* 6 July 1797, Haverhill, 2nd of issue of 7, daughter of Solomon Kimball and Polly Shepard. *M.:* 29 March 1826, James N. Ayer, 2nd m.

Fig. 59. Fanny Rand Hammatt, Boston, Massachusetts, 1809. *B.:* ? 1801, Boston, Massachusetts, daughter of William Hammatt and Fanny. *M.:* before 31 December 1823, Thomas Richardson, by Rev. Odin Ballou. *D.:* 5 April 1825, Boston, aged 23.

Fig. 66. Lucy Rugg, Lancaster, Massachusetts, 1st qtr. 19th century. *B.:* 4 February 1806, 8th of issue of 14, daughter of Joseph Rugg and Mary Hazen. *M.:* 18 November 1830, Isaac Weatherbee, a chairmaker and shoemaker. *D.:* 6 March 1857, Gardner, Massachusetts.

Fig. 69. Catharine Schrack, Philadelphia, Pennsylvania, 1815. Her father was an innkeeper listed in the Philadelphia directories. 1802: Schrack, Abraham, innkeeper, 139 N. Third St.; 1803: Schrack, Abraham, innkeeper, 295 N. Third St.; 1808–11: Schrack, Abraham, innkeeper, 38 High; 1816: Schrack, Abraham, innkeeper, 58 High.

Fig. 70. Maria Bolen, Philadelphia, Pennsylvania, 1816. *B.:* 24 March 1802, Philadelphia, Pennsylvania (baptized at St. Matthews Lutheran Church). *M.:* ?, John Barris.

Fig. 73. Mary Linstead, Barrington, Massachusetts, 1818. *B.:* ?, Woodbridge, Suffolkshire, England. She came to America aged four, residing in Barrington, Massachusetts. *M.:* ?, Isaac Parker of Royalton, Vermont, at Cuyahoga Falls, Summit County, Ohio. Removed to Chicago where their child, Lucy Ann, was born 17 December 1838.

Fig. 78. Mary Hibberd Garrett, Willistown, Pennsylvania, 1820. *B.:* 8th month 26th day 1805 (Quaker dating), Willistown, Chester County, Pennsylvania, daughter of Josiah Garrett and Lydia Hibberd, members of Goshen Monthly Meeting of Friends. *D.:* 7th month– ist day 1831, unmarried, aged 25 years, 20 months 5 days.

Fig. 80. Ann E. England, White Clay Creek, Mill Creek Hundred, New Castle County, Delaware, 1820. *B.:* 3 March 1804, at White Clay Creek, Mill Creek Hundred, New Castle County, Delaware, daughter of Joseph England and 2nd w. Eliza Boulden (m. 21 July 1802). *D.:* 20 May 1827, unmarried, in 23rd year, at home of her parents on White Clay Creek, near Newark, Delaware. Buried at "old burying ground," New Castle, Delaware. Joseph England served in

the House of Representatives (1799–1810) and was a state senator from 1810 until his death (24 April 1828).

Fig. 81. Mary Ann Morton, Portland, Maine, 1820. *B.:* 29 March 1808, daughter of John Morton, a blacksmith, and Rachel Bolton, who married, 10 May 1807, Gorham, Maine. *M.:* 4 December 1830, Daniel Elliott of Parsonsfield, Maine. *D.:* 17 December 1865.

Fig. 83. Rachel Denn Griscom, Chester County, Pennsylvania, 1821. *B.:* 5th day, 11th mo. 1808, at Salem, New Jersey, eldest of issue of 11, daughter of Samuel Griscom and Ann Powell (Recorded at Salem Monthly Meeting of Friends).

Fig. 88. Sarah Ann Hartman, Mount Holly, Burlington County, New Jersey, 1823. *B.:* ? 1808, Mount Holly, Burlington County, New Jersey, daughter of Samuel Hartman and Martha. (Edward Thomas became her legal guardian 8 February 1825 per Evesham Township Burlington County Court Records after her father's death.)

Fig. 89. Ann H. Vogdes, Willistown, Chester County, Pennsylvania, 1823. *B.:* 21 July 1808 at Willistown, eldest of issue of 8, daughter of Aaron Vogdes and Ann Hayman. *D.:* 7 August 1826, unmarried. Buried at cemetery of St. David's Protestant Episcopal Church at Radnor, now Delaware County.

Fig. 93. Eveline Freeman Wheeler, Morristown, New Jersey, 1824. *B.:* c. 1815, daughter of Phillip Wheeler and Polly Groute. *M.:* ?, Samuel Porter Cooke. This sampler descended in the family and was owned by a descendant, Carroll Amos Dwinell.

Fig. 98. Mary Breed Gove, Weare, New Hampshire, 1827. *B.:* 15 December 1814, Weare, New Hampshire, daughter of Moses Gove, a Quaker, and Sarah Chase. *M.:* 15 May 1833, Josiah Bartlett, of Deering, New Hampshire. They lived at Deering. *D.:* 11 January 1881. Teacher: Phebe Hoag Chase, Weare, New Hampshire. *B.:* 3 March 1810, in Weare, 3rd of issue of 6, daughter of John Chase and Betty Dow. *M.:* 25 June 1845, Dr. Enoch Green. *D.:* ? 1849, of cholera.

Fig. 111. Amy Mode, Chester County, Pennsylvania, 1834. Amy was the daughter of William Mode, who operated a gristmill near Coatsville, Pennsylvania, during the eighteenth century. In 1812 the gristmill was converted to a paper mill. The town of Modena was named for the Mode family, in which this sampler descended.

Fig. 114. Caroline Eliza Sayre, Newark, New Jersey, 1835. *B.:* 11 June 1824, daughter of James Randolph Sayre and 2nd wife, Hannah Reeve. *M.:* 8 February 1849, Albert Sayre, of Elizabeth, New Jersey. He was a dry-goods merchant in Newark until his death, 10 March 1876. James Randolph Sayre was a builder and mason in New York City and Newark. Newark city directories, 1835, 1836, list him: "Sayre, James R., dealer in bricks and lime. Orange/above High Office Mechanic's Wharf."

BIBLIOGRAPHY

Books

Adrosko, Rita J. "Natural Dyes in the United States." *United State National Museum Bulletin* 281, Washington, D.C.: Smithsonian Institution Press, 1968. Reprint. *Natural Dyes and Home Dyeing.* New York: Dover Publications, 1971.

Andrews, Charles C. *The History of the New-York African Free-Schools, from Their Establishment in 1787, to the Present Time, . . .* New York: Mahlon Day, 1830. Reprint. New York: Negro Universities Press, 1969.

Ashton, Leigh. *Samplers, Selected and Described.* London and Boston: The Medici Society, 1926.

Baker, Muriel L. *The ABC's of Canvas Embroidery.* Sturbridge, Mass.: Old Sturbridge Inc., 1968.

Beautement, Margaret, and Lowcock, Eileen. *The Golden Hands Complete Book of Embroidery.* New York: Random House, 1973, pp. 154–155.

Bemiss, Elijah. *The Dyer's Companion.* New York: Evert Duyckinck, 1815. Reprint. Foreword by Rita J. Adrosko. New York: Dover Publications, 1973.

Bentley, William. *The Diary of William Bentley, D.D.* 4 vols. Salem, Mass.: Essex Institute, 1905–1914.

Blandin, Mrs. I. M. E. *History of Higher Education of Women in the South Prior to 1860.* New York and Washington: The Neale Publishing Co., 1909.

Bolton, Ethel Stanwood, and Coe, Eva Johnston. *American Samplers.* Boston: The Massachusetts Society of Colonial Dames of America, 1921. Reprint. New York: Dover Publications, 1973.

Bowne, Eliza Southgate. *A Girl's Life Eighty Years Ago: Selections from the Letters of Eliza Southgate Bowne.* Introduction by Clarence Cook. New York: Charles Scribner's Sons, 1887.

Brecht, Samuel Kriebel, ed. *The Genealogical Record of the Schwenkfelder Families . . .* Pennsburg, Pa.: The Board of Publication of the Schwenkfelder Church, 1923.

Bremner, Robert H., ed. *Children and Youth in America. Vol. I, 1600–1865.* Cambridge, Mass.: Harvard University Press, 1970.

Bridenbaugh, Carl, and Bridenbaugh, Jessica. *Rebels and Gentlemen Philadelphia in the Age of Franklin.* New York: Oxford University Press, 1968.

Bronson, J., and Bronson, R. *The Domestic Manufacturer's Assistant and Family Directory in the Arts of Weaving and Dyeing.* Utica, N.Y.: William Williams, 1817. Reprint. *Early American Weaving and Dyeing the Domestic Manufacturer's Assistant and Family Directory in the Arts of Weaving and Dyeing.* Introduction by Rita J. Adrosko. New York: Dover Publications, 1977.

Channing, George G. *Early Recollections of Newport, R. I. from the Year 1793 to 1811.* Providence, R.I.: A.J. Ward, Charles E. Hammett, Jr., 1868.

Christie, Mrs. Archibald. *Sampler and Stitches.* Great Neck, N.Y.: Hearthside Press Inc., 1971.

Cobb, Jonathan H. *A Manual Containing Information Respecting the Growth of the Mulberry Tree, with Suitable Directions for the Culture of Silk.* Boston: Carter, Hendee, 1833.

Colby, Averil. *Samplers.* Newton Centre, Mass.: Charles T. Branford, 1965.

Comstock, F. G. *A Practical Treatise on the Culture of Silk, Adapted to the Soil and Climate of the United States.* Hartford, Conn.: P.B. Gleason, 1839.

Cooper, Grace Rogers. *The Copp Family Textiles.* Smithsonian Studies in History and Technology, No. 7. Washington, D.C.: Smithsonian Institution Press, 1971.

Craig, James H. *The Arts and Crafts in North Carolina 1699–1840.* Winston Salem, N.C.: Museum of Early Southern Decorative Arts, Old Salem, Inc., 1965.

Crakelt, William. *Entick's New Spelling Dictionary, Teaching to Write and Pronounce the English Tongue with Ease and Propriety.* London: Charles Dilly, 1787.

Davidson, Mary M. *Plimoth Colony Samplers.* Marion, Mass.: The Channings, 1974.

Davis, Mildred J. *Early American Embroidery Designs.* New York: Crown Publishers, 1969.

Dewees, Watson W. *A Brief History of Westtown Boarding School with a General Catalogue of Officers, Students, Etc.* 3rd ed. Philadelphia: Watson W. Dewees, 1884.

Dexter, Elizabeth Anthony, Ph.D. *Career Women of America 1776–1840.* Francestown, N.H.: Marshall Jones, 1950.

———. *Colonial Women of Affairs, Women in Business and the Professions in America Before 1776.* 2d ed., rev. Boston: Houghton Mifflin Co., 1931. Reprint. Clifton, N.J.: Augustus M. Kelley, 1972.

Dow, George Francis. *The Arts and Crafts in New England, 1704–1775: Gleanings from Boston Newspapers.* Topsfield, Mass.: The Wayside Press, 1927. Reprint. New York: Da Capo Press, 1967.

Dreesmann, Cécile. *Embroidery.* Toronto: The Macmillan Company, 1969.

———. *Samplers for Today.* New York: Van Nostrand Reinhold, 1972.

Earle, Alice Morse. *Child Life in Colonial Days.* New York: The Macmillan Company, 1899. Reprint. 1915.

———. *Colonial Dames and Good Wives.* Boston and New York: Houghton, Mifflin, 1895.

———, ed. *Diary of Anna Green Winslow, a Boston School Girl of 1771.* Boston: Houghton, Mifflin, 1894. Reprint. Williamstown, Mass.: Corner House Publishers, 1974.

———. *Home Life in Colonial Days.* New York: The Macmillan Company, 1898. Reprint. New York: Grosset & Dunlap, 1907.

Eastman, Sophia. *In Old South Hadley.* Chicago: published by the author, 1912.

Emery, Irene. *The Primary Structures of Fabrics.* Washington, D.C.: The Textile Museum, 1966.

Emery, Sarah Anna. *Reminiscences of a Nonagenarian.* Newburyport, Mass.: William H. Huse, 1879.

Enthoven, Jacqueline. *The Stitches of Creative Embroidery.* New York: Reinhold Publishing, 1964.

Fennelly, Catherine. *Town Schooling in Early New England, 1790–1840.* Sturbridge, Mass.: Old Sturbridge Inc., 1962.

Fisher, George. *The American Instructor: or, Young Man's Best Companion.* 9th ed. Philadelphia: B. Franklin and D. Hall, 1748.

———. *The American Instructor: or, Young Man's Best Companion.* 10th ed., rev. Philadelphia: B. Franklin and D. Hall, 1753.

———. *The American Instructor: or, Young Man's Best Companion.* 14th ed., rev. and cor. New York: H. Gaine, 1770.

———. *The Instructor: or, American Young Man's Best Companion.* 30th ed., rev., cor., enl. Worcester, Mass.: Isaiah Thomas, 1785.

———. *The Instructor, or American Young Man's Best Companion, Improved.* Philadelphia: John Bioren, 1812.

———. *The Instructor; or, Young Man's Best Companion.* 22nd ed. Edinburgh: Alexander Donaldson, 1773.

Fürst, Rosina Helena. *Das Neüe Modelbuch von Schönen Nädereÿen, Ladengewürck, und Paterleinsarbeit.* Ander theil. Nürnberg: Paülüs Fürsten, 1666.

Gottesman, Rita Susswein. *The Arts and Crafts in New York, 1726–1776: Advertisement and News Items from New York City Newspapers.* 1. New York: The New-York Historical Society, 1938.

Groce, George C., and Wallace, David H. *The New-York Historical Society's Dictionary of Artists in America 1564–1860,* New Haven, Conn.: Yale University Press, 1969.

Grow, Judith K., and McGrail, Elizabeth. *Creating Historic Samplers.* Princeton, N.J.: The Pyne Press, 1974.

Hanley, Hope. *Needlepoint in America.* New York: Charles Scribner's Sons, 1969.

Harbeson, Georgiana Brown. *American Needlework: The History of Decorative Stitchery and Embroidery from the Late 16th to the 20th Century.* New York: Coward-McCann, 1938. Reprint. New York: Bonanza Books, 1961.

Hole, Helen G. *Westtown Through the Years 1799–1942.* Westtown, Pa.: Westtown Alumni Association, 1942.

Hopkins, Samuel, D.D. *Memoirs of the Life of Mrs. Sarah Osborn . . .* Worcester, Mass.: Leonard Worcester, 1799.

Huish, Marcus B. *Samplers and Tapestry Embroideries.* New York: Longmans, Green, 1913. Reprint. New York: Dover Publications, 1963.

Johnson, Clifton. *Old-Time Schools and School-Books.* New York: The Macmillan Company, 1974. Reprint. Foreword by Carl Withers. New York: Dover Publications, 1963.

Johnson, Samuel. *A Dictionary of the English Language.* 2. London, 1799.

Kassell, Hilda. *Stitches in Time: The Art and History of Embroidery.* New York: Duell, Sloan and Pearce, 1966.

Klamkin, Marian. *Hands to Work: Shaker Folk Art and Industries.* New York: Dodd, Mead, 1972.

Krueger, Glee F. *New England Samplers to 1840.* Sturbridge, Mass.: Old Sturbridge Inc., forthcoming.

Lambert, Miss. *The Hand-Book of Needlework.* New York: Wiley & Putnam, 1842.

Lane, Rose Wilder. *Woman's Day Book of American Needlework.* New York: Simon & Schuster, 1963.

Leechman, Douglas. *Vegetable Dyes from North American Plants.* Toronto: The Southern Ontario Unit of the Herb Society of America, 1969.

Leedom, Benjamin J. *Westtown Under the Old and New Régime.* Würzburg, Germany: Bonitas-Bauer, 1883.

Little, Frances. *Early American Textiles.* New York: The

Century Co., 1931.

Little, Nina Fletcher. *Country Arts in Early American Homes.* New York: Dutton Paperbacks, 1975.

Livingston, Ann Home. *Nancy Shippen Her Journal Book . . .* Edited and compiled by Ethel Armes. Philadelphia: J.B. Lippincott, 1935.

Lord, Priscilla Sawyer, and Foley, Daniel J. *The Folk Arts and Crafts of New England.* Philadelphia: Chilton Book Co., 1965.

Lotz, Arthur. *Bibliographie der Modelbücher: Beschreibendes Verzeichnis der Stick- und Spitzenmusterbücher des 16 und 17 Jahrhunderts.* Leipzig: Karl W. Hiersemann, 1933.

Meulenbelt-Nieuwburg, Albarta. *Embroidery Motifs from Old Dutch Samplers.* New York: Charles Scribner's Sons, 1974.

Morgan, Helen M., ed. *A Season in New York, 1801: Letters of Harriet and Maria Trumbull.* Pittsburgh: University of Pittsburgh Press, 1969.

Mulhern, James. *A History of Secondary Education in Pennsylvania.* Lancaster, Pa.: published by the author, 1933.

Nason, Elias. *Memoir of Mrs. Susanna Rowson with Elegant and Illustrative Extracts from Her Writings in Prose and Poetry.* Albany, N.Y.: Joel Munsell, 1870.

Nylén, Anna-Maja. *Swedish Handcraft.* Translated by Anne-Charlotte Hanes Harvey. New York: Van Nostrand Reinhold, 1977.

Orlofsky, Patsy, and Orlofsky, Myron. *Quilts in America.* New York: McGraw-Hill Book Company, 1974, pp. 267–274.

Parrish, Edward. *Education in The Society of Friends Past, Present, and Prospective.* Philadelphia: J.B. Lippincott, 1865.

Patten, Ruth. *Interesting Letters of the Late Mrs. Ruth Patten, of Hartford, Conn.* Hartford: D.B. Moseley, 1845.

Patten, William, D.D. *Memoirs of Mrs. Ruth Patten of Hartford, Conn. with Letters and Incidental Subjects.* Hartford: P. Canfield, 1834.

Peterson, Grete, and Svennås, Elsie. *Handbook of Stitches.* Foreword by Jacqueline Enthoven. New York: Van Nostrand Reinhold, 1971.

Prime, Alfred Coxe. *The Arts and Crafts in Philadelphia, Maryland and South Carolina, 1721–1785: Gleanings from Newspapers.* Philadelphia: The Walpole Society, 1929. Reprint. New York: Da Capo Press, 1969.

———. *The Arts and Crafts in Philadelphia, Maryland and South Carolina 1786–1800: Gleanings from Newspapers.* Philadelphia: The Walpole Society, 1932. Reprint. New York: Da Capo Press, 1969.

Reichel, William C., and Bigler, William H. *A History of the Rise, Progress, and Present Condition of the Moravian Seminary for Young Ladies at Bethlehem, Pennsylvania, With Its Catalogue of Its Pupils 1785–1858.* 2d ed., rev. and enl. Philadelphia: J.B. Lippincott, 1870.

Schiffer, Margaret Berwind. *Furniture and Its Makers of Chester County, Pennsylvania.* Philadelphia: University of Pennsylvania Press, 1966, pp. 232–237, fig. 144.

———. *Historical Needlework of Pennsylvania.* New York: Charles Scribner's Sons, 1968.

Seligman, G. Saville, and Hughes, Talbot. *Domestic Needlework.* London: Country Life, 1926.

Seybolt, Robert Francis. *The Private Schools of Colonial Boston.* Cambridge, Mass.: Harvard University Press, 1935. Reprint. New York: Arno Press and The New York Times, 1969.

Sigourney, Lydia H. *Letters to My Pupils with Narrative and Biographical Sketches.* New York: Robert Carter & Bros., 1860.

Sill, Gertrude Grace. *A Handbook of Symbols in Christian Art.* New York: The Macmillan Company, 1975.

Smedley, Susanna, comp. *Catalog of Westtown Through the Years, Officers, Students, and Others Fifth Month 1799 to Fifth Month 1945.* Westtown, Pa.: Westtown Alumni Association, 1945.

Spruill, Julia Cherry. *Women's Life and Work in the Southern Colonies.* Chapel Hill, N.C.: University of North Carolina Press, 1938. Reprint. New York: W.W. Norton, 1972.

Stauffer David McNeeley. *American Engravers Upon Copper and Steel Part II Check-list of the Works of the Earlier Engravers.* New York: The Grolier Club of the City of New York, 1907.

Stokes, I. N. Phelps, and Haskell, Daniel C. *American Historical Prints; Early Views of American Cities, Etc. from the Phelps Stokes and Other Collections.* New York: The New York Public Library, 1933.

Stone, Edwin M., comp. *Mechanics' Festival, An Account of the Seventy-first Anniversary of the Providence Association of Mechanics and Manufacturers . . .* Providence, R.I.: Knowles, Anthony & Co., Printers, 1860.

Stoudt, John Joseph, Ph.D. *Early Pennsylvania Arts and Crafts.* Foreword by S. K. Stevens. New York: A.S. Barnes, 1964.

———. *Pennsylvania German Folk Art: An Interpretation.* 28. Allentown, Pa.: The Pennsylvania German Folklore Society, 1966.

Swain, Margaret H. *Historical Needlework, A Study of Influences in Scotland and Northern England.* New York: Charles Scribner's Sons, 1970.

Swan, Susan Burrows, *Plain and Fancy: American Women and Their Needlework, 1700–1850.* New York: Holt, Rinehart & Winston, 1977.

———. *A Winterthur Guide to American Needlework.* New York: Crown Publishers, 1976.

Trumbull, Hammond, ed. *The Memorial History of Hartford County, Connecticut 1633–1883.* 2. Boston: Edward L. Osgood, 1886.

Vanderpoel, Emily Noyes, comp. *Chronicles of a Pioneer School from 1792 to 1833 Being the History of Miss Sarah Pierce and Her Litchfield School.* Cambridge, Mass.: published by author, 1903.

———. *More Chronicles of a Pioneer School from 1792–1833 Being Added History on the Litchfield Female Academy Kept by Miss Sarah Pierce and Her Nephew, John Pierce Brace.* New York: The Cadmus Book Shop, 1927.

Wade, N. Victoria. *The Basic Stitches of Embroidery.* 2d ed. The Victoria and Albert Museum, London: Her Majesty's Stationery Office, 1966.

Webster, Noah, esq. *A Compendious Dictionary of the English Language.* Hartford, Conn.: Hudson & Goodwin, 1806.

Weygandt, Dr. Cornelius. *The Dutch Country Folks and Treasures in the Red Hills of Pennsylvania.* New York: D. Appleton-Century, 1939, pp 249–251.

Wheeler, Candace. *The Development of Embroidery in America.* New York: Harper & Bros., 1921.

Wingate, Dr. Isabel B., ed. *Fairchild's Dictionary of Textiles.* New York: Fairchild Publications, 1970.

Woody, Thomas. *A History of Women's Education in the United States.* 2 vols. New York: Science Press, 1929.

Periodicals

Barsky, Bernice. "Samplers." *The Family Creative Workshop.* 15. New York and Amsterdam: Plenary Publications International, 1975: 1,848–1,859.

Bolton, Ethel Stanwood. "Five Contemporary Samplers." *Antiques* 14 (July 1928): 42–45.

Bowen, Richard Le Baron. "The Scott Family Needlework." *Rhode Island Historical Society Collections* 2 (January 1943): 11–21; 2 (April 1943): 49–57.

Browne, Benjamin F. "Some Notes Upon Mr. Rantoul's Reminiscences." *Historical Collections of the Essex Institute* 5 (October 1863): 197–202.

———. "Youthful Recollections of Salem." *Historical Collections of the Essex Institute* 50 (October 1914): 289–296.

Demarest, Mary A. "Some Early New Brunswick Schools for Girls." *Proceedings of the New Jersey Historical Society* 53 (July 1935): 163–185.

Engelstad, Helen. *Norske Navneduker.* Oslo: Forlagt Av H. Aschehoug, 1938: 3–23.

Farnam, Anne. "Textiles at the Essex Institute." *Essex Institute Historical Collections* 110 (October 1974): 253–258.

Franklin, Ruth E. "Some Early Schools and Schoolmasters of Newport." *Bulletin of the Newport Historical Society* 96 (January 1936): 13–31.

Garrett, Elizabeth Donaghy. "American Samplers and Needlework Pictures in the DAR Museum, Part I: 1739–1896." *Antiques* 105 (February 1974): 356–364.

———. "American Samplers and Needlework Pictures in the DAR Museum, Part II: 1804–1840." *Antiques* 107 (April 1975): 688–701.

Giffen, Jane C. "Susanna Rowson and Her Academy." *Antiques* 98 (September 1970): 436–440.

Ginsburg, Cora. "Textiles in the Connecticut Historical Society." *Antiques* 107 (April 1975): 712–725.

Hare, Lloyd C. M. "The Greatest American Woman: A Life of Lucretia Mott, Social Pioneer." *Americana Illustrated* 30 (July 1936): 387–460.

"History in Needlework." *Historical New Hampshire* (April 1946): 9–13.

Holdridge, Barbara, and Holdridge, Lawrence B. "Ammi Phillips 1788–1865." *Connecticut Historical Society Bulletin* 30 (October 1965): 97–145, fig. 102, p. 134.

Keith, Elmer D. "Architectural Sidelights from Samplers." *Antiques* 57 (June 1950): 437–439.

King, Donald. "The Earliest Dated Sampler." *Connoisseur* 149 (April 1962): 234, 235.

Lindgren-Fridell, Marita. "Några Upplandska Märk-Och Mönsterdukar." *Uppland.* Uppsala, Sweden, 1941: 30–48.

Little, Nina Fletcher. "The Blyths of Salem: Benjamin, Limner in Crayons and Oil, and Samuel, Painter and Cabinetmaker." *Essex Institute Historical Collections* 108 (January 1972): 49–57.

Mayorcas, J. D. "English Stumpwork." *Connoisseur* 188 (April 1975): 254–260.

Miner, George L. "Rhode Island Samplers." *Rhode Island Historical Society Collections* 13 (April 1920): 41–51.

Nylander, Jane. "Some Print Sources of New England Schoolgirl Art." *Antiques* 110 (August 1976): 292–301.

Rantoul, Robert S. "Mr. Rantoul's Youth and Apprenticeship." *Historical Collections of the Essex Institute* 5 (October 1863): 193–196.

———. "Rantoul Genealogy, &c." *Historical Collections of the Essex Institute* 5 (August 1863): 145–152.

Ring, Betty. "The Balch School in Providence, Rhode Island." *Antiques* 107 (April 1975): 660–671.

———. "Collecting American Samplers Today." *Antiques* 101 (June 1972): 1,012–1,018.

———. "Mrs. Saunders' and Miss Beach's Academy, Dorchester." *Antiques* 110 (August 1976): 302–312.

———. "Saint Joseph's Academy in Needlework Pictures." *Antiques* 113 (March 1978): 592–599.

———. "Salem Female Academy." *Antiques* 106 (September 1976): 434–442.

Schetky, Ethel Jane McD., guest ed. "Dye Plants and Dyeing—A Handbook." *Plants and Gardens* 20. Brooklyn, N.Y.: Brooklyn Botanic Garden, 1964: 77–82, 92–94.

Smith, Huldah M. "Some Aspects of William Bentley as Art Collector and Connoisseur." *Essex Institute Historical Collections* 97 (April 1961): 151–164.

Townsend, Gertrude. "Judith Paul's Sampler (1781)." *Rhode Island Historical Society Collections* 34 (July 1941): 78–80.

Tucker, Jonathan. "Old Schools and School-Teachers of Salem." *Historical Collections of the Essex Institute* 7. (December 1865): 241–243.

Catalogues of Permanent Collections and Special Exhibitions

Callister, J. Herbert, and Warren, William L. *Bed Ruggs/1722–1833.* Hartford, Conn.: Wadsworth Atheneum, 1972.

Cincinnati Museum Exhibition of a Collection of Samplers Lent by Mr. Alexander W. Drake of New York January 9th to 30th, 1909. Eden Park: Cincinnati Art Museum, 1909.

The Decorative Arts of New Hampshire: A Sesquicentennial, June 28, 1973 to September 29, 1973. Concord, N.H.: New Hampshire Historical Society, 1973.

De Pauw, Linda Grant, and Hunt, Conover. *Remember the Ladies: Women in America, 1750–1815.* New York: The Viking Press in association with the Pilgrim Society, 1976.

Fairbanks, Jonathan L.; Cooper, W. A.; Farnum, A.; Jobe, B. W.; Katz-Hyman, M. B. *Paul Revere's Boston: 1735–1818.* Boston: Museum of Fine Arts, 1975.

Holdridge, Barbara C., and Holdridge, Lawrence B. *Ammi Phillips: Portrait Painter, 1788–1865.* Foreword by Mary Black. New York: Clarkson N. Potter, for Museum of American Folk Art.

Horner, Marianna Merritt. *The Story of Samplers.* Philadelphia: Philadelphia Museum of Art, 1963.

The John Brown House Loan Exhibition of Rhode Island Furniture, Including Some Notable Portraits, Chinese Export Porcelain & Other Items, May 16–June 20, 1965. Providence: Rhode Island Historical Society, 1965.

King, Donald. *Samplers.* The Victoria and Albert Museum, London: Her Majesty's Stationery Office, 1960.

Lipman, Jean, and Winchester, Alice. *The Flowering of American Folk Art, 1776–1876.* New York: The Viking Press in cooperation with the Whitney Museum of American Art, 1974.

Montgomery, Charles F., and Kane, Patricia E., gen. eds. *American Art: 1750–1800 Towards Independence.* Boston: New York Graphic Society for Yale University Art Gallery, New Haven, Connecticut, and The Victoria and Albert Museum, London, 1976.

Payne, Francis G. *Guide to the Collection of Samplers and Embroideries.* Cardiff, Wales: National Museum of Wales and by the Press Board of the University of Wales, 1939.

Pennsylvania Folk Art, October 20–December 1, 1974. Foreword by Howard A. Feldman. Allentown, Pa.: Allentown Art Museum, 1974.

Schorsch, Anita. *Mourning Becomes America: Mourning Art in the New Nation.* Clinton, N.J.: The Main Street Press, 1976.

Manuscripts

Litchfield, Conn. Litchfield Historical Society and Museum. Benjamin Tallmadge, A.L.S., to Hon. John R. Cushman of Troy, N. Y., March 30, 1823.

Litchfield, Conn. Litchfield Historical Society and Museum. MS 8739. Jonathan Turbon, "An Emblem of the Uncertainty of Man's Life, etc." n.d. (c. 1720–1750 according to William L. Warren).

Providence, R. I. Private collection. James Howard to his sister Lucy at Miss Balch's boardinghouse, July 1805 correspondence.